To Dinnie,

In Appreciation for your kindness over the years, your professional expertise on the Job and above all, your Friendship. I wish you the very best in your new Colorado Adventure and look forward to a visit and Free Gourmet Treats! God Bless

and love,

Christmas, 1998

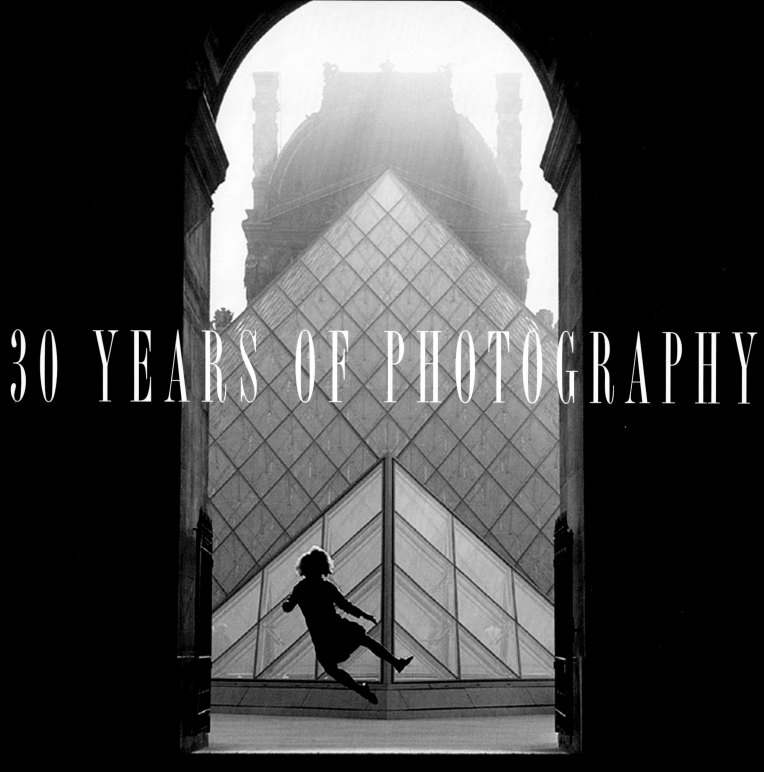

30 YEARS OF PHOTOGRAPHY

A young Parisian jumps for joy at the Louvre.

WITH AN ARTIST'S EYE AND PHILOSOPHER'S SOUL, JIM STANFIELD HAS COVERED
THE WORLD AND ITS HERITAGE FOR NATIONAL GEOGRAPHIC. IN THIS
BOOK HE REVISITS THE PLACES AND THE MOMENTS OF
HIS REMARKABLE CAREER.

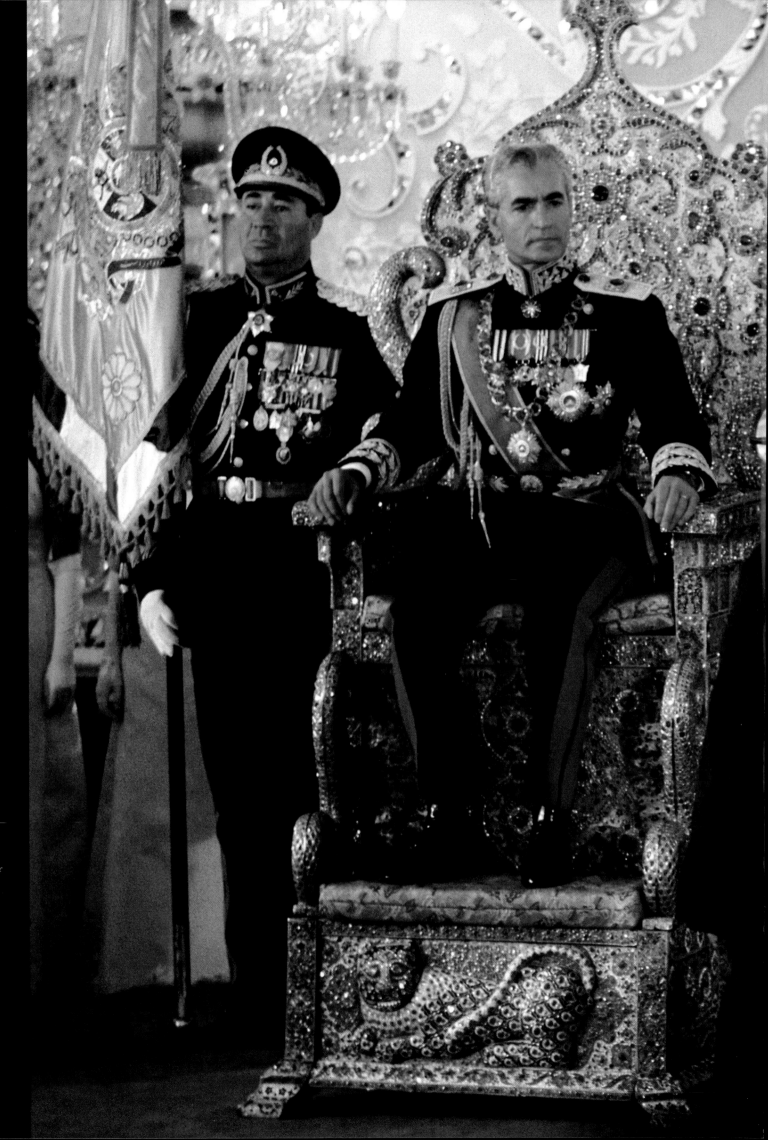

IRAN'S SHAH CROWNS
HIMSELF AND HIS EMPRESS
March 1968

*Royal ornaments beyond
price bedeck the Shah of
Iran at his self-coronation
in 1967. This picture,
which was not published
in the article, shows him
face-to-face with a Muslim
cleric. The Ayatollah
Khomeini, then in exile,
would overthrow the Shah
in 1979. This experience
in my early years helped
when I later photographed
the grandeur of Windsor
Castle and the treasures of
the Vatican.*

ROME OF THE EAST
December 1983

*Following pages: Capturing
a time long ago is always
a challenge. The Eastern
Orthodox faith that
anchored the ancient
Byzantine Empire seems
embodied in these isolated
monasteries at Meteora, —
Greece. The haunting
purple light of the mists
swirling about the sugarloaf
mountains is achieved by
opening the camera's
shutter three to four
minutes just before dawn.*

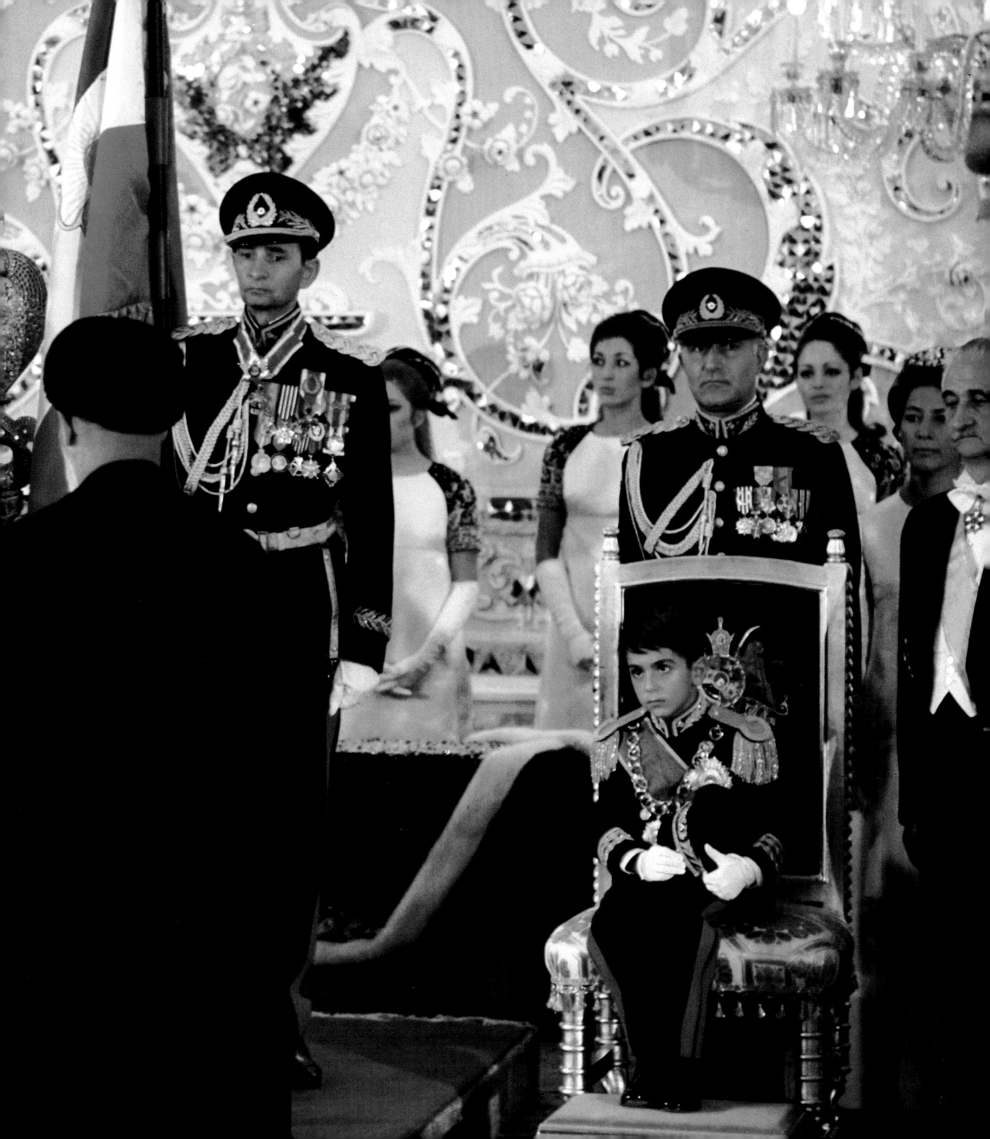

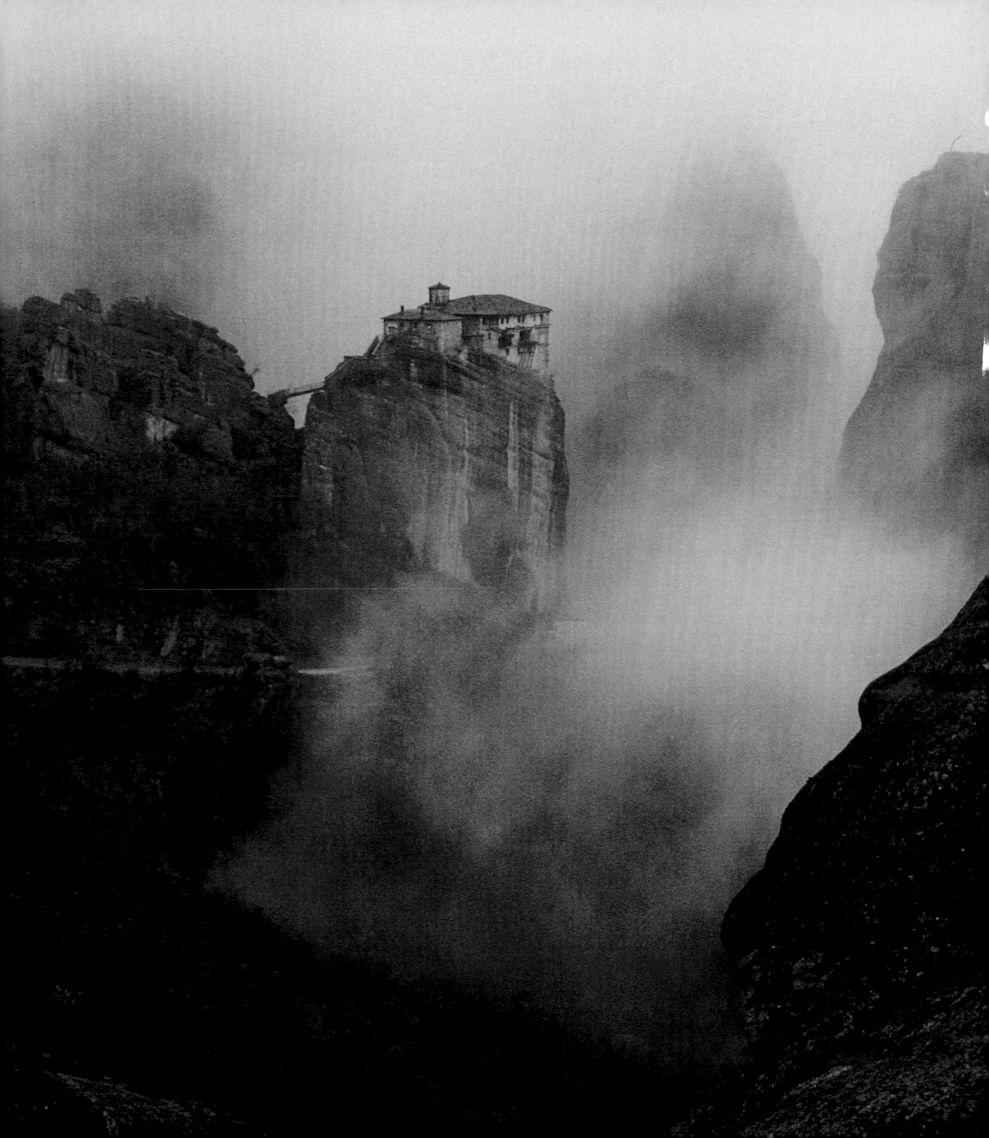

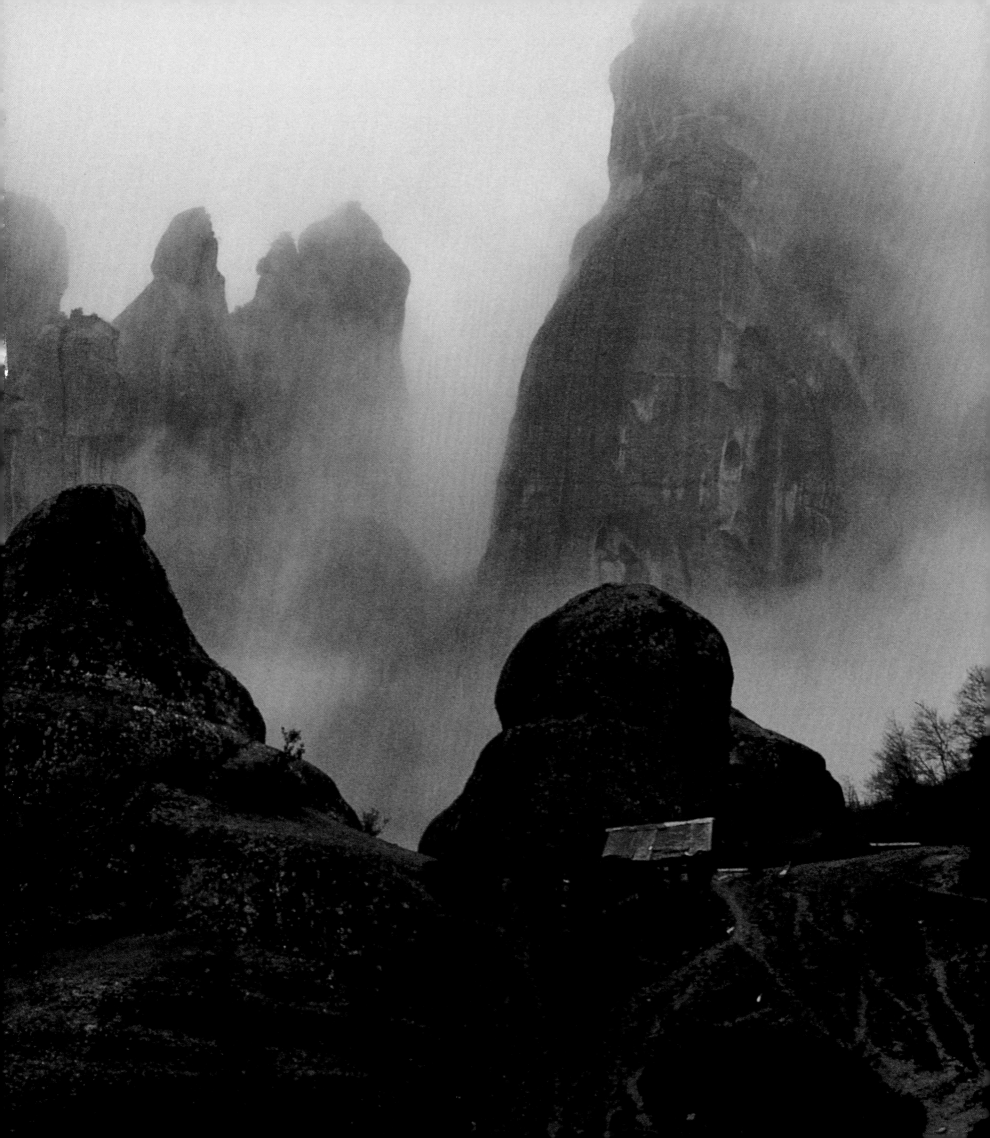

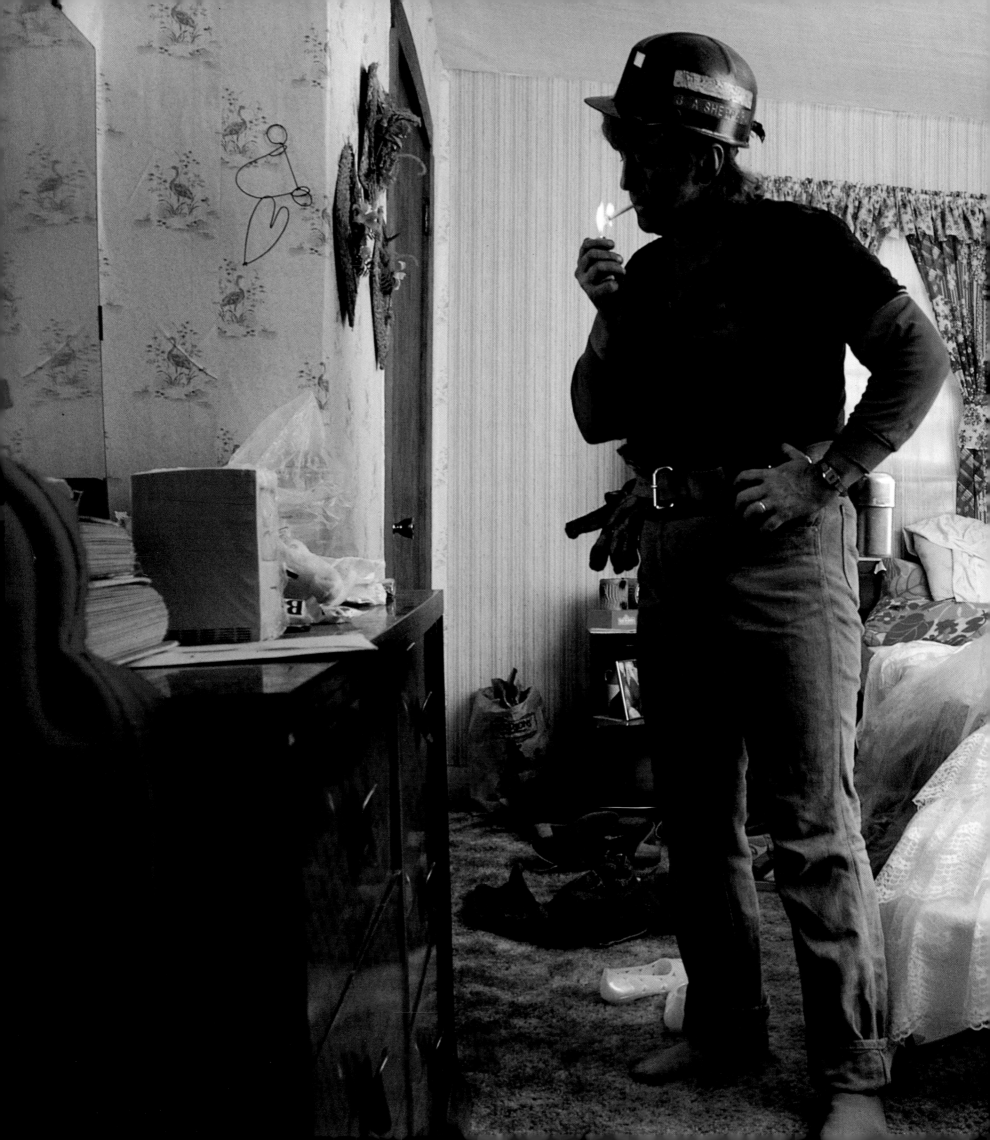

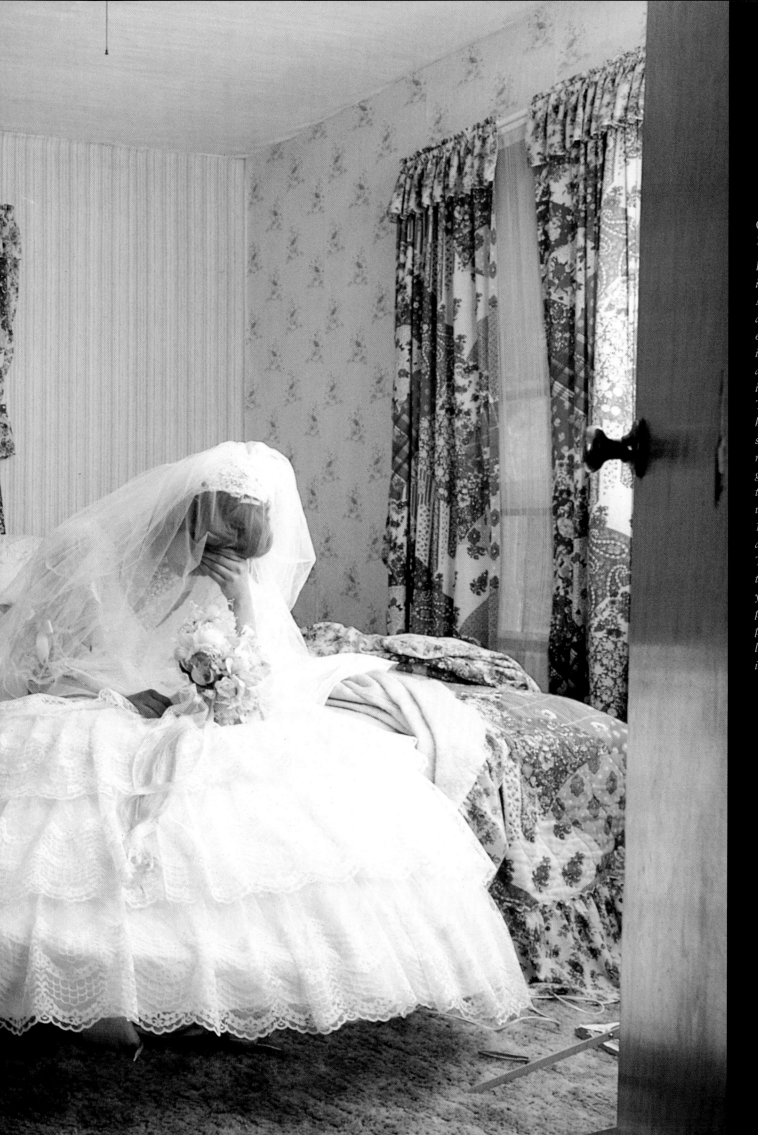

COAL MINER'S DAUGHTER
1986

I joined many photographers in the Day in the Life of America *project, a one-day assignment to capture the essence of the United States in one book. I chose miners and I was particularly intrigued by women miners. This West Virginia woman had just returned from her shift to find her daughter ready to hem her bridal gown. It was a week before the wedding, and the mother was still hoping to talk her 15-year-old out of marrying a jobless 14-year-old boy. This picture did not make the book. It is hard when you have a memorable photograph that does not get published because space is limited and it is not an integral part of the story.*

7

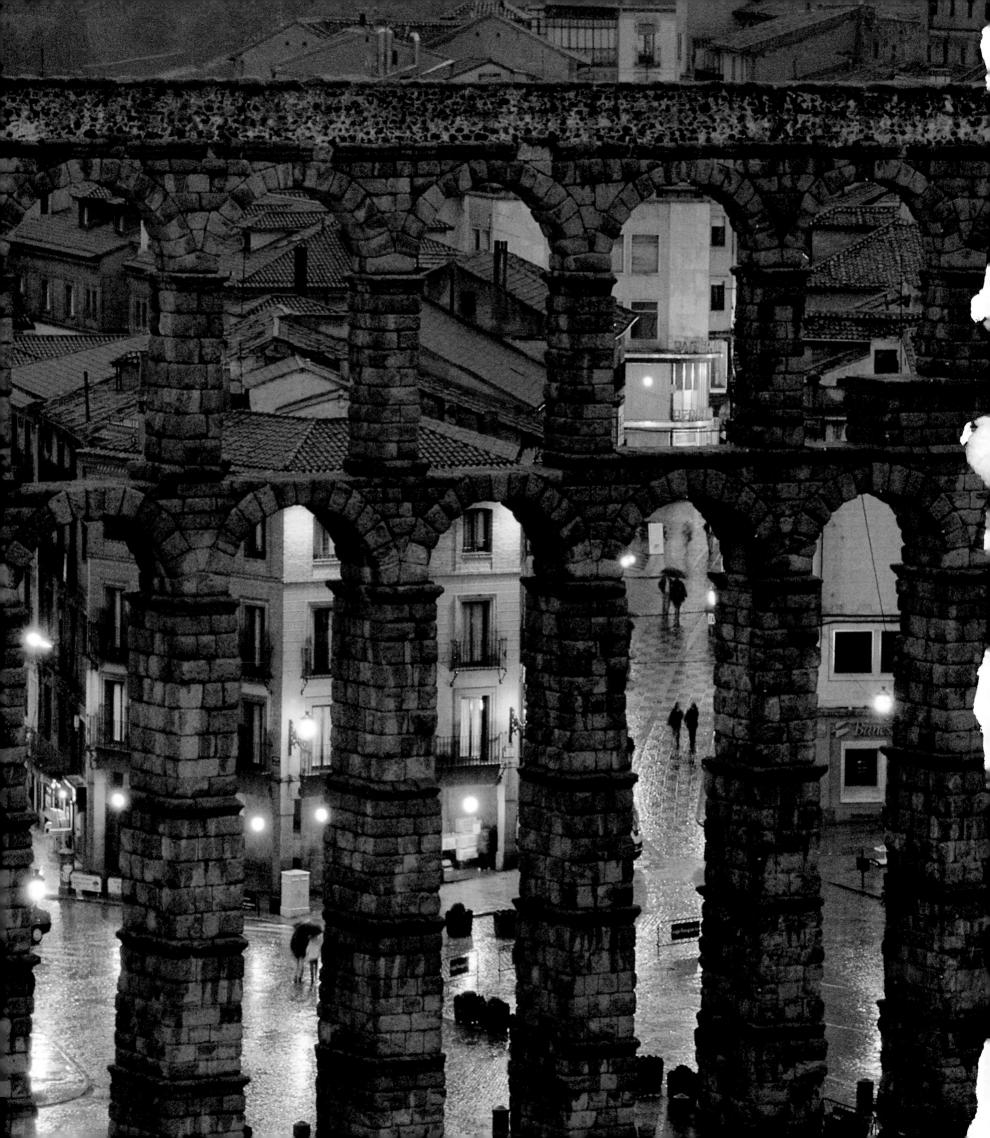

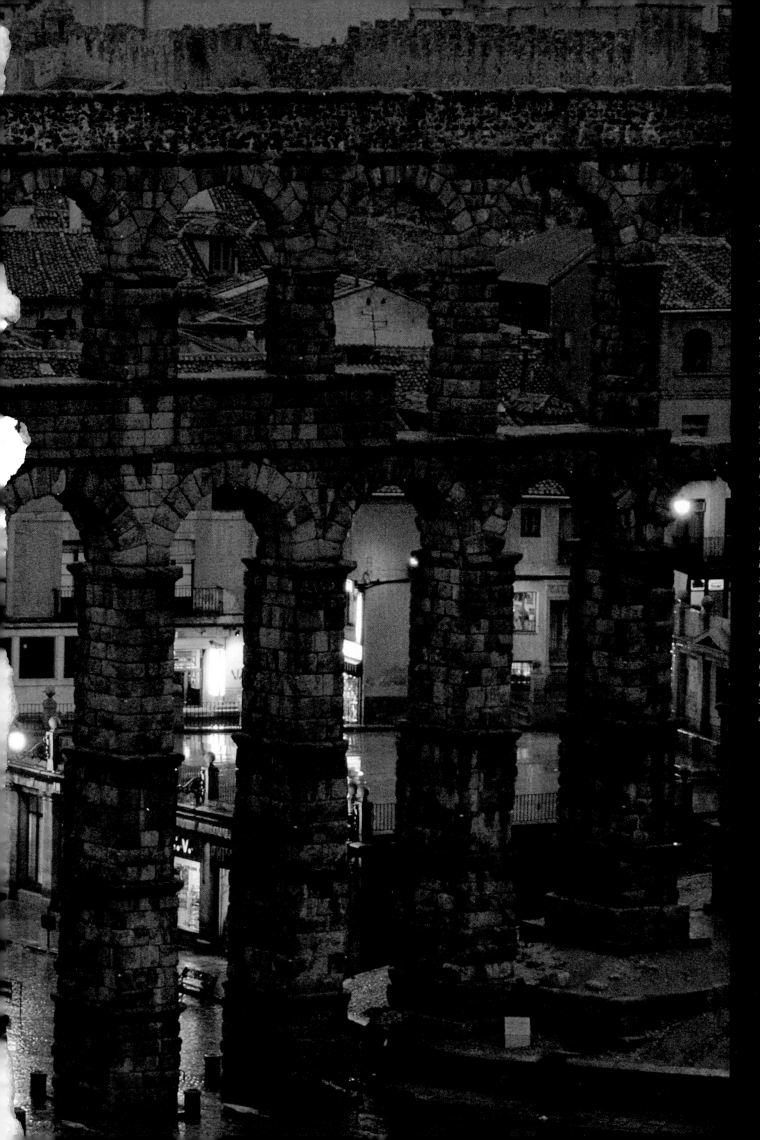

THE POWER AND THE GLORY OF THE ROMAN EMPIRE
July 1997

Enduring Rome seems exemplified in the great aqueduct in Segovia, Spain, which still carried fresh water until the mid-19th century. Subjects with a broad sweep of history and geography call for a lot of research, but you never do enough. If I had, I would have known that the day I arrived in Segovia was Good Friday when the city would be filled with pilgrims and short on parking places and hotel rooms. My research on this great journey had narrowed my choices to Segovia and the 50-mile-long causeway in Tunisia. I shot both and we ran both, one in each part of the two-part story on the glories of ancient Rome.

9

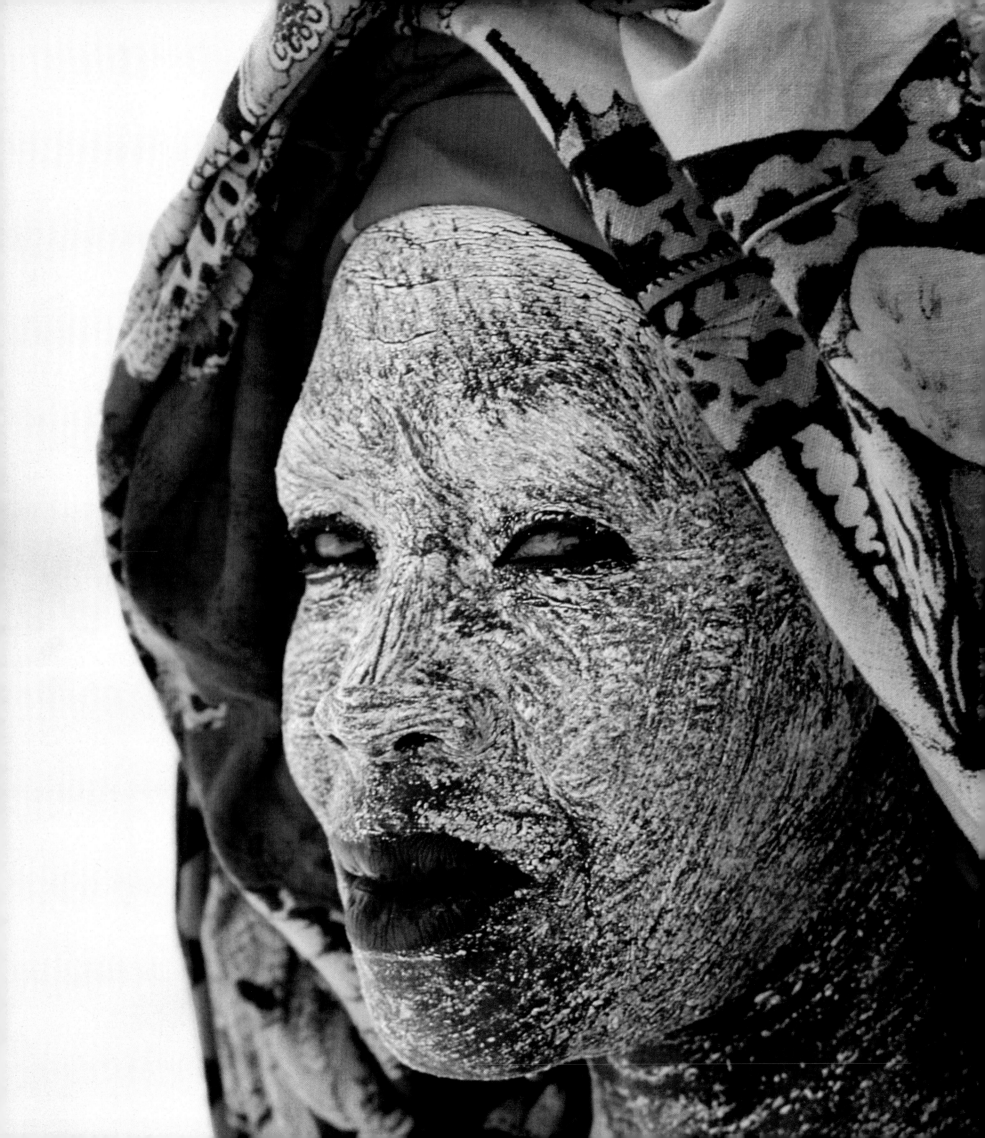

*With one of the most
striking faces I have ever
photographed, this woman
from Mozambique Island
seemed ideal to portray the
beauty of those island
women who entranced the
Portuguese sailors
venturing eastward in the
15th and 16th centuries.
Before I left Mozambique
to follow those explorers
toward the Indies, I had
exposed 143 rolls of film
just on the women of the
island. This woman painted
her face with ground tree
bark to keep it moist in the
blistering sun. When I saw
her, I was sure she was the
human connection to
a time past.*

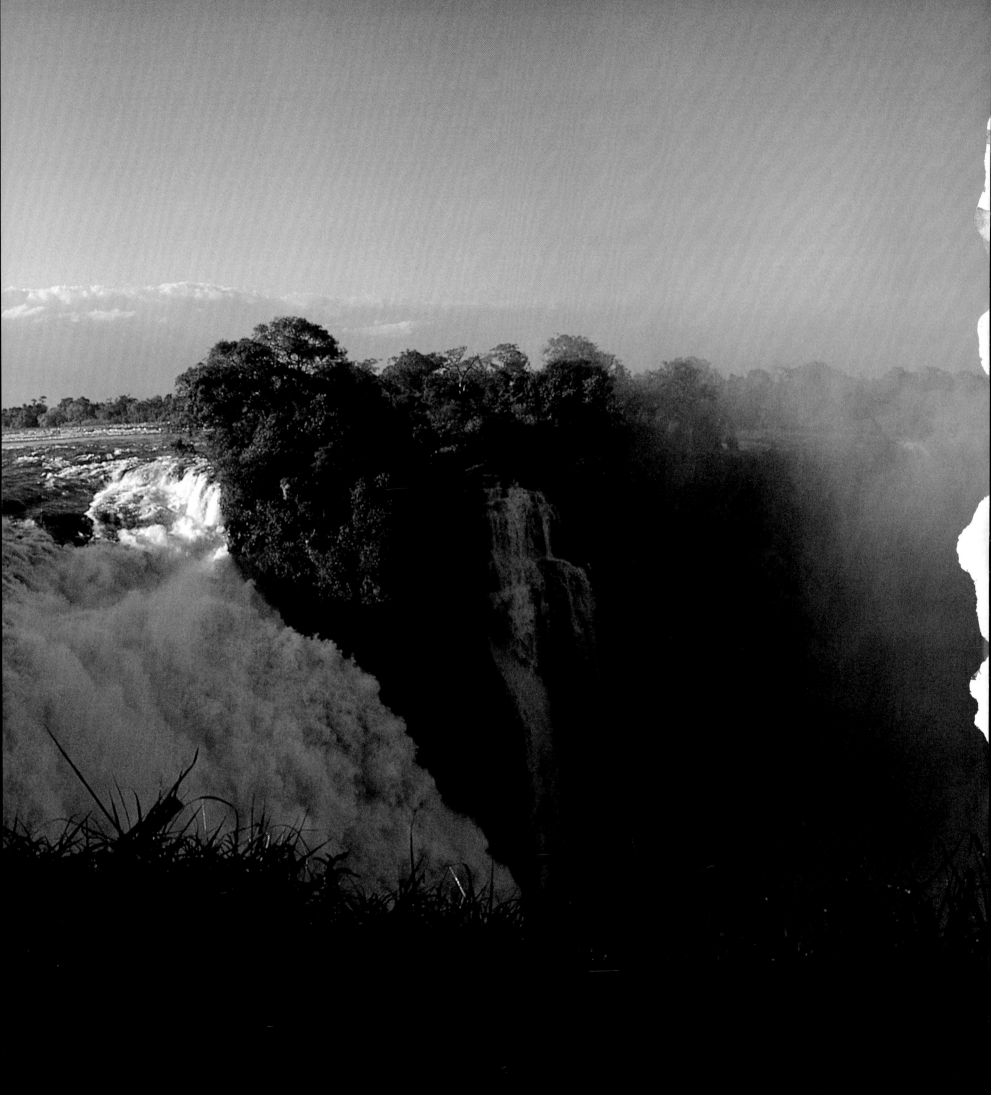

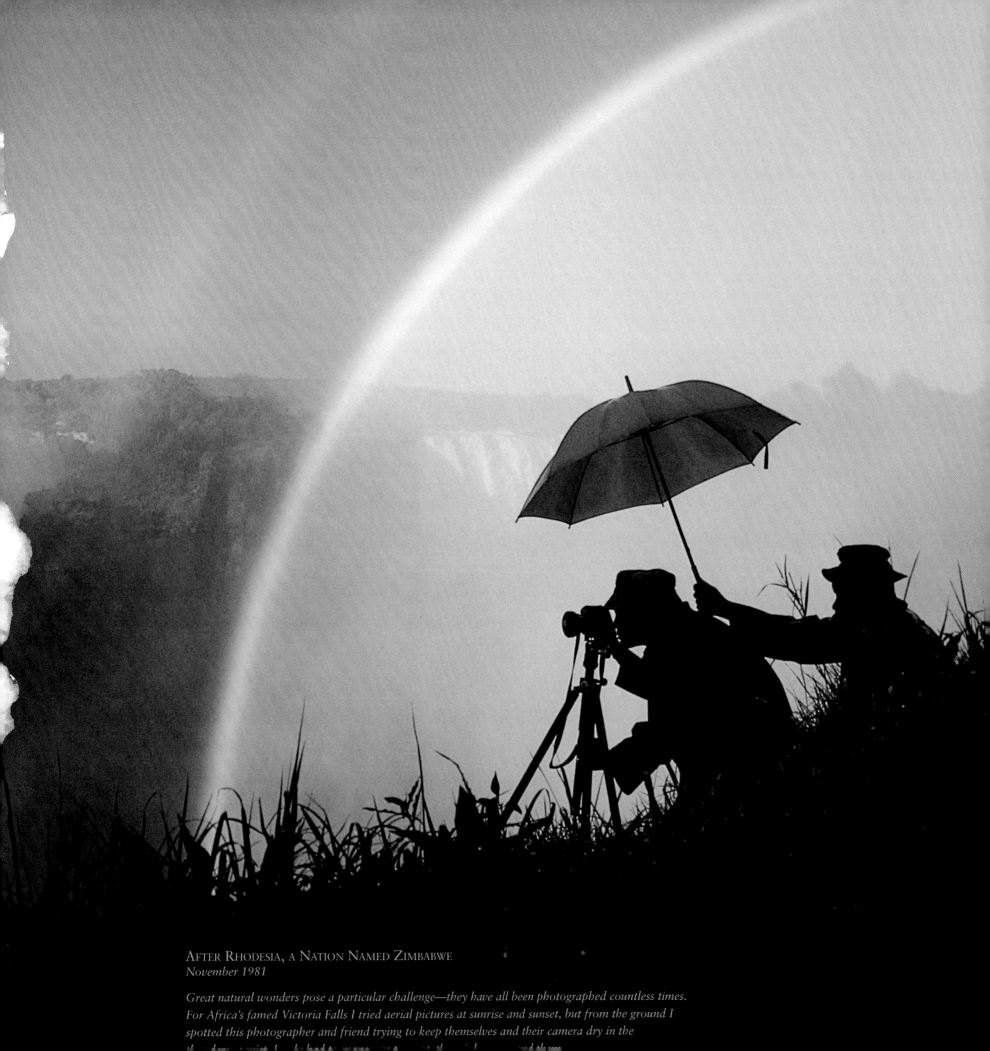

AFTER RHODESIA, A NATION NAMED ZIMBABWE
November 1981

Great natural wonders pose a particular challenge—they have all been photographed countless times.
For Africa's famed Victoria Falls I tried aerial pictures at sunrise and sunset, but from the ground I
spotted this photographer and friend trying to keep themselves and their camera dry in the

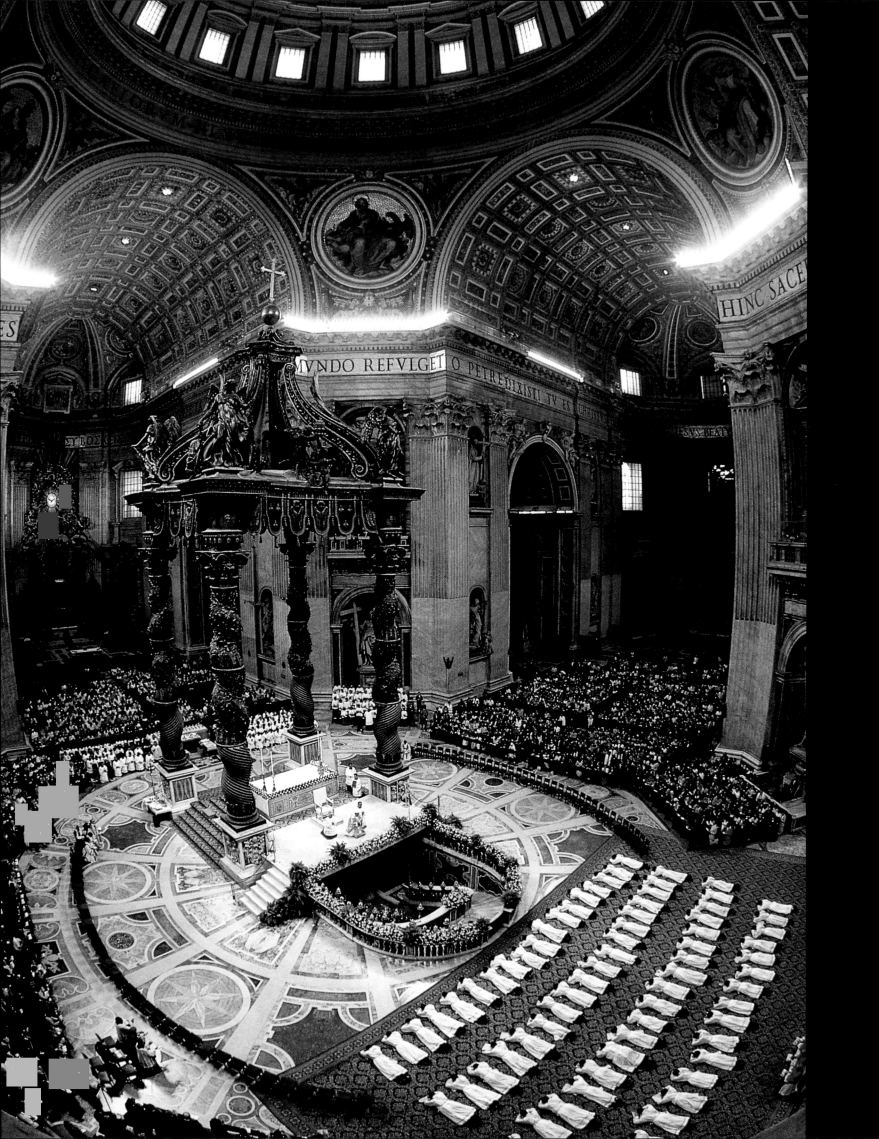

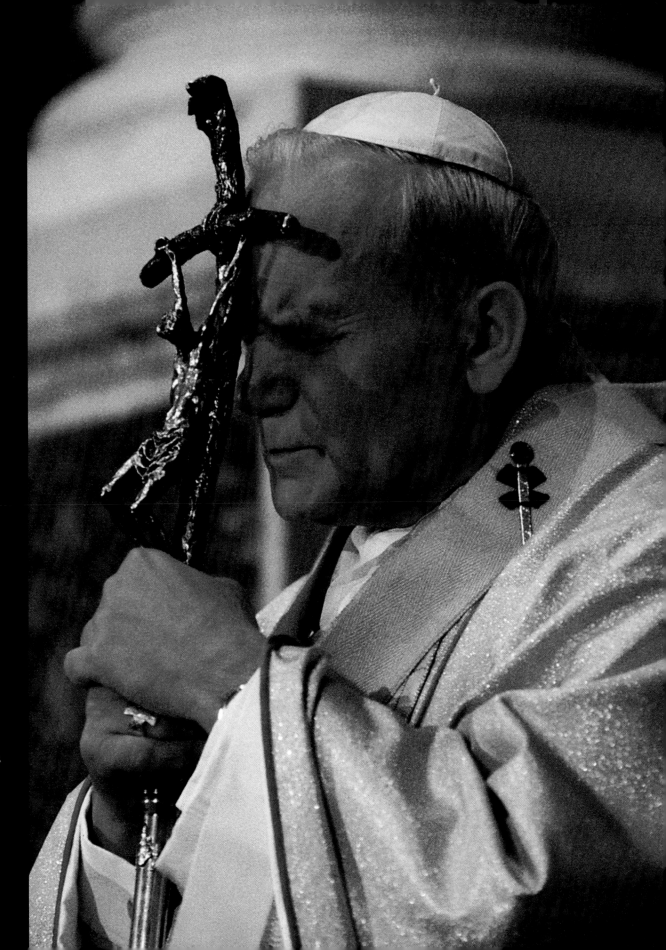

VATICAN CITY
December 1985

The panoply of the great church and personal moments of the Pope were my goals during the Vatican assignment. The total submission of the priests in their ordination ceremony, as well as the magnificence of St. Peter's Basilica, touches the faithful. The Holy Father with the bishop's crosier pressed to his brow was slated for the cover of the December issue until the remains of the Titanic *were found. It did appear in* Inside the Vatican, *a Society book published in 1991.*

WINDSOR CASTLE
November 1980

Following pages: A serene snow dusts the grounds of Britain's Windsor Castle in this long-lens view. At first officials said no photographs of people employed by the Crown would be allowed. However, this picture of Prince Philip driving the Queen's four-in-hand not only earned full access but also was chosen by Her Majesty for her Christmas card.

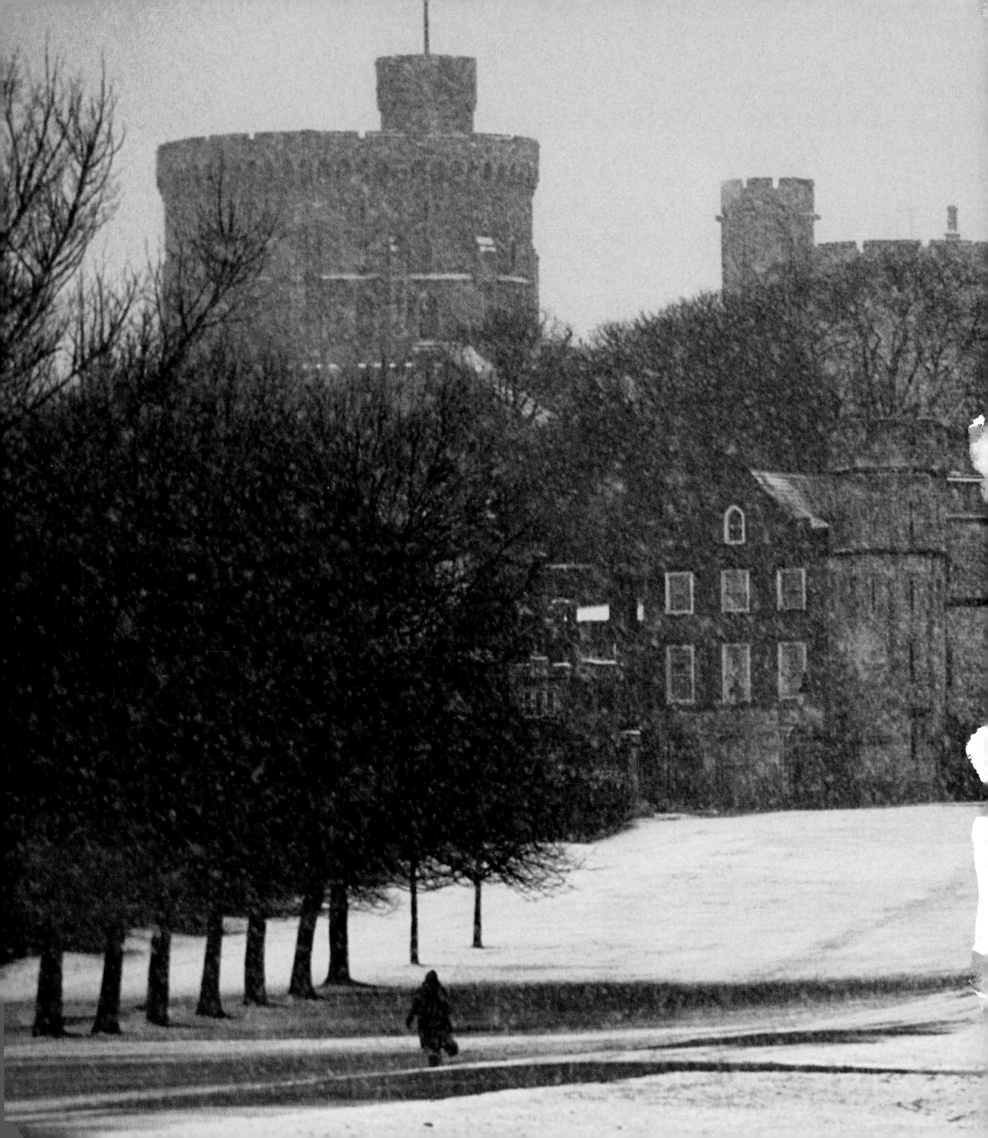

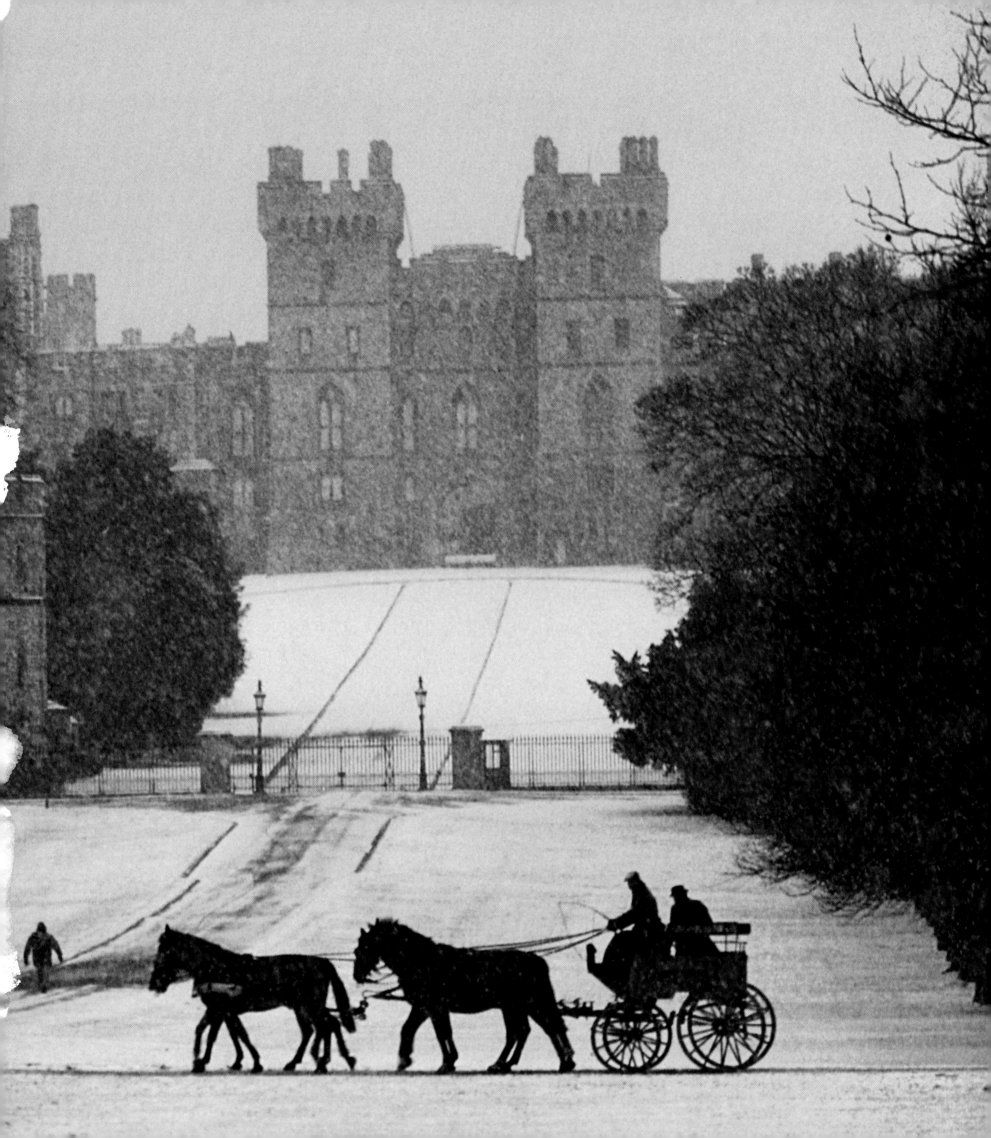

NATIONAL GEOGRAPHIC

EYE of the BEHOLDER

MES L. STANFIELD

EYE OF THE BEHOLDER

By James L. Stanfield

Published by
The National Geographic Society
John M. Fahey, Jr. *President*
 and Chief Executive Officer
Gilbert M. Grosvenor *Chairman of the Board*
Nina D. Hoffman *Senior Vice President*

Prepared by The Book Division
William R. Gray *Vice President*
 and Director
Charles Kogod *Assistant Director*
Barbara A. Payne *Editorial Director*
 and Managing Editor
David Griffin *Design Director*

Staff for this book
Leah Bendavid-Val *Editor*
Constance H. Phelps *Art Director*
Elizabeth A. Moize *Text Editor*
James B. Enzinna *Researcher*
Carl Mehler *Map Director*
Kevin G. Craig *Assistant Editor*
Sarah P. Quarrier *Assistant Illustrations Editor*
R. Gary Colbert *Production Director*
Lewis R. Bassford *Production Project Manager*
Richard S. Wain *Production Manager*
Janet A. Dustin *Illustrations Assistant*
Peggy Candore, Dale-Marie Herring *Staff Assistants*

Manufacturing and Quality Control
George V. White *Director*
John T. Dunn *Associate Director*
Vincent P. Ryan *Manager*
Polly P. Tompkins *Executive Assistant*

Stanfield, James L.
 Eye of the beholder :
 the photography of James L. Stanfield.
 p. cm.
 At head of title: National Geographic
 Includes index.
 ISBN 0-7922-7379-6
 1. Documentary photography.
 2. Stanfield, James L.
 I. National Geographic Society (U.S)
 II. National Geographic.
 III. Title.
 TR820.5.S688 1998 98-25669
 770'.92--DC21
 CIP

CONTENTS

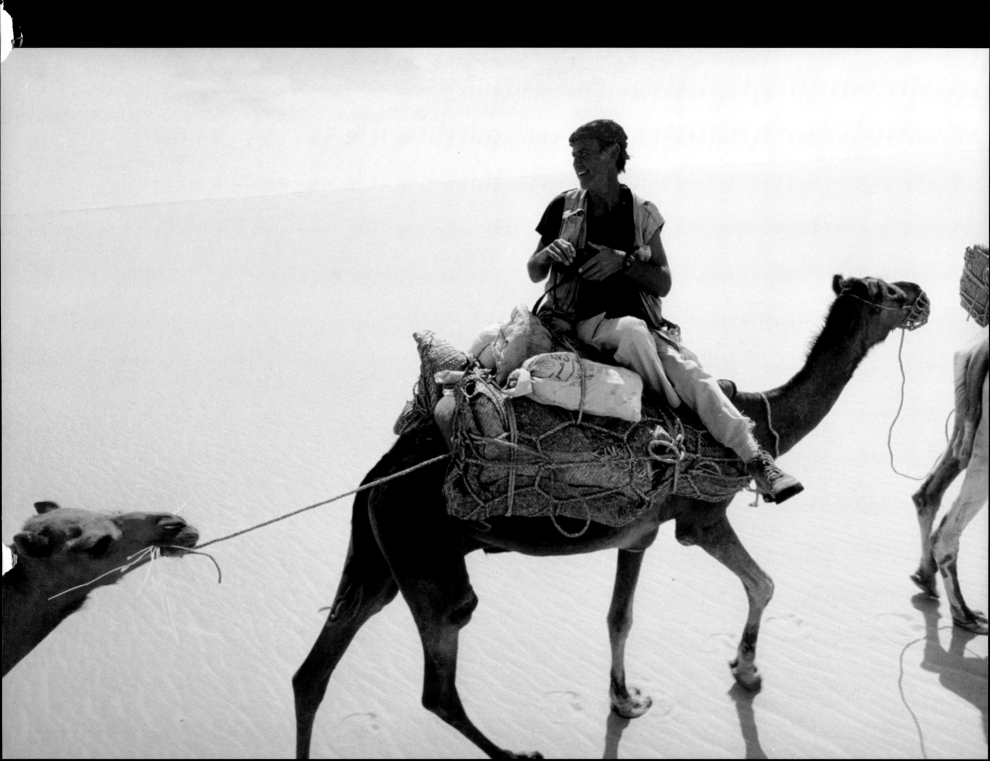

EYE OF THE BEHOLDER

The Jim Stanfield Story by Thomas J. Abercrombie

With the wail of the full-blown Sahara storm still raging outside our battered tents, I snap awake suddenly, startled to find myself propped nearly upright in a canvas-lined sinkhole. During the night the steady sirocco had hissed the dry sand out from under the windward side of my tent floor. I clamber out into the stinging darkness toward photographer Jim Stanfield's pup tent. He had gone to sleep, I remembered, head into the wind, after weighting down his tent corners with heavy camera cases.

"You okay, Jimmer?" I yell, poking my flashlight through a rent in the bucking fabric. There's Stanfield, head down in his sinkhole, equipment cases tumbled in around him. Spitting sand, he claws his way out into the abrasive storm with a motorized Leica swathed in a plastic bag around his neck. Dawn already struggles to light up the howling gloom, but visibility is no more than 20 or 30 feet.

"Isn't this great!" Jim answers, his usual upbeat reaction to chaos and calamity.

Behind sand-clogged loads, camels huddle against the onslaught. *Click.* A turbaned caravanner shelters embers for a breakfast fire with large leathery hands. *Click.* Another pours the sand out of his teapot. *Click.* A camel boy struggles with a goatskin water bag. *Click.* Idriss, the caravan boss, plods between the beasts checking for damage. *Click-grind-grind-clunk!* Flying sand has ambushed the delicate camera.

A dead ringer for actor Clint Eastwood, Stanfield looks like an outtake from *The Good, the Bad, and the Ugly,* squinting through dust and a three-day stubble. But a wry smile tempers the scowl. He's got the pictures!

By the time we finish the last of Idriss's tea—sipping slowly to let the sand settle—the storm has already retreated southward, and caravanners are loading the growling camels and beating them into line under hot blue skies. Now Stanfield carefully unpacks his precious panoramic camera. After the short dawn prayers, the caravan, 400 camels strong, steps off into the dunes. *Whirrrrrrrrrr-click!* Another Stanfield masterpiece— ultimately a dramatic three-page foldout in NATIONAL GEOGRAPHIC—is born.

Back at the little mud-brick hotel in Agadez, Niger, we scrub the grime out of our clothes and string a rope in the hot breeze scouring the courtyard. By the time we hang the last shirt on the line, the first one is dry. Over the first sand-free meal in weeks, writer and photographer compare notes for our article on Ibn Battuta, the great Muslim traveler.

"Plenty of excitement, knockout scenery, fantastic people, great photographs," Jim says. "This is the best damn trip I've ever made."

That's a rave review coming from James L. Stanfield, whose travel credits during his 30-year career as a top shooter for NATIONAL GEOGRAPHIC read like a world atlas. He has circumnavigated South America following Darwin's wake, trekked through the Himalayan kingdom of Bhutan, and photographed Japan's Inland Sea, Iran, Bulgaria, Syria, Poland, the Fiji Islands, Burma, Israel, Australia. He has illustrated books on China, the mighty Mississippi, and the American Revolution. Priding himself on his ability to tackle any assignment, Stanfield pours heart and soul into every subject that comes his way.

Milwaukee born, Stanfield grew up in a family of photographers. His father, Harold, and his uncle Foster were colleagues of mine on the photo staff of the *Milwaukee Journal,* leader in the art of news photography. Two other uncles were shooters for the *Journal's* morning competition, the *Sentinel.* A fourth ran a portrait studio. Young Jim, an avid sketcher ever since kindergarten, first opted for pen and brush, graduating from Milwaukee's Layton School of Art in 1959. But his first job drew him back to the world of cameras. As an "inside man" at the

Journal's photo lab he developed and printed news and feature photographs for the newspaper's bulging news, sports, business, entertainment, food, and women's sections.

Under picture editor Robert Gilka, the *Journal* fielded a team of 20 staff photographers equipped with state-of-the-art cameras, lenses, and lighting equipment. (It was *Journal* photographer Ed Farber who developed the first practical, portable strobe-flash unit that today we all take for granted.) But technology was merely a means to the end: compelling photo reporting, the quality that consistently won awards, in local, national, and international competitions. *Journal* staffers went on to *Life,* NATIONAL GEOGRAPHIC, and the big international photo agencies. In 1958 Gilka himself left Milwaukee for the GEOGRAPHIC and was soon named the magazine's director of photography. Small wonder young Stanfield was caught up in all this. His first published picture, a fisherman silhouetted among the girders of a bridge over the Milwaukee River, taken on Jim's day off, leads off the scrapbook of his early clippings.

When his National Guard unit, Wisconsin's 32nd "Red Arrow" Division, was called up during the Berlin crisis, Specialist 4th Class Stanfield turned his cameras on the soldier's life: Warriors pouring out of attack helicopters, climbing cliffs, hurling grenades, digging foxholes, drying wash over the barrel of a tank, salmon fishing on a weekend pass. He was soon winning military photo contests, seven in all.

After two years in the army, Stanfield returned to the *Journal* as a full-fledged staff photographer, producing captivating coverage not only of his first love, the great outdoors—Canada geese, fall colors, a bear hunt, fishing scenes—but also of the full spectrum of news events as well.

"Stanfield studied with nationally known photo specialists on the *Milwaukee Journal* staff," Bob Gilka says, "sports experts, fashion photographers, lighting masters who could light an auditorium or a whole city block, as well as news photographers who could capture the drama of a robber on the run, a train wreck, or a four-alarm fire. Jim mastered all the techniques with a persistence that drives him to this day."

"For an article on Syria, for instance, while shooting the ancient village of Malula, Jim found the perfect vantage point from atop a nearby hill. Jim climbed the steep hill 11 mornings—until the snow fell and the light finally dawned to his satisfaction," Gilka remembers.

In 1965, Jim began shooting his first assignments, as a freelancer, for NATIONAL GEOGRAPHIC, working through New York photo agency, Black Star. Jim spent his first few years on what GEOGRAPHIC terms "local" assignments—North American subjects. He began by helping out with a state story on Illinois, then set off for the Canadian Rockies. GEOGRAPHIC photographers constantly send their film back for review by the director of photography, a crack technical staff, and a picture editor, who supports, nurtures, and critiques all work. In his report to Jim on one of his film shipments from Canada's Banff National Park, photography director Gilka wrote, "Coverage of the Sarcee Indian powwow colorful. Great section of the tribal dancers. But why didn't you get into the tepees?"

In every GEOGRAPHIC coverage, with its stress on human geography, people and the details of their lives count most. These intimate, inside views are always the most difficult to capture on film. To arrive on the scene a complete stranger and insert yourself into someone's private life demands tact, confidence, and patience. Camera techniques are only a small part of the game.

To illustrate a comprehensive story on gold for the January 1974 magazine, Jim traveled with writer Peter

Milwaukee Journal

Master of the 4x5 Speed Graphic camera, Harold W. Stanfield worked for more than 40 years for Wisconsin newspapers. He was Jim Stanfield's father, first teacher, and mentor.

EYE OF THE BEHOLDER

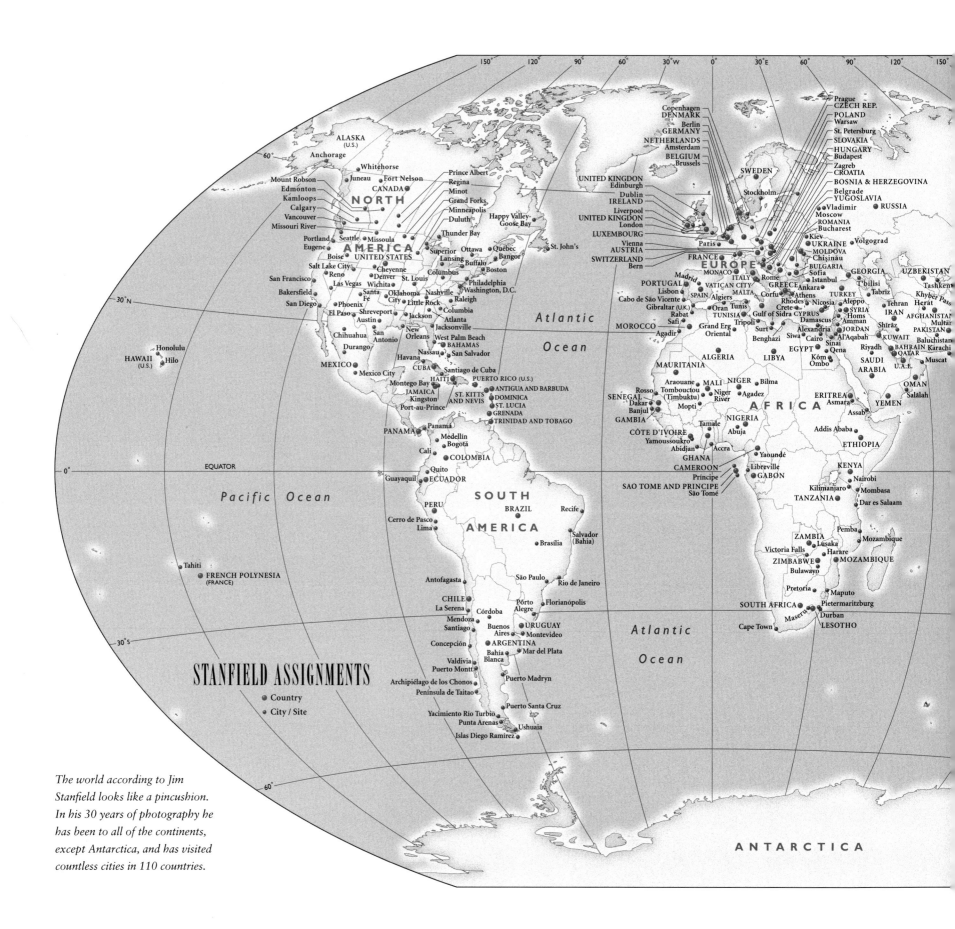

The world according to Jim Stanfield looks like a pincushion. In his 30 years of photography he has been to all of the continents, except Antarctica, and has visited countless cities in 110 countries.

STANFIELD ASSIGNMENTS

- Country
- City / Site

White, one of GEOGRAPHIC's most eloquent wordsmiths and a world-class charmer whose relentless, but sensitive curiosity deftly opens hearts—and doors. "I learned a lot from Peter," Stanfield recalled recently. "He was the master reporter that I wanted to be, only with my camera."

A big turning point for Jim came with a story on the Potomac River Valley, which appeared in the October 1976 magazine. Traveling up one bank and down the other, Jim began living with tobacco farmers, fishermen, and coal miners, often in their homes as part of the family. He came back with a compelling study of the historical river plus a bonus: a separate picture story on the people of the Potomac. Jim had learned how to get "into the tepee."

"Looking back," Jim says, "gold and the Potomac were the first coverages I made for GEOGRAPHIC that I was really satisfied with. I've been back several times to spend my holidays with those families along the Potomac. After 20 years we still stay in touch."

In 1967, Stanfield joined the GEOGRAPHIC photo staff. He found specialists among his colleagues—Dean Conger on the Soviet Union, Bob Sisson on natural history, Bill Allard on cowboy life, George Mobley on the frozen Arctic lands, Emory Kristoff for high-tech underwater subjects. But Jim prided himself on being a ready-for-anything general assignment correspondent. By now the camera had become a third eye.

Then Gilka dropped a real challenge into his lap: a worldwide coverage of rats.

He began among the cages of various research laboratories across the country and a trained rat circus, then spent a week with municipal exterminators in the sewers of Rome, followed by long nights in a godown, or warehouse, in Bombay.

"The work was anything but glamorous," said Tom Canby, author of the GEOGRAPHIC article, "The Rat, Lapdog of the Devil." "But Jim can adapt to anything—and come up smiling.

"Photographing inside the ornate Bhagwati Karniji temple in Rajasthan, a Hindu shrine teeming with a reported 40,000 to 80,000 sacred rats, was a nightmare. Out of respect we doffed our shoes at the marble doorway to tiptoe through the acrid wastes of the little monsters, being careful not to step on any. They chewed holes in Jim's camera bag, gnawed through his electric cords, shorting out his strobe lights, and crawled up his tripod and his pants leg."

Later during the coverage, in the Philippines, Stanfield and Canby took revenge, of a sort. On southern Luzon, swarms of rats regularly ravage rice fields and granaries, devouring up to half the harvest. The GEOGRAPHIC team helped farmers there isolate a swarm in the middle of a paddy, killing a hundred or so with sickles and sticks. That evening Jim and Tom joined the villagers to dine on the fat, grain-fed rodents, deep-fried in coconut oil and seasoned with ginger, garlic, and onion. "Not bad," Jim insists. "A little gamy, like squirrel or rabbit." But he admits nobody asked for doggy bags.

A major turning point in Jim's career began with the 60-page tour-de-force he produced on the Byzantine Empire with writer Merle Severy. In this richly detailed panorama, spanning continents and centuries, Jim found his niche. He and Severy went on to produce three more such epics: The Portuguese empire in Asia, Süleyman the

EYE OF THE BEHOLDER

Magnificent, and the French Revolution. Each would require more than a year of fieldwork, the kind of in-depth coverages that only the GEOGRAPHIC could produce. To the magazine's liberal backing of months, miles, and money, Stanfield added his boundless energy and enthusiasm and lifted these once-glittering civilizations back to life.

"Jim is the most cerebral photographer I ever worked with," Severy has said. "When experts would show us around the museums, mosques, and cathedrals, he would be filling his black books with notes and sketches. After he had seen everything, after he had digested all his homework, only then did he return with his cameras.

"And what a kit it was!" Severy says. "His cameras, lenses, strobe lighting gear, tripods, cartons of film, books, and maps—they filled more than a dozen trunks and cases. In smaller hotels along the way he had to take two rooms, one for himself, one for his mountain of luggage.

"Although, by the nature of their tasks, a writer and a photographer travel at different speeds, Jim and I always kept in close touch. Ours was a symbiotic relationship. He eagerly sought my thoughts on the pictures so that he could hew to the story line; he, in turn, passed on countless leads for my text," Severy added.

In 1996, Stanfield embraced the Mongol Empire of Genghis Khan, another blockbuster that took him and writer Mike Edwards from China's Great Wall across the wild steppes of Central Asia to the fringe of Eastern Europe. "Jim tracked the Mongols like a bloodhound," Mike says, "always sticking as close to the subject as possible. He never took the plane if he could travel overland, never took a taxi around town if he could walk," Mike recalls.

Surely one of Stanfield's lasting monuments will be the book he illustrated on Pope John Paul II and the Vatican. *Inside the Vatican,* published in 1991, has already sold more than 450,000 copies in a dozen languages.

"I had photographed the Holy City for an article in the magazine some years before," Jim said. "But this time I wanted to dig deeper, beyond the public pageantry and the museums, to present a more personal view and, if possible, show more of the Holy Father's human side. Fortunately, access was easier after my work on the magazine article."

Bart McDowell, author of *Inside the Vatican,* has high praise for Stanfield's efforts. "People respond to Jim's dedication. His enthusiasm for our project was contagious. He was the hardest working photographer I ever collaborated with. He started every morning early, very early. Working with Jim was like traveling with a rooster.

"For dealing with the labyrinthine, 2,000-year-old bureaucracy of the Holy See, Jim brought just the right temperament to bear—the charm of a diplomat, the endurance of a marathon runner, the daring of a tightrope walker, and the patience of a, well, of a saint," Bart says.

Jim used every camera in his kit, plus several he had specially designed by the experts in the Society's custom photo equipment shop. In places where he was not allowed, Jim placed radio-controlled motorized cameras high in St. Peter's Basilica, first painting them the color of the mosaics to camouflage them. Ultimately he was able to photograph the Pope in his private apartments and in his garden and to fly with the Holy Father in his helicopter to the summer palace in Castel Gandolfo.

Stanfield's antidote to the loneliness and long days that curse any GEOGRAPHIC correspondent is total immersion in his work. On several collaborations with Jim, ranging from China to Timbuktu, I had all I could do to keep up. He begins just before the sun raises the curtain on the day's drama and scouts with his camera until the light flattens toward mid-morning. Then he schedules indoor subjects or tends to captions, letters, and phone calls. He worries over his photographs—sorting out subjects, scribbling notes to himself, keeping lists,

sketching layouts in his battered notebooks that writer Bart McDowell characterizes as "illuminated manuscripts." His discipline and stamina are legendary. He rarely stops for breakfast or lunch. When the light ripens again in the late afternoon, he's on the prowl again. Nor is darkness wasted; often he uses the evening hours to travel between stops.

Back again at Washington headquarters, Jim continues to log 16-hour days, arriving at his desk before sunrise and usually staying at his chores until long after the rest of the office has emptied. There are meetings with picture editors and layout editors, art designers and researchers, captions to be typed and mail to be answered, equipment to be checked and repaired. Just going through and editing the film from a long trip can take weeks at the light table. During one major assignment Jim and I did together he shipped back some 1,500 rolls—57,000 slides. After he and the editors have painstakingly sifted these down to the 80 best, even Jim needs a break. He might slip away for a day or two to the Ontario lake country for a cast at some northern pike. But back home his suitcases are already packed, ready for the next adventure.

We still get together, Jim and I, over Peking duck at the Yenching Palace, aboard my small sailboat, or, more recently, at Jim's new home on the Atlantic coast. Here, after a house in the suburbs, then years of ascetic apartment living, the nomad finally has found the place to sink his roots.

Coming up the drive I flush a doe and her fawn from the pines. In the autumn skies above, squadrons of snow geese and honking Canadas circle in V-formations.

"I fell in love with this region when I came down years ago to photograph Chincoteague's annual pony roundup for a Geographic children's book," Jim explains. "I came back many times after that to camp and to fish. When I found this piece of shore for sale I decided to settle."

In Jim's living room we watch through the tall windows as the lowering sun makes autumn's colors burn more brightly. From the high walls and balconies around us dozens of startled faces peer silently down on our dialogue, masks Jim has collected during his 30 years in the field: A scowling New Guinea headhunter, a frown and a smile from a masquerade in Venice, Tibetan devils, and an African fertility goddess. Here also are silver daggers from Yemen, Fijian cannibal forks and bowls, Asian elephant bells, silk carpets from Nain and Isfahan, lacquer screens and fierce puppets from the South China coast, and Mongolian horse trappings. Interestingly enough, in this camera artist's retreat there hangs only one photograph, and I am pleased to say it is one of mine from Afghanistan.

Jim retired officially in 1996 but as an active freelancer he hasn't slowed much. At the time of our last visit, he had just finished sorting through some 35,000 slides for a major, two-part story on the Roman Empire that took a year of travel over three continents. So extensive was his coverage that the editors decided to publish it as a two-part series, a total of 70 pages. I notice his studio is stacked with camera cases all ready to go, along with notes and research for his next opus: the civilization of ancient Greece. The Atlantic's sea bass are safe for awhile.

"I don't need to tell you that the GEOGRAPHIC is the best life a guy could ask for," Jim says. "It's an open ticket to the whole world. You get to slip into the lives of Bedouins, cowboys, miners, soldiers, fishermen—even kings, movie stars, and millionaires."

"Truth is, I wouldn't trade jobs with any of 'em."

Milwaukee Journal

Young Jim Stanfield bought his first camera from award-winning Milwaukee Journal *photographer Ted Rozumalski, who "taught me about detail," says Jim.*

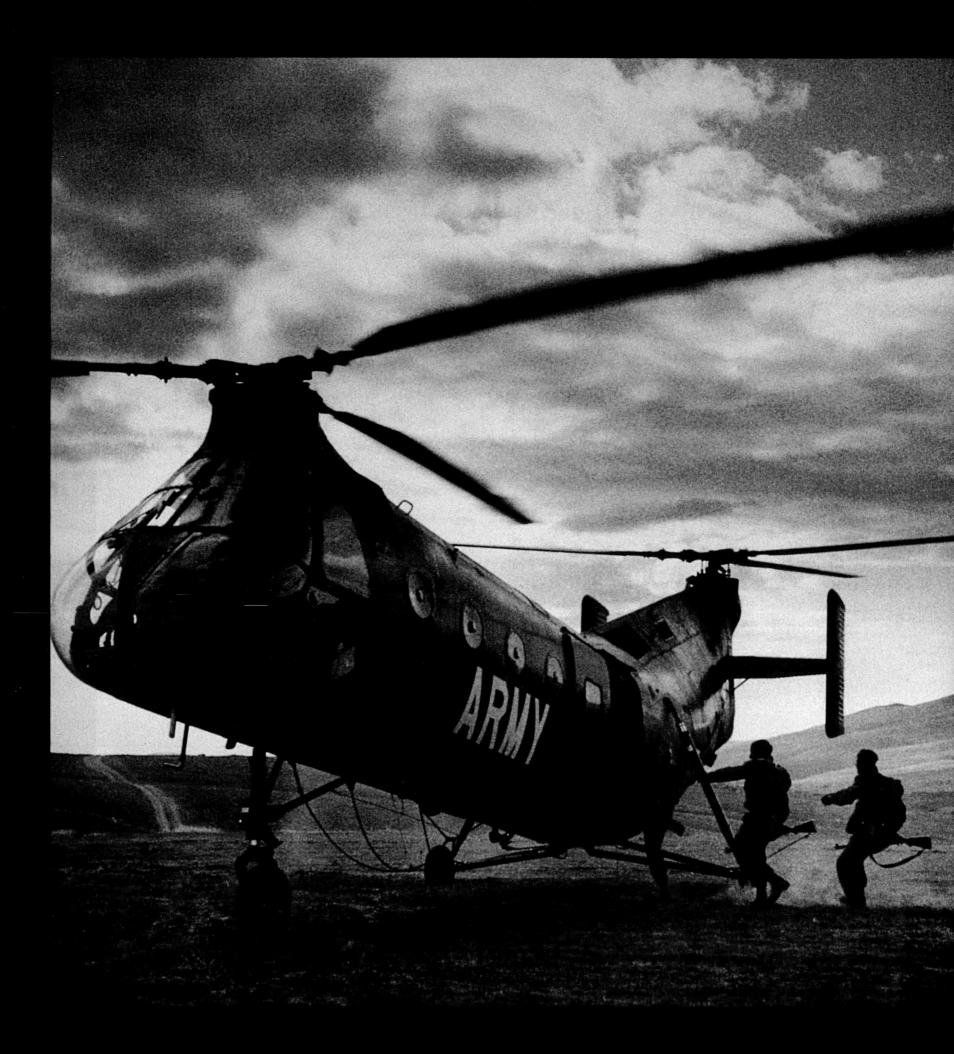

THE EARLY YEARS

Bred in the bone, photography seemed preordained for a youngster who grew up in a family of newspaper photographers, helped his father in the darkroom, and was fascinated by exotic lands and people. I began my career at the *Milwaukee Journal* and in the army with black-and-white photographs, such as this one taken at a war games exercise in Washington State during the Berlin crisis. After the Army, I rejoined the *Journal* where I learned from some of the greats in the photographic world. I spent five years as a news photographer, then I was given a chance to follow my dream to the NATIONAL GEOGRAPHIC magazine.

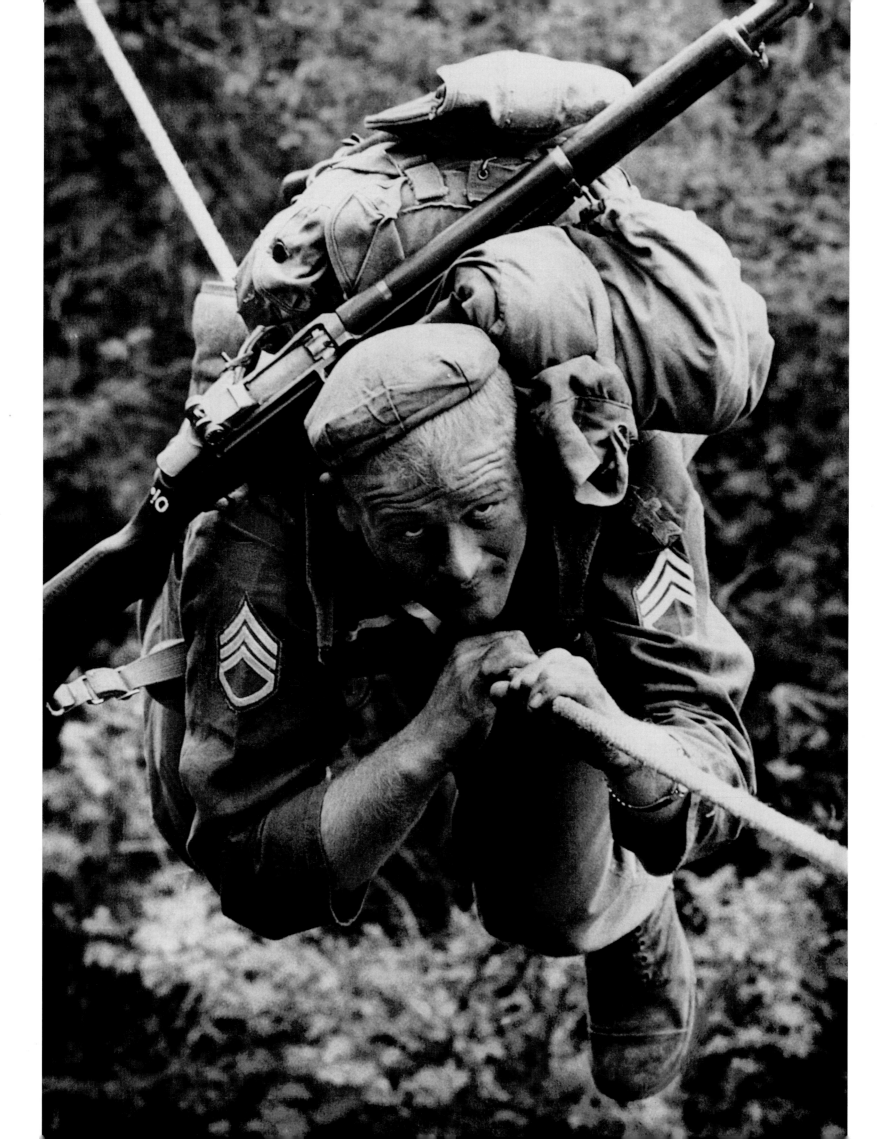

THE EARLY YEARS

My father and his three brothers broke into news photography in the twenties when it was all glass plates and flash powder. Those four guys probably destroyed more home interiors and drapes with smoke and flame than anyone else in the Midwest. They stayed with it for 40 years at the *Milwaukee Journal* and *Milwaukee Sentinel*. Dad photographed Tom Mix, Babe Ruth, Lou Gehrig, Al Capone, and Judy Garland. I thought it was pretty neat. He worked alongside such great photographers as Howard Sochurek, Tom Abercrombie, and Frank and Joe Scherschel. I was impressed.

We had a darkroom in the basement where my brothers and I learned to print pictures. When I told Dad I wanted to follow in his footsteps, he and Mom jokingly threatened to send me to the house of correction. Dad realized how hard he had worked and the danger he had put himself in many times—for very little reward. When he was convinced that that was what I wanted to do he said, "Stay at the newspaper no more than five years and learn everything that you possibly can, especially color. And if you're worth your salt, go on to a magazine—*Life*, *Look*, the NATIONAL GEOGRAPHIC."

I began my career in my father's footsteps, joining the *Journal* in 1960 as a darkroom technician. I learned from the best at a newspaper renowned for its photographers. It printed color daily using innovative techniques developed by the paper's own staff and mechanical departments. Delegations from newspapers around the country constantly traveled to Milwaukee to study the *Journal*'s photography and printing techniques.

My first pictures for the paper were black-and-white. Short on experience, I was low man on the totem pole on a staff of 20. I certainly did not qualify for heavy assignments, so during my off time I "cruised." I shot weather and feature pictures; I invented work. And some of it was published, mostly sports and outdoor shots.

During the Berlin crisis in 1961, I was called up with my National Guard unit, Wisconsin's 32nd "Red Arrow" Division, which was sent to Fort Lewis, Washington. We had quite a press corps, and I covered everything from the world's fair in Seattle to President John Kennedy's address at the University of Washington. A war games exercise produced the helicopter shot on the previous pages, as well as the picture (left) of a sergeant struggling across a single rope bridge. They were part of a picture essay documenting the Special Forces, or Green Berets, that earned seven awards in the military category of the 1963 National Press Photographers Association "Pictures of the Year" competition.

After 17 months I returned to civilian life on the *Journal*, and like most of the staff shot whatever came along—fashion, sports, society, food, home furnishings, and the news. When I saw other photographer's work, I would try to figure out how they lit their subjects. They were not using spotlights, they were lighting them with strobes. They knew how to use lights, and it was never near the camera. *Journal* photographers never used light near the camera. They would lug those 1,000-watt strobes over to the arena to photograph Marquette basketball. One time I got to cover the sectional basketball tournament in Cedarburg, Wisconsin, and I thought, I'd really go for it. I took those big strobes and plugged them all into one socket, and at the first play at my end of the court I blew half the gymnasium's lights out.

I first met Bob Gilka when we both found ourselves in a cherry picker photographing the July 4 circus parade

Festooned with cameras, neophyte news photographer Stanfield rode an icebreaker across Lake Michigan in 1963, one of the rare years when the lake nearly froze shore to shore.

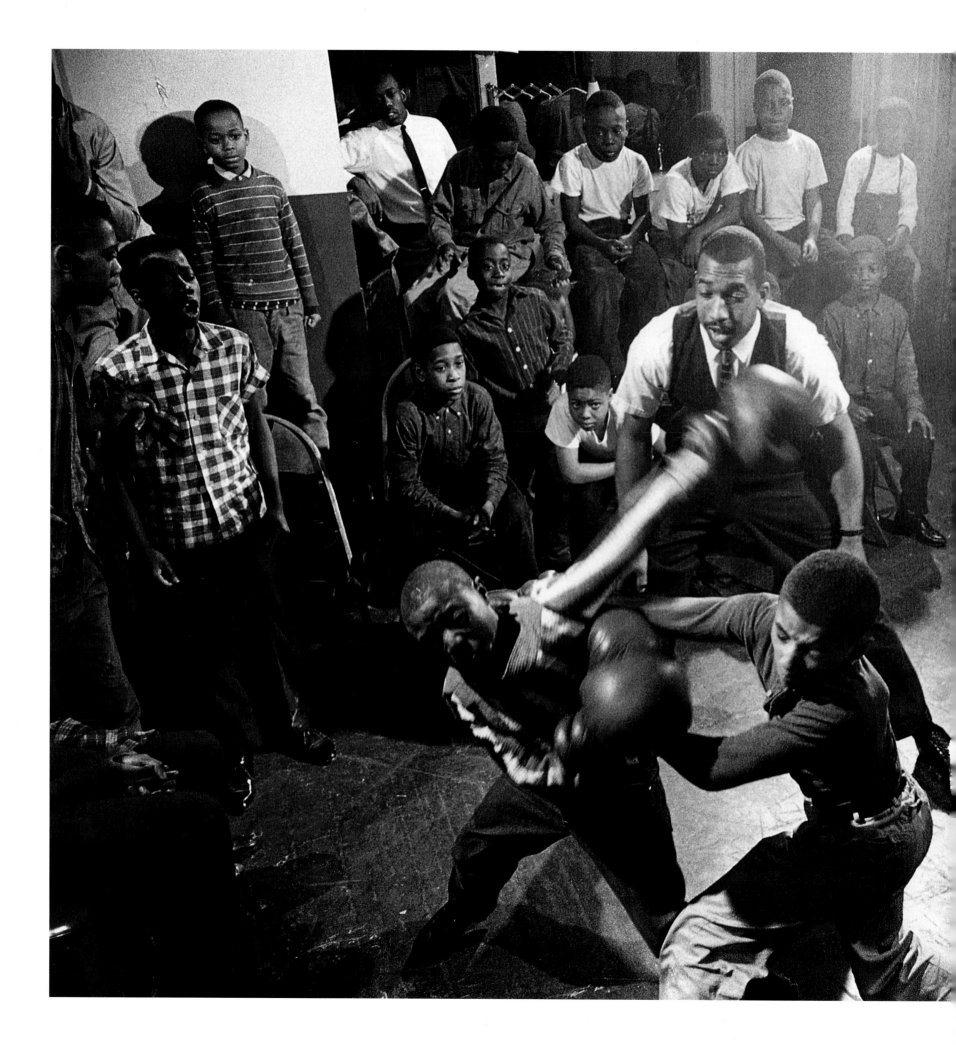

Two kids slugging it out at a Milwaukee YMCA appeared as part of a picture story in the Journal *and won an award from* Look *magazine for sports photography in 1963. I photographed the 1964 strike at the Pressed Steel Tank Company on my own time before going to work on the evening shift at the* Journal. *I tried to emulate the hard news photographers, who were also artists, able to do anything from crime stories to sports to concerts. I thrived on keeping busy from dawn until dark, and I still do.*

The University of Missouri journalism school, arguably the best in the country, holds a workshop each fall in some small Missouri town. A lot of GEOGRAPHIC staff attend as faculty, and young photographers learn from the pros. In 1964, it was in Neosho and I picked Metcalf's Trading Post for my subject. Butterflies flew in the door, guys bought guns and chewing tobacco, kids came by with their fishing poles. It was the winning picture story that year. When Leonard Bernstein saw his portrait, taken when he came to Milwaukee to conduct a concert, he asked that I send him two copies. He kindly signed one and sent it back.

in Milwaukee. Bob had been picture editor at the *Journal* before my time. Now he was director of photography for NATIONAL GEOGRAPHIC magazine. Before he left town, Gilka left a bag of film with a mutual friend with instructions for me to send my work along for him to review.

The GEOGRAPHIC was working on an article on Illinois, and they asked if I could document Lincoln's New Salem. They were pleased with the results, so Gilka asked for my portfolio. I sent him everything but the kitchen sink. He sent it back about a month later, pointing out where I was strong and where I wasn't. He told me I needed experience with color and with shooting people pictures. "I'll send you some film," he said. "Pick out some stories you'd like to do—just go out and photograph them, and send them to me. I'll critique them and send them back."

So we did this for what seemed like eons. It was actually only about two years. I would go out and shoot the country dentist, or anything else that struck my fancy. He would send me little projects now and then like the Illinois assignment. Finally in 1965 I was runner-up for Newspaper Photographer of the Year and won the *Look* grand prize for sports photography. Gilka wrote to ask, "What do you want to do? Do you want to stay at the newspaper, do you want to freelance, or do you want to work for a magazine?" He knew what I could do, he had been watching the *Milwaukee Journal* and various other newspapers around the country. He gravitated to news photographers because they are exposed to just about everything, they have quick minds, and the variety is vast. "I want to work for a magazine," I told him.

If it had not been for Gilka I would probably be selling storm windows at Sears. He saw something in me that I never saw in myself. And so I followed my father's advice. I worked for the newspaper 5 years and 11 days and then went on to the NATIONAL GEOGRAPHIC.

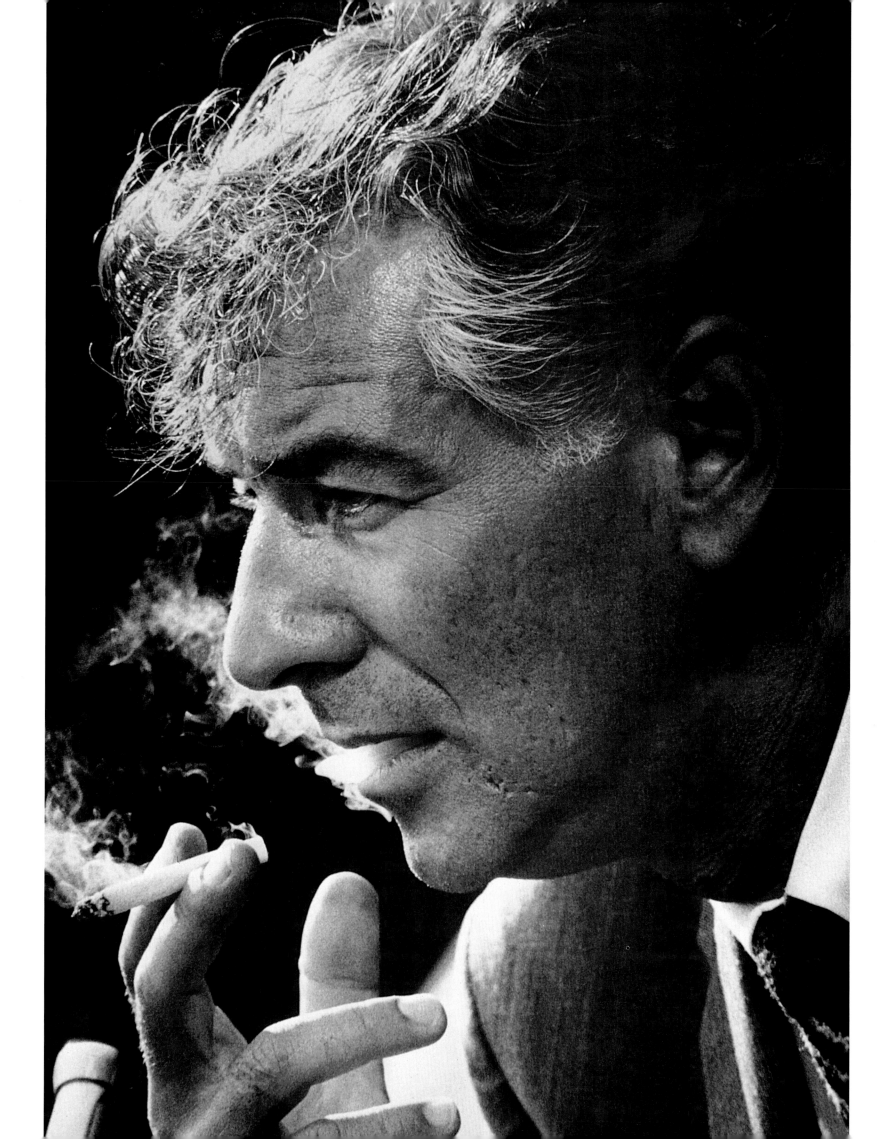

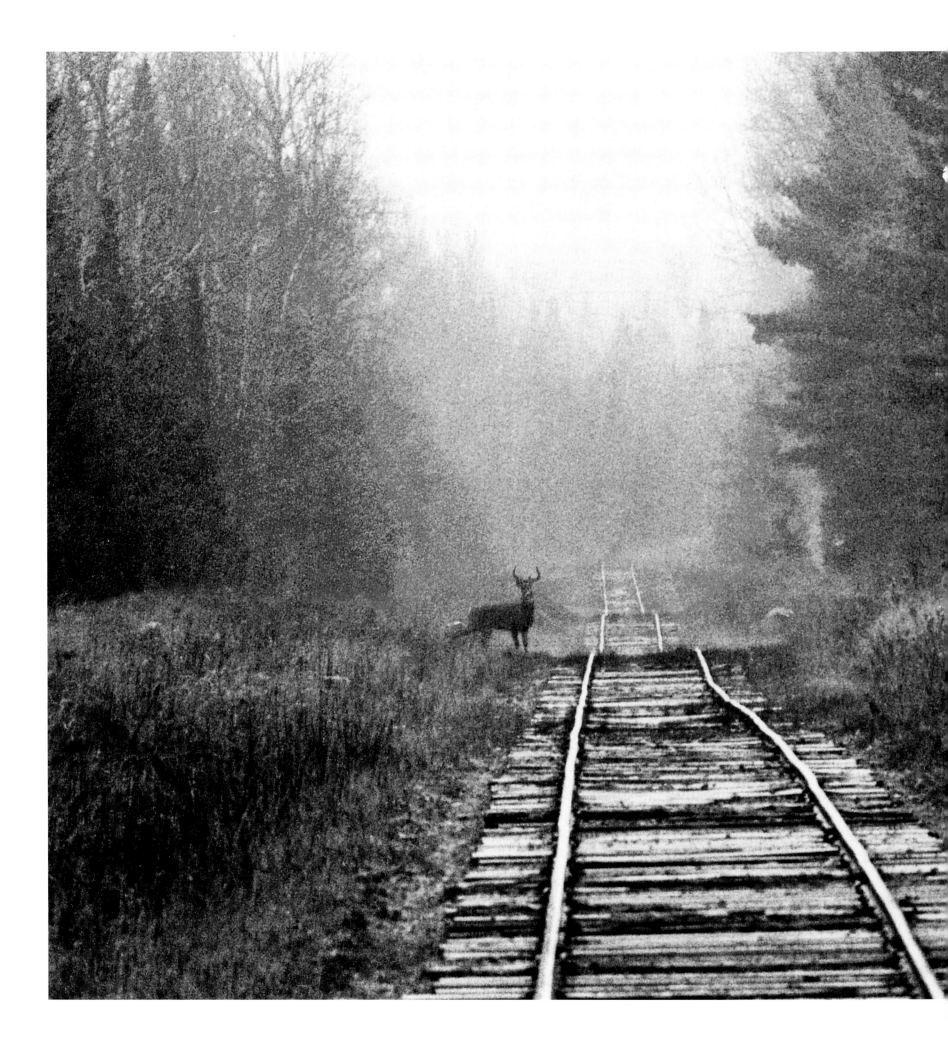

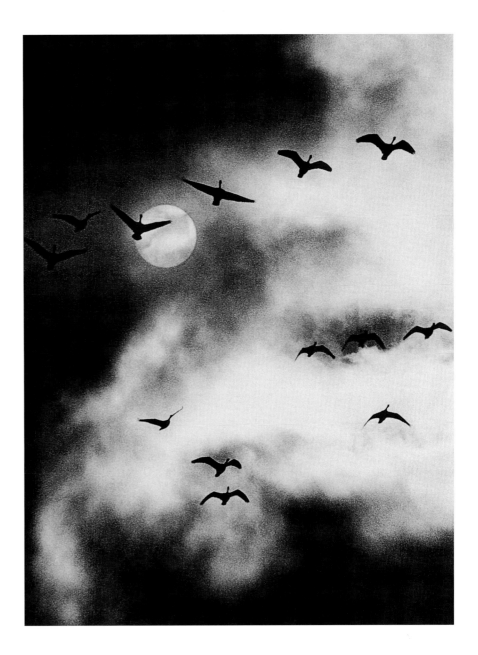

Are photographers lucky, or do we just know a picture when we see one? On the opening day of deer season in 1964 I was in a nice, warm station wagon with some hunters—all complaining of no deer. I got out to take a look at an old railroad track with my 400mm lens. All of a sudden this huge buck walked right into the frame. Realizing others might be aiming my way, I squeezed off four frames and quickly jumped back in the car. The Journal *ran this picture on the front page. Only then did the hunters believe my story. Geese homing in on Horicon Marsh won the pictorial first prize in the 1964 Pictures of the Year competition.*

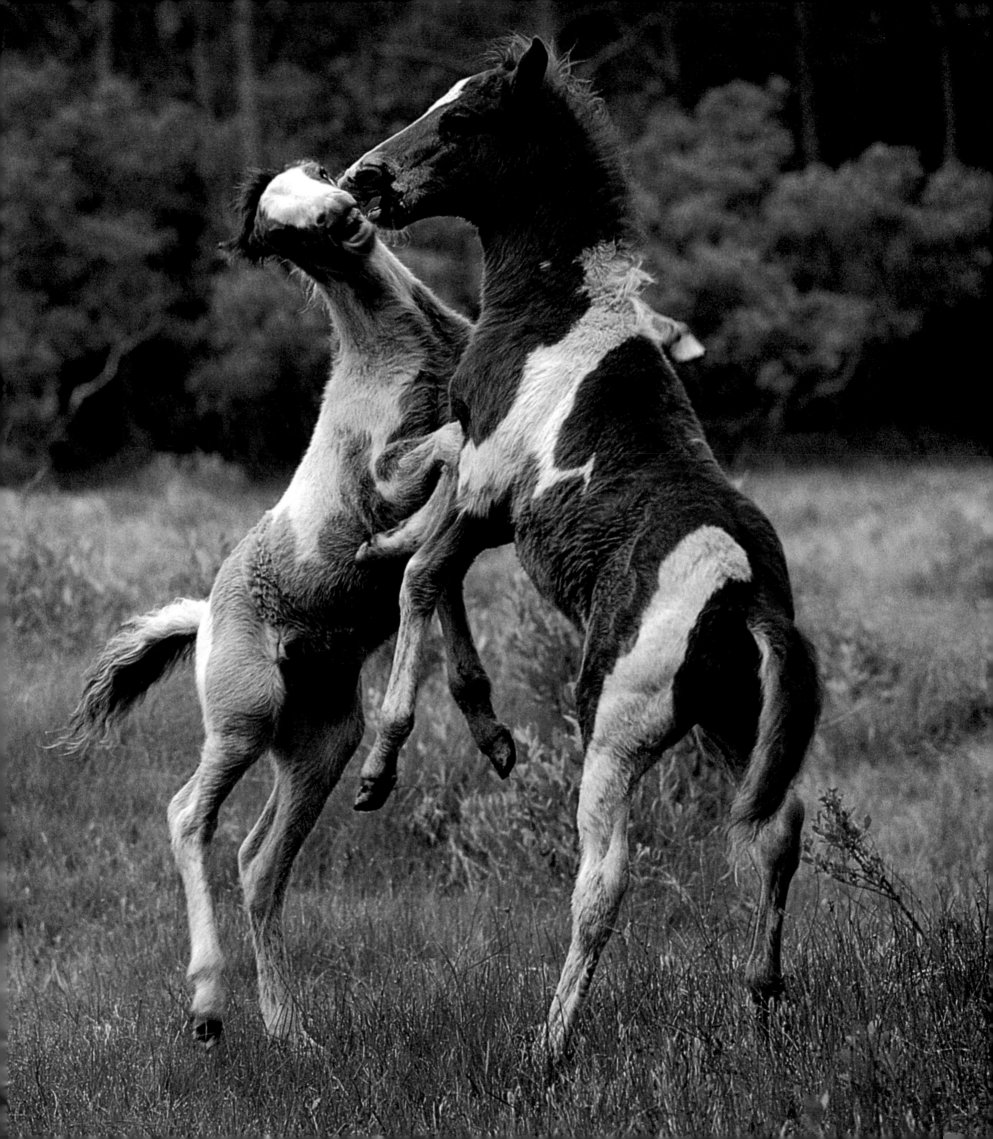

THE EARLY YEARS AT NATIONAL GEOGRAPHIC

"You figure large in my plans for the GEOGRAPHIC, Jim," wrote Bob Gilka in September 1966. "Bear in mind that staff photographers average seven months a year away from home…and that we don't do certain kinds of photography you might like to do and that we do more of some kinds of photography than you might like to do." He went on to point out that "The right kind of wife is an absolute must for a GEOGRAPHIC staffer."

Before I left the *Journal,* I was assigned to photograph Barbara Bonville, Miss Wisconsin of 1963. Four years later Miss Wisconsin became Mrs. Stanfield, the same year I began my first staff assignments for NATIONAL GEOGRAPHIC.

When the Geographic launched a children's book program in 1972, I was assigned to the first few volumes.

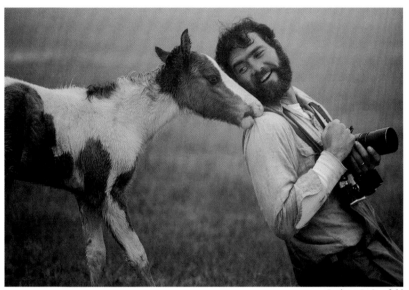

Barbara B. Stanfield

My favorite was *The Wild Ponies of Assateague Island.* I lived with the ponies for about three and a half months. I was there when these two (opposite) were born; I was the first thing they saw after their mother. The colt followed me everywhere and even slept beside me when I camped near the herd.

In the next few years several stories came along that brought major changes in my career. First I worked with the consummate gentleman Peter White on a worldwide story on gold. Peter is probably the greatest researcher/traveler/writer/reporter that I've ever known. I studied his determined approach and his attitude toward the story and its people. I could see how he set people at ease and how easy it was to diplomatically open so many closed doors. Then came the Potomac River.

Wild ponies frolic on Assateague Island on the Maryland and Virginia coasts. Descendants of horses perhaps from colonial days, the ponies are rounded up yearly and foals—like this one nuzzling me—are sold at auction by the Chincoteague Volunteer Fire Company.

I worked for three months on that story and didn't have anything out of the ordinary until I started to live with the people along the river—the miners and hermits and especially Carolinas Peyton, a bottomland farmer who, at 88 years old, was still running a 50-acre farm with his daughter, Lydia, two great-grandsons, Tommy and Tony, and the mules, Pete and Queenie. I fell in love with those folks—and with Lydia's fried potatoes. She had a wood-burning stove in her kitchen and only one window. It was hotter than stink in that kitchen, but we would sit there and sweat and eat those fried potatoes. My wife and I went back for Thanksgiving. I brought the turkey, and Lydia made the potatoes. Carolinas is gone now. Lydia told me, "You know the last couple of years of his life, he just didn't want to get out of bed; he just didn't do anything anymore." He died at 106.

At the end of my coverage I had a separate picture story to go with the general Potomac coverage. It won every contest possible. I knew when I finished it that I would never have another story like that. I know it today.

Even Bob Gilka, instead of being silent as he almost always was, actually said, "That was a first-class job." Gilka is a man of very, very few words, tough. But I wouldn't want him any other way and neither would any other photographer I know. He was very proud of the GEOGRAPHIC, its integrity, and proud of the GEOGRAPHIC staff. In turn, you became a better ambassador for the GEOGRAPHIC. Most of what I know about editing and journalism, knowing what really made up a great story for the GEOGRAPHIC, came from Gilka. And he could talk you into anything. When he brought me into his office and said, "I've got this story on rats," I wrinkled up my nose and thought: What have I done to deserve this? In three minutes he had me convinced that the rat story was going to be the best story in the world, and I wasn't going to give it away to anyone.

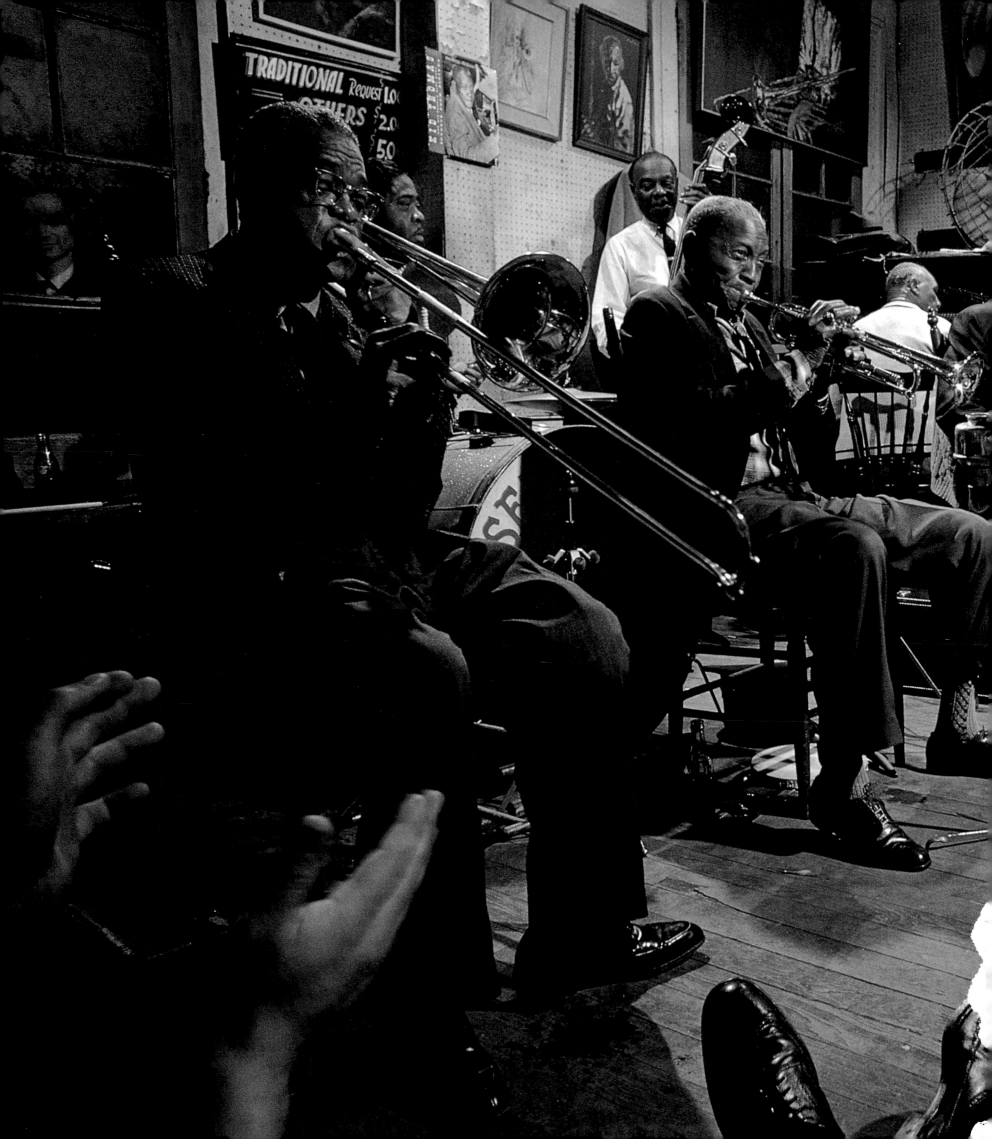

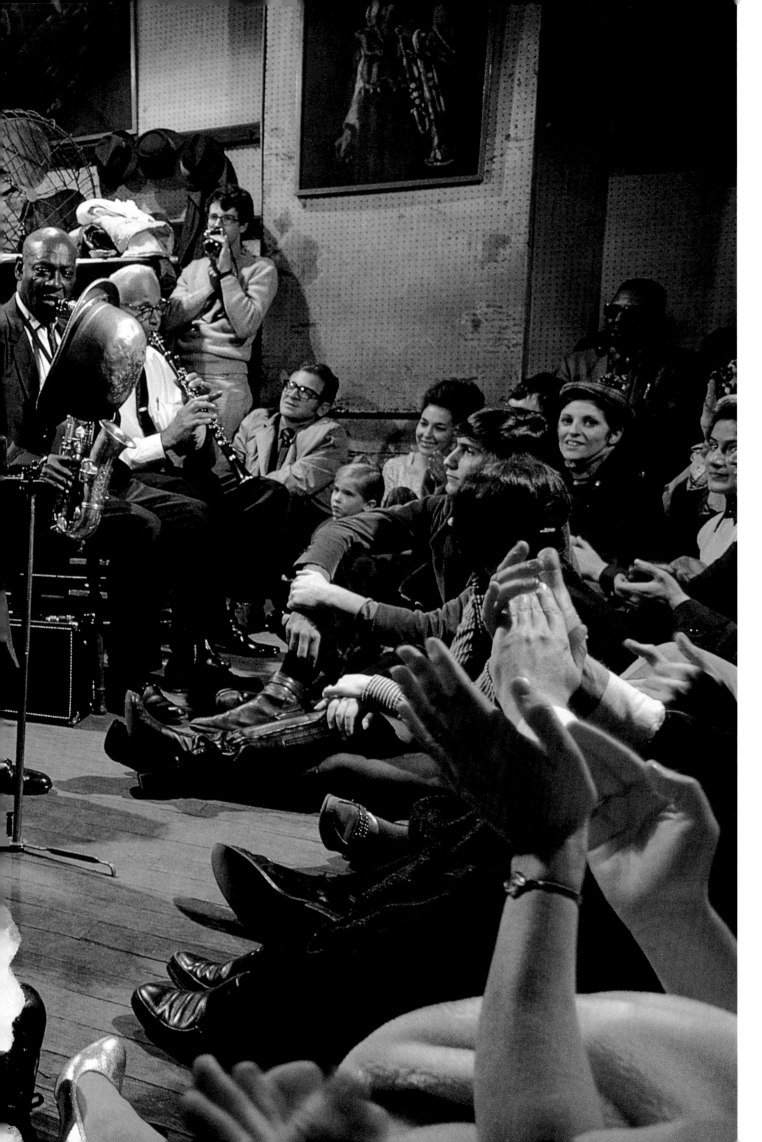

NEW ORLEANS
AND HER RIVER
February 1971

I got to know the Mississippi pretty well in the 1970s, photographing a book, The Mighty Mississippi, *and articles on Mark Twain and New Orleans. In the Crescent City, I followed trumpet-playing Kid Thomas Valentine and his band for a couple of days when they played clubs and funerals. It was in Preservation Hall on a Saturday night that I captured band and audience with the spirit I was looking for. But it was a tight squeeze. Those are my feet in the foreground.*

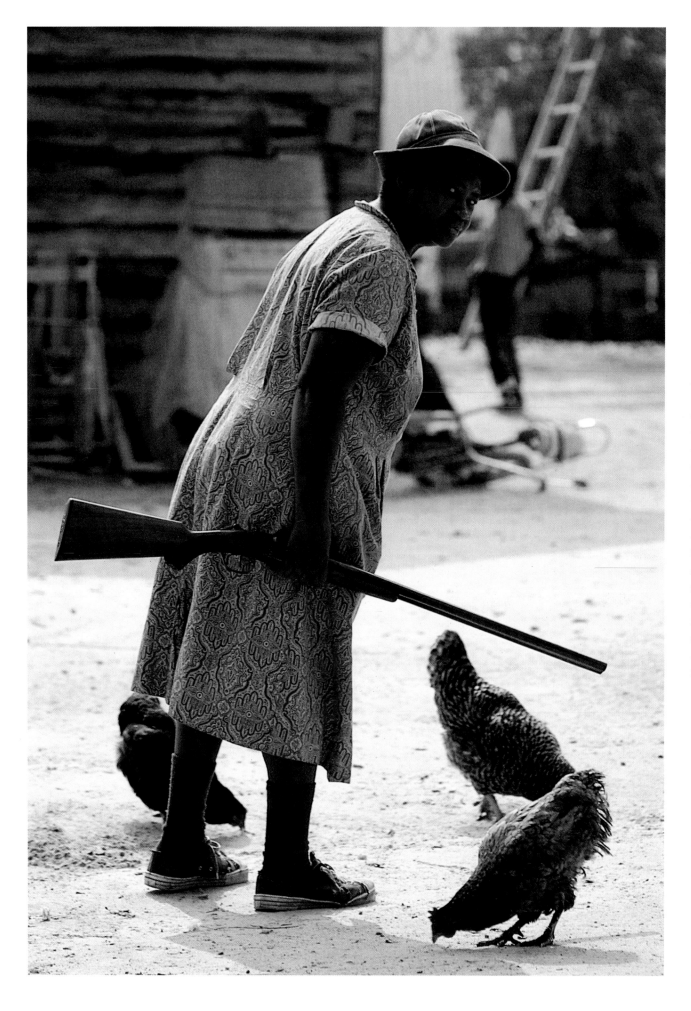

A Good Life on The Potomac
October 1976

Good folks became old friends on the Potomac River story, which remains my favorite. I first met 88-year-old Carolinas Peyton (opposite) driving two mules and a flatbed wagon with two kids bouncing around in back. He invited me back to the house where I made this picture of his daughter, Lydia, holding this big shotgun. She had just killed a chicken hawk that was after her hens. I traveled around with Carolinas when he shoed horses for neighbors or worshipped at the Good Hope Baptist Church, where he served as deacon. I took most of the pictures that appeared in the story in the first three days. Everything worked perfectly. The only thing that went wrong was that I got the greatest set of chiggers around my ankles that I've ever had in my life.

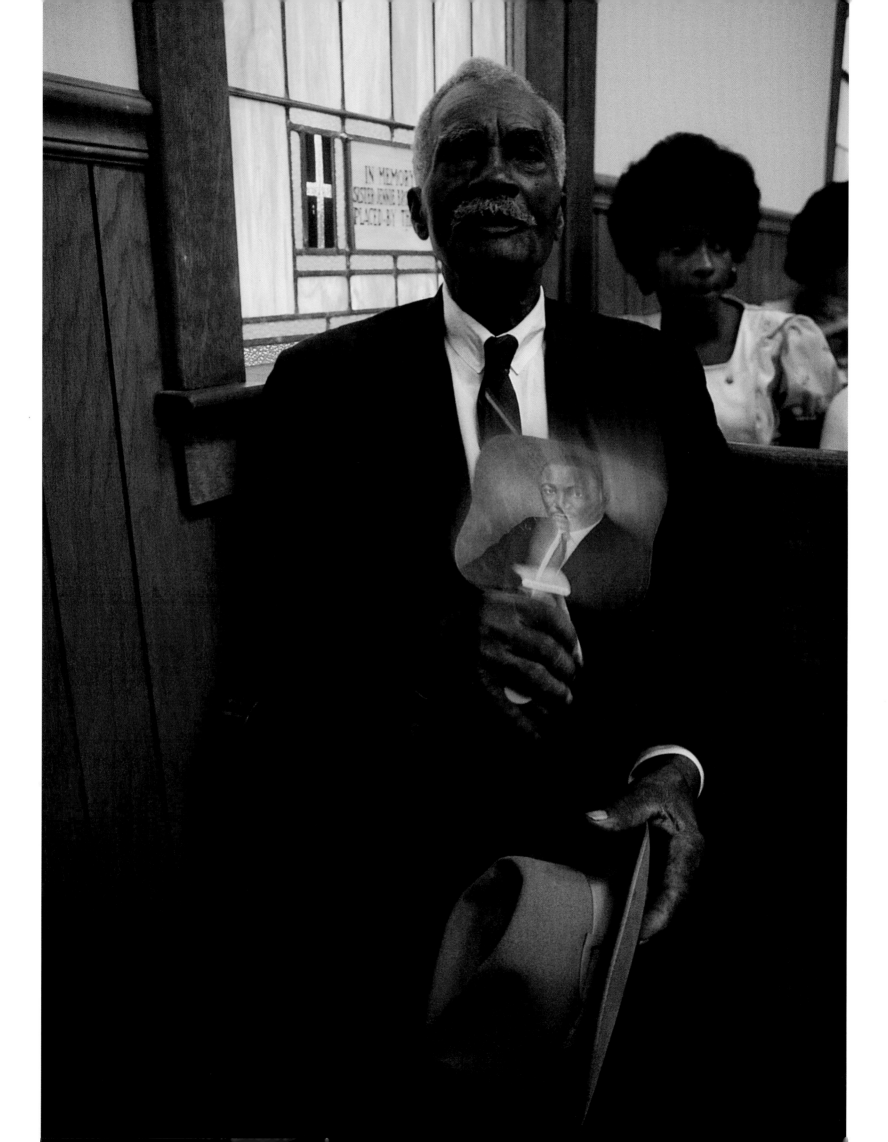

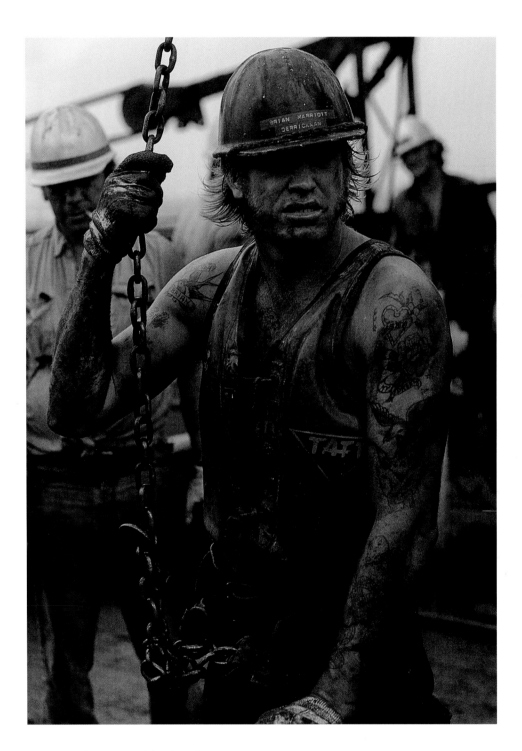

WESTERN AUSTRALIA, THE BIG COUNTRY
February 1975

Gritty Western Australia introduced me to two of the toughest guys I have ever met. This roughneck supposedly stayed one step ahead of the law and his three wives by working on an offshore oil rig, but maybe my leg was being pulled. Manager Les Brown (opposite) runs Ivanhoe Station in the Kimberley region. Determined to get this stray, he jumped out of the pickup truck while it was still rolling, grabbed the steer by the ear and, wham, *with one hand threw it on its side, then into the truck.*

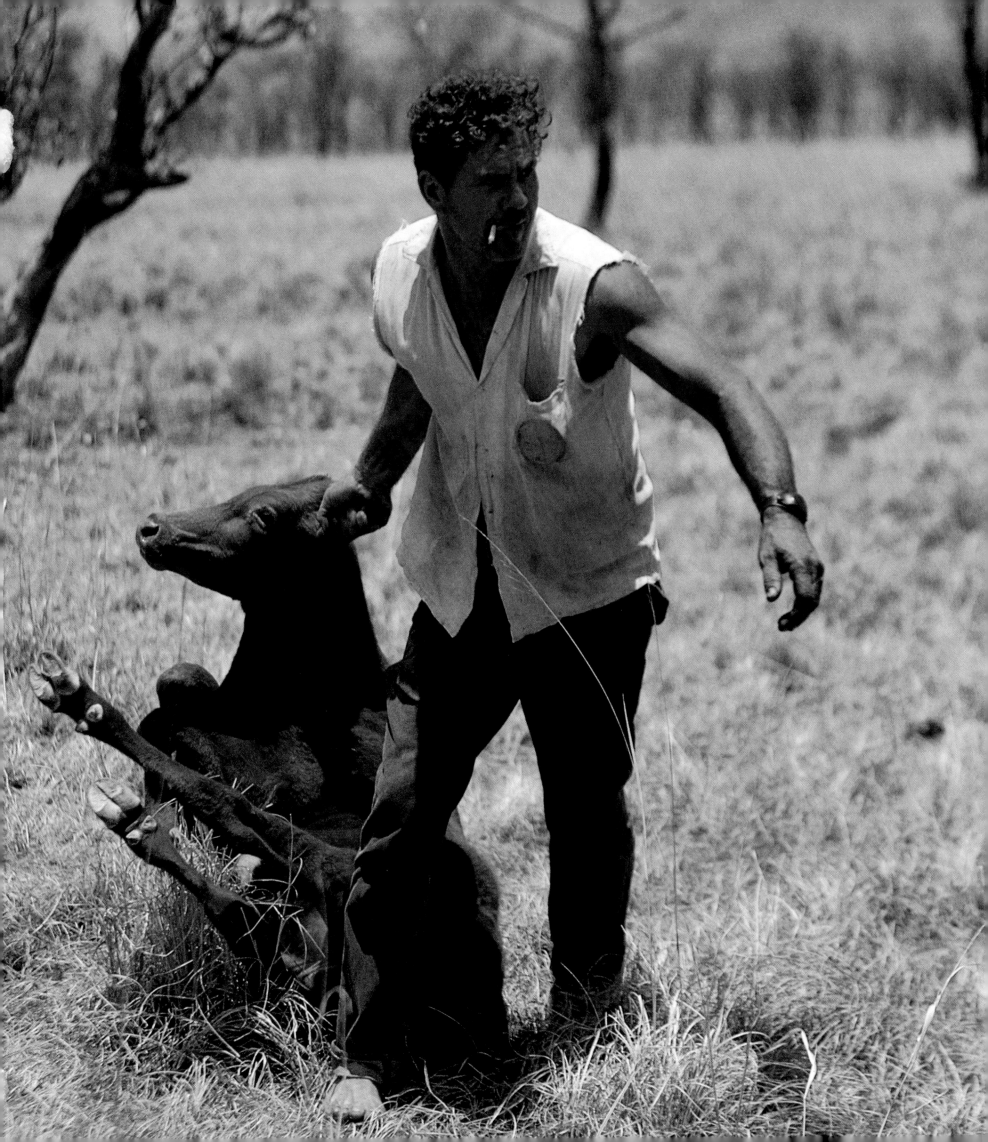

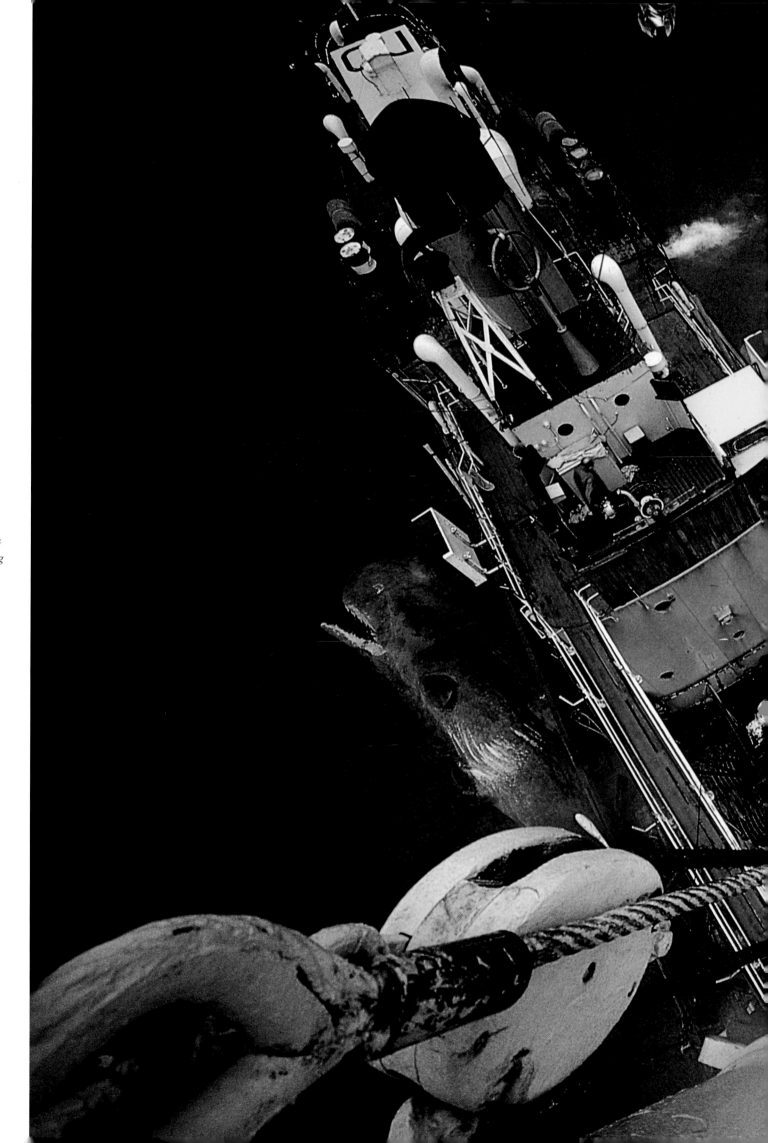

WESTERN AUSTRALIA,
THE BIG COUNTRY
February 1975

*We were out of Albany,
off the southern coast of
Western Australia, hunting
sperm whales. Like Ahab,
the captain and master-
gunner, Cheslyn Stubbs,
had a peg leg. Somehow a
harpoon line had wrapped
around his leg and taken it
off. I stayed on board three
or four days, climbing to the
top of the rigging to get this
shot of five sperm whales
lashed to the ship. The boat
was hauling them to the
nearby flensing site. This was
the last of Australia's whaling
operations, now ended.*

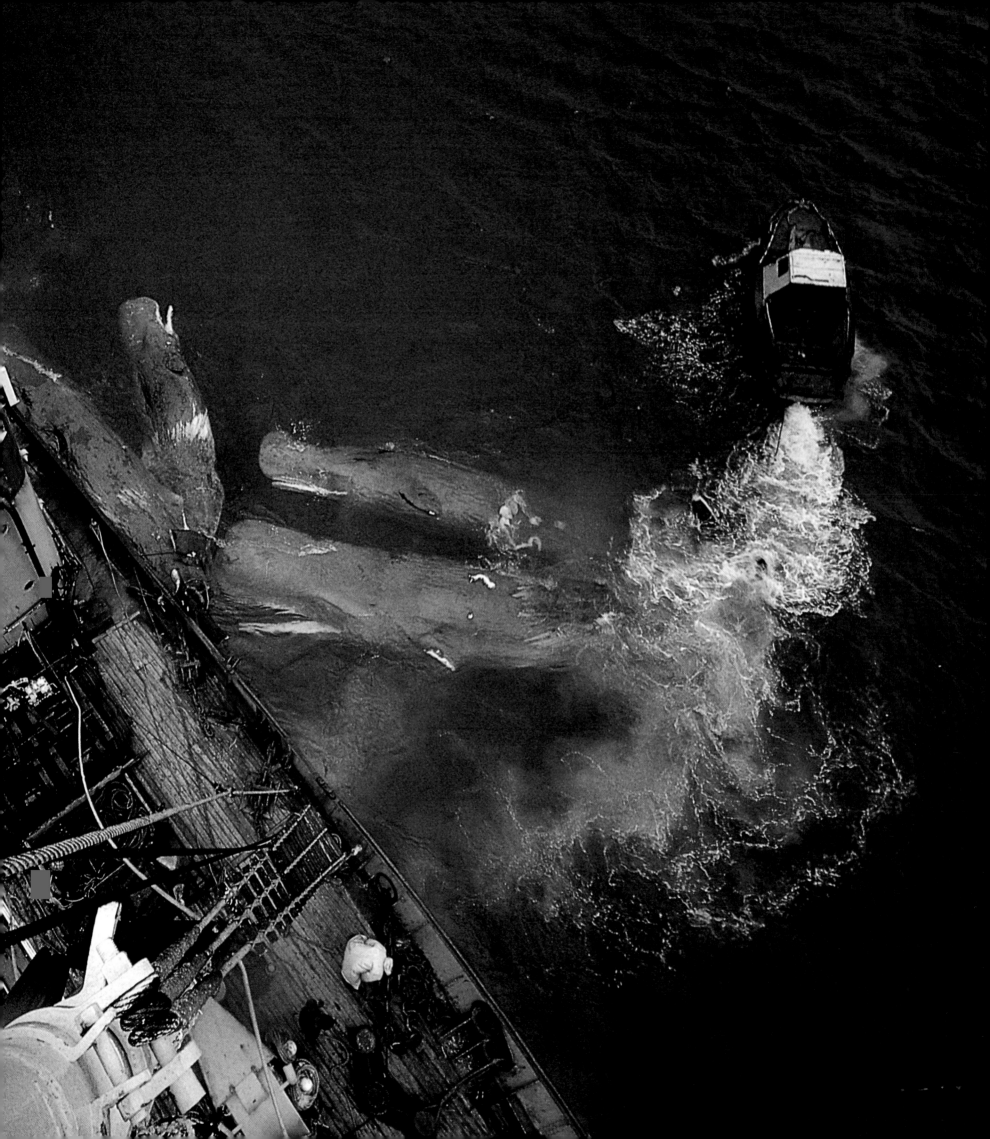

FROM RATS TO RICHES

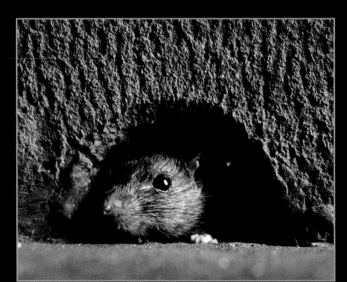

Early in my career I made up my mind not to specialize in any particular kind of photography. Some assignments were more appealing than others. A worldwide coverage on rats took me from the rice fields of the Philippines, where they are hunted, to the Bhagwati Karniji temple in Rajasthan, India, where the rodents are respected and protected. Their rat holes are even carved out for them by the priests of the temple, one of whom keeps a prayerful attitude as the rodents scurry about the floor in the unpublished photograph at right. More palatable subjects were the delectability of chocolate, the opulence of gold, and the glitter of Paris 200 years after the French Revolution.

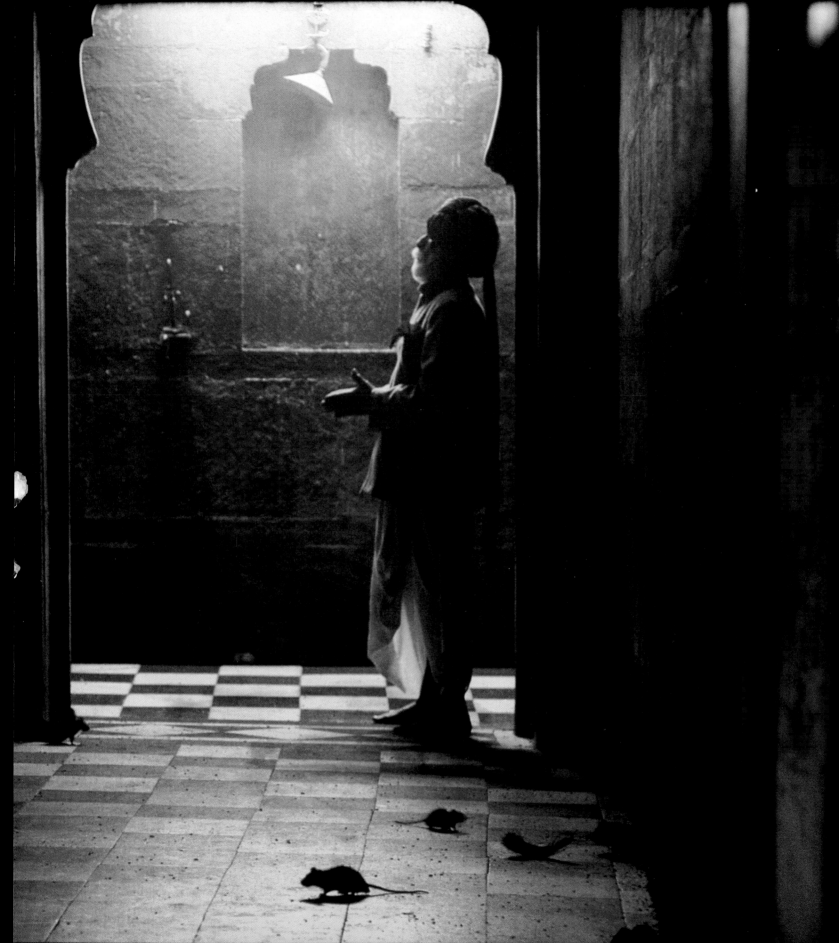

FROM RATS TO RICHES

If I ever needed a sense of humor, it was on the rats assignment. Working with Philippine rice farmers was fine. Even eating fried rats was an experience. But nothing quite prepared me for the Bhagwati Karniji temple in Rajasthan, India, where thousands of rats reside. They are called kabas, the children of the Hindu goddess Karniji to whom the temple is dedicated. The kabas are believed by many worshipers to be their reincarnated forebears.

Villagers, who rotate as temple priests, had never seen people making pictures quite like the GEOGRAPHIC does, spending days finding the right subjects, documenting small details, setting up the lights. Upon entering the temple, you must remove your shoes. I was terrified that I might step on one of the little fellas, so I kind of shuffled along the floor, which plays total havoc with your socks. I burned mine promptly after leaving.

Country stories filled my plate for the next few years: Japan, Syria, Bulgaria, Pakistan, Zimbabwe, Burma, Israel, Poland. My passport read like an atlas and my notebooks bulged with addresses, names of the best and the worst guides and interpreters, notable restaurants, wine labels, pressed wildflowers, and general comments—"great day," "bad," "do laundry," "finish captions," and "ship film."

In 1980 Bill Garrett became Editor of the NATIONAL GEOGRAPHIC, and I don't know of anyone better suited to the job. I always felt that if you didn't grow with Bill Garrett, as some didn't, you would just fall by the wayside. Garrett had been a photographer, picture editor, and layout editor. He was a visual genius.

No squeamishness is attached to eating rats found in Philippine rice fields. Sixty percent of this rice crop went to rats. Writer Tom Canby and I ate these critters that evening, cooked in coconut oil, with a little garlic, ginger, and onion. It was similar to squirrel or rabbit. Rats are protected in the Bhagwati Karniji temple (opposite) in Rajasthan, India, where worshipers bring offerings of sweets, grain, and milk.

One of the biggest challenges he ever threw at me was shooting for the single issue on the French bicentennial. A big problem for me was Paris, because every great photographer has done it. I would struggle to find a different vantage point. I would come down from strategic points, and I would look at the postcard stands on the way back to my hotel. All the pictures seemed nicer than the ones I had just struggled with. I found a vantage point on the roof of St. Gervais church, just across from Notre Dame. I had to go through a Dutch nun's bedroom. I went six or seven times, but it had to be while she was at prayer. When I would hear that Garrett was still not satisfied, I would go back to the mother superior and ask for permission again. I suspect she wondered what kind of B-team rookie the GEOGRAPHIC was using. Garrett gave you time, he gave you money, but you felt the pressure. I knew that if I didn't make a better picture in France, he would come over and do it himself.

I spent a year in France. Being away from home seemed normal. I still average eight months a year in the field. The GEOGRAPHIC is a demanding mistress and perfection has its price. Social life and home life took a back seat, and after 20 years it cost me my marriage.

What I lack in talent or confidence, I make up for with brute strength or stamina. I remember my boss, Gilka, asked Howard LaFay, a great GEOGRAPHIC writer I worked with in Syria, "When the hell is Stanfield coming back?" and Howard said, "When he covers the last blade of grass." When things do pop you feel pretty good. I come back from the field and I am physically and mentally exhausted, and then the editor gives me a pat on the back and I'm ready to go again.

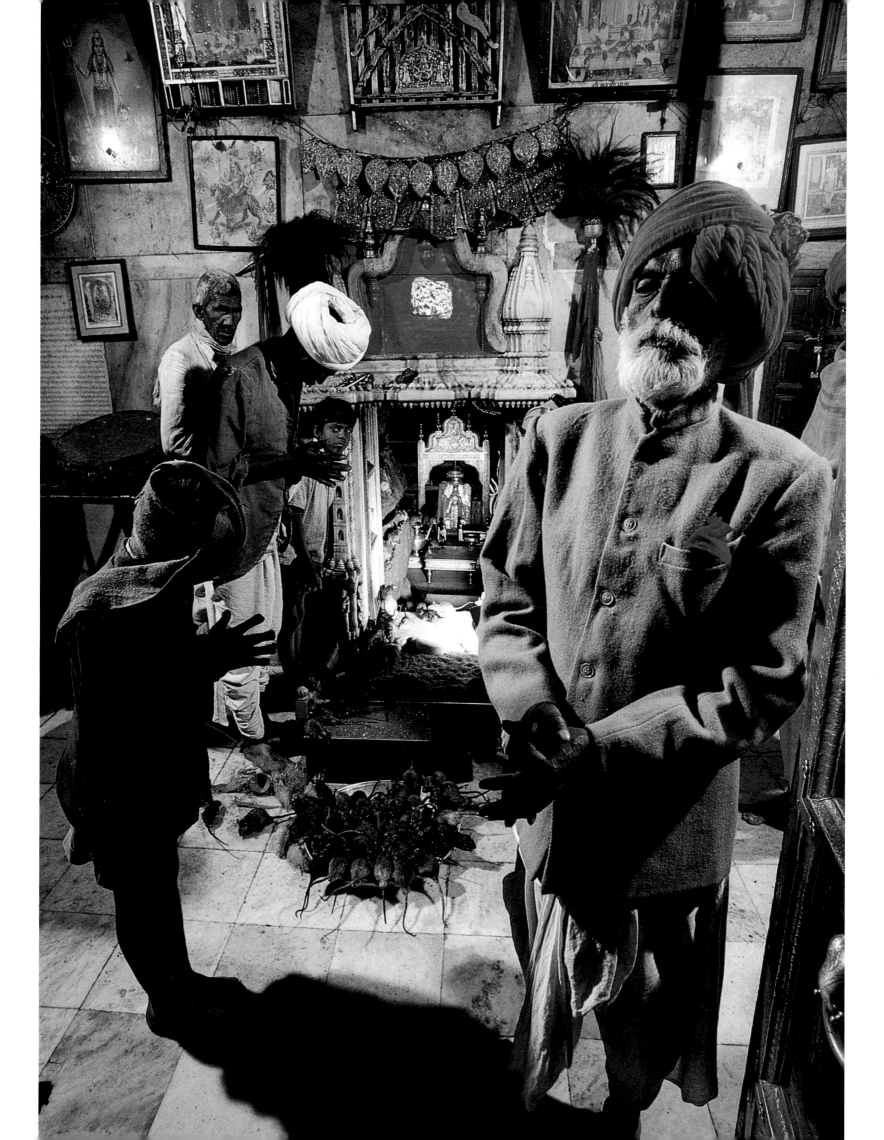

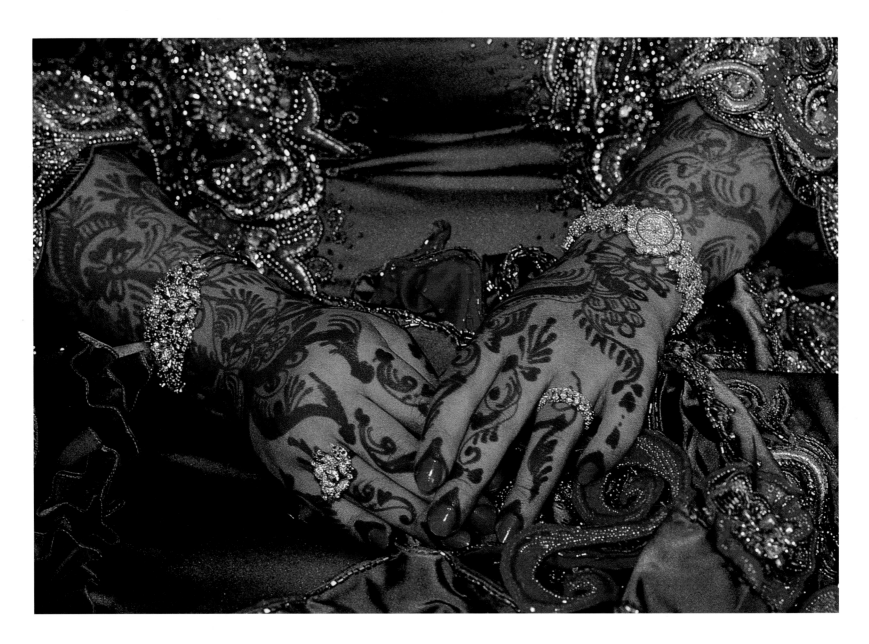

OMAN
May 1995

*Brides reveal much about a country or culture. Henna decorates the hands of a bride in
Oman, a sultanate rich in traditions and wealth. One thousand women attended the* lailat al
henna *ceremony on the eve of the wedding—and I was the only man.*

GOLD, THE ETERNAL TREASURE
January 1974

*When Peter White and I traveled to India on the gold story, we wanted to photograph a Bengali bride. Ever the
optimist, Peter asked the customs agent, "Do you know of any weddings?" He replied, "Yes, my niece is getting
married next Saturday and you are welcome." She was bedecked with gold everywhere, even her cheeks.*

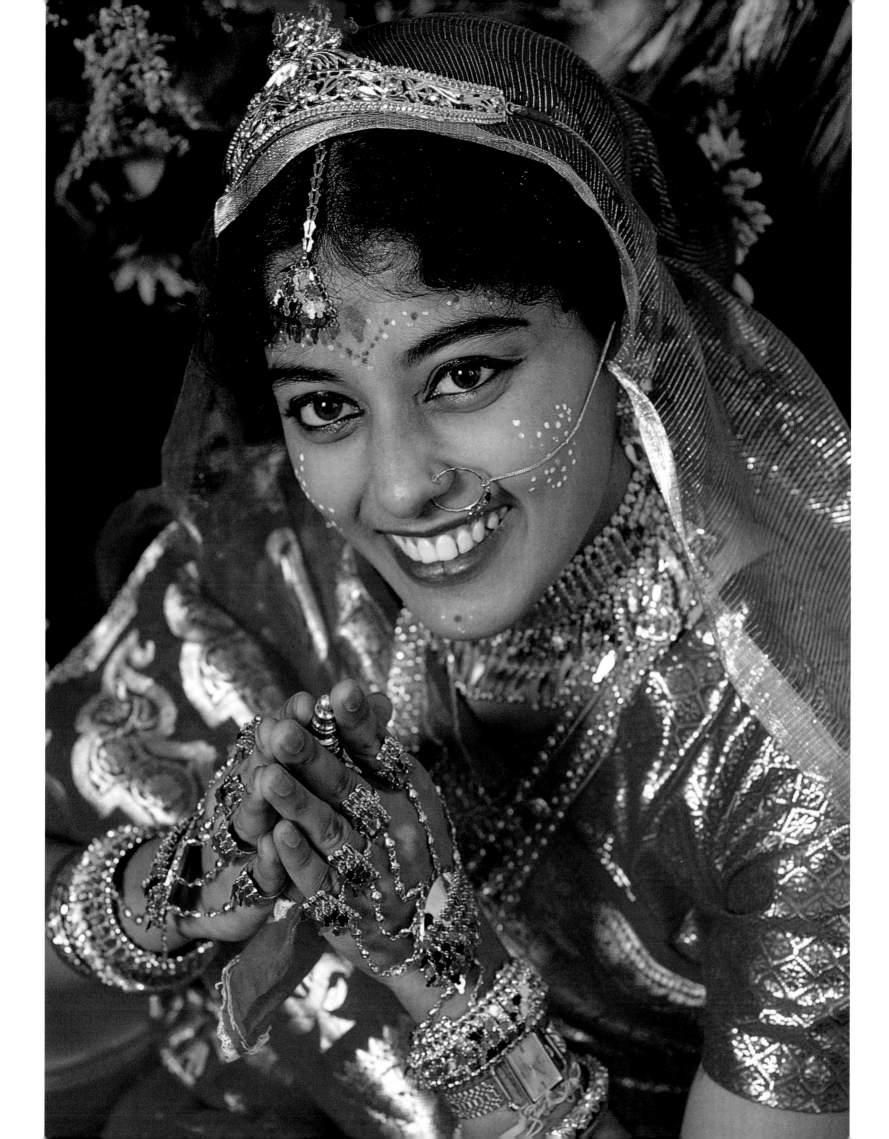

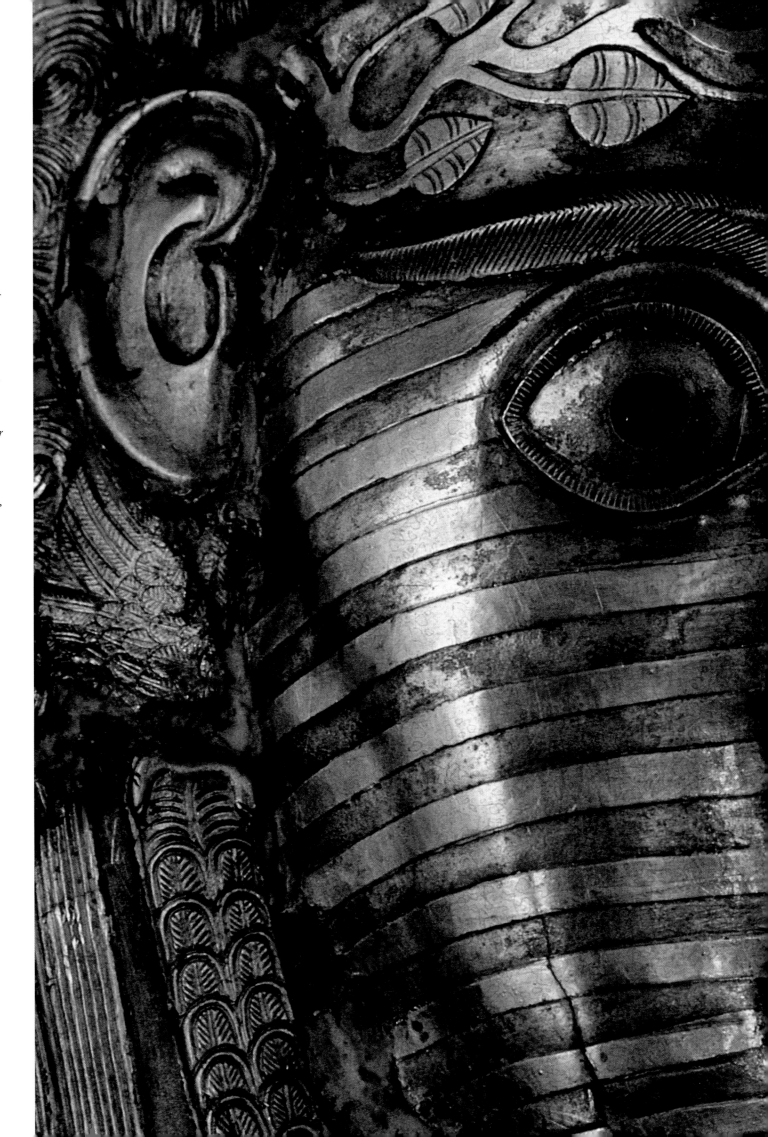

ANCIENT BULGARIA'S
GOLDEN TREASURES
July 1980

*Trappings of a Thracian
warrior chief, this silver-and-
gold greave, or leg guard,
was fashioned as a fearsome
face. It was found in a tomb
dating from about 375 B.C.
Illustrations editor Charlene
Murphy and I worked long
and hard to get permission
to photograph this and other
treasures for a sidebar that
accompanied a story on
Bulgaria. With permission
came officials and the police,
who surrounded me while I
worked. Three men, each
with a different key, opened
the vault where the hoard
was kept—and then they
gave me only about ten
minutes to photograph it.*

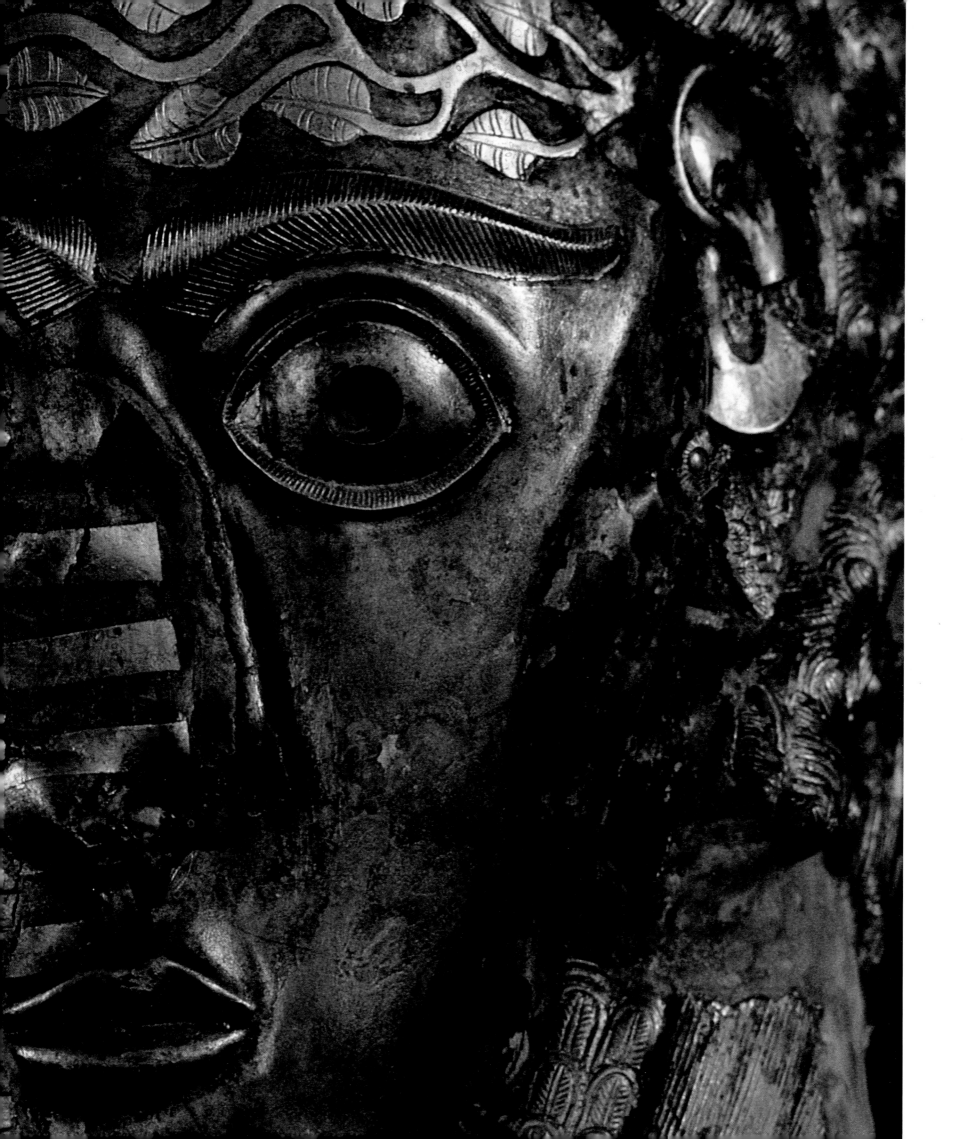

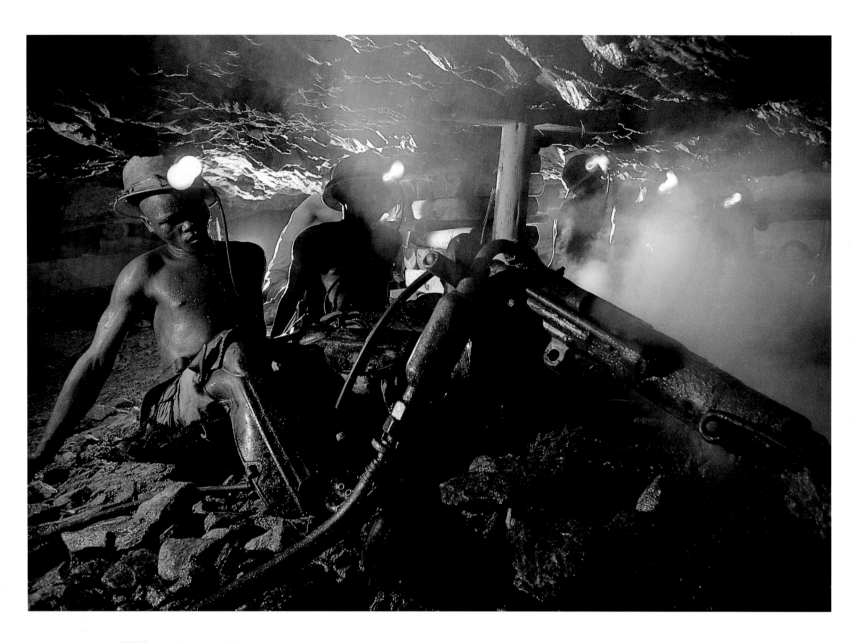

GOLD, THE ETERNAL TREASURE
January 1974

Small Bantu miners drill with their feet in this South African gold mine. It was probably about 115°F and wet from the water-cooled drills. Writer Peter White fainted and they took him out on a railroad car. I got my second wind and my picture, but I ruined three cameras in the process. It was the most strenuous day of my life. Photographing gold smugglers was a different adventure. I was told not to shoot faces of the crew on a dhow carrying gold bars from Dubayy to Bombay. So I shot silhouettes and hands (opposite). However, it wasn't long before everyone was begging, "Take my picture with my buddies for my Mom."

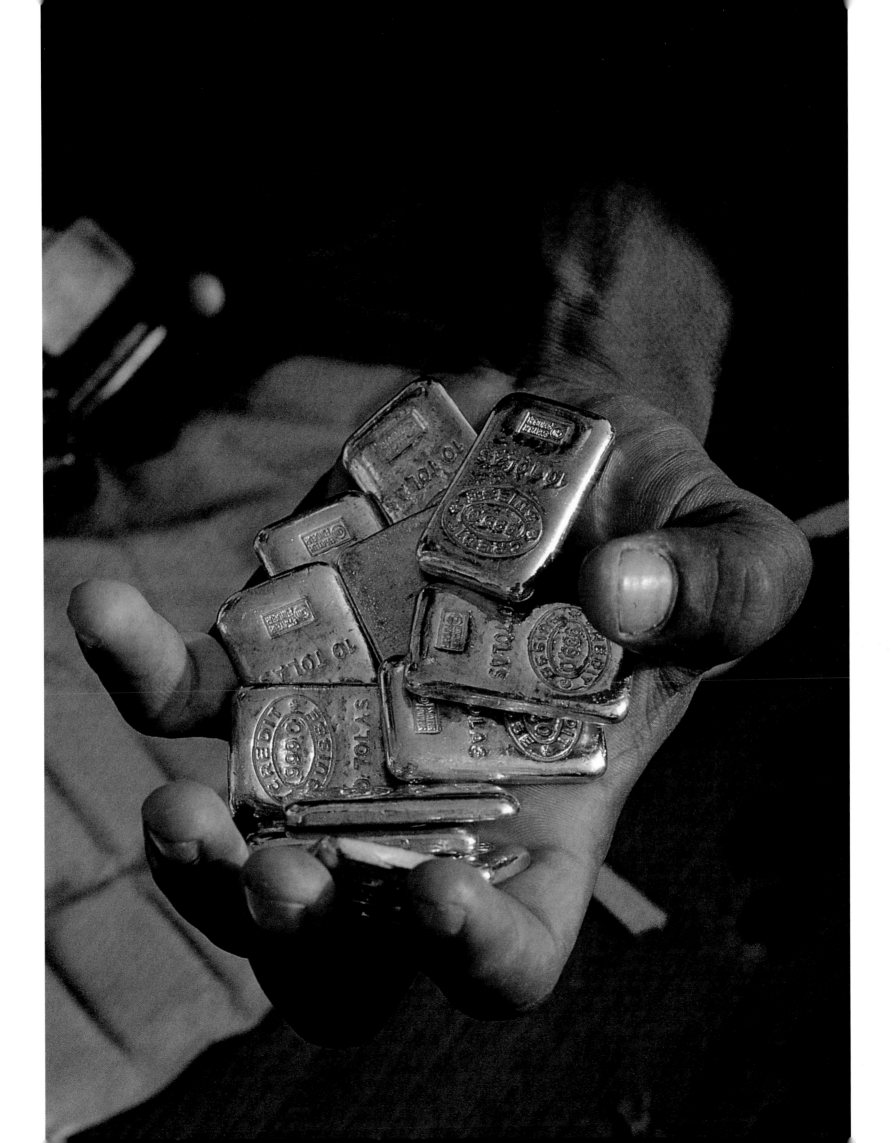

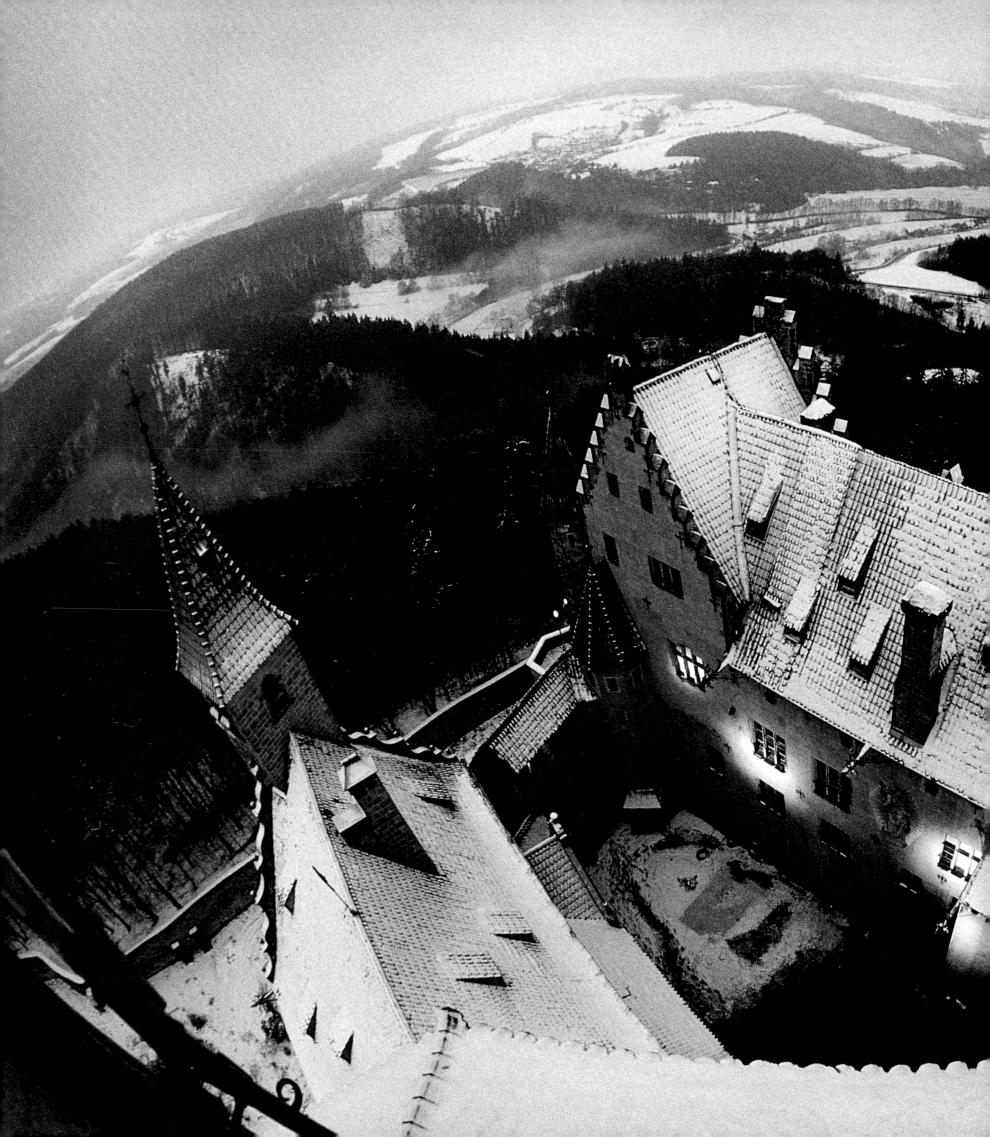

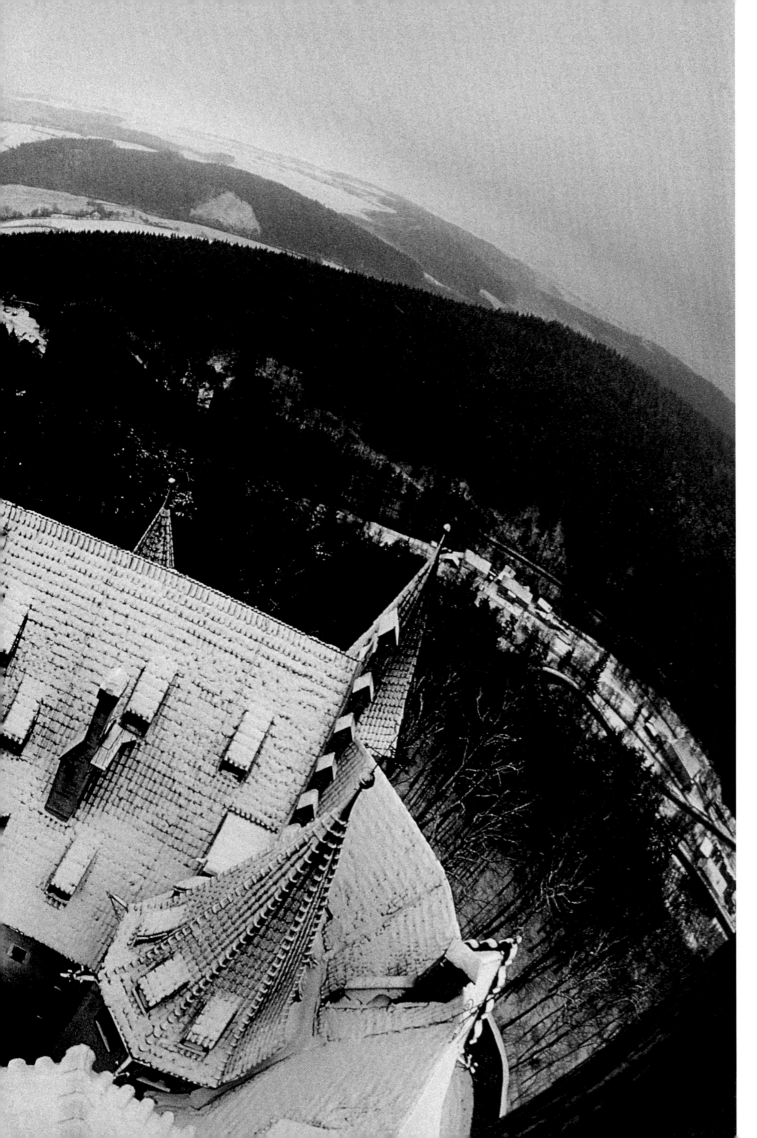

CZECHOSLOVAKIA:
THE VELVET DIVORCE
September 1993

One of my first objectives when photographing a place is to get a good overall shot. This usually means getting as high as I can, in this case looking out of a skylight from the highest cupola of Bouzov Castle. A dusting of snow and a long exposure relieved the darkness of this fortress, once commandeered by the Nazis and Hermann Göring. Today it is often used as a movie set, as it was when I visited. This 16mm lens curves the Earth in a semi-fisheye view, enabling me to see the entire castle.

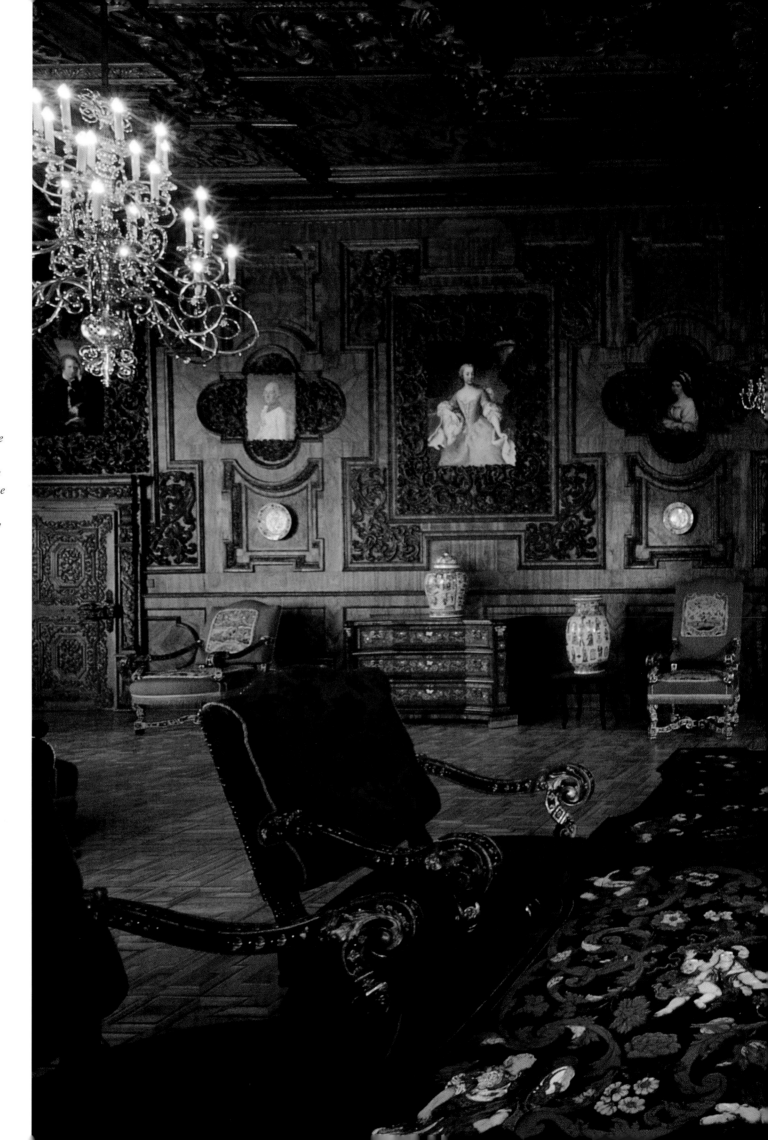

**CZECHOSLOVAKIA,
THE VELVET DIVORCE**
September 1993

*A stark contrast to the
bleak exterior of Bouzov
Castle, the splendor of
Hluboká Castle is preserved
as a museum. Magnificent
furniture and paintings fill
140 chambers. To light this
huge room, adorned with
portraits of the Bavarian
Schwarzenbergs, I had to hire
a movie lighting crew. There
are hundreds of castles in the
Czech Republic, and each one
seemed better than the last.
My illustrations editor finally
told me, "No more castles."*

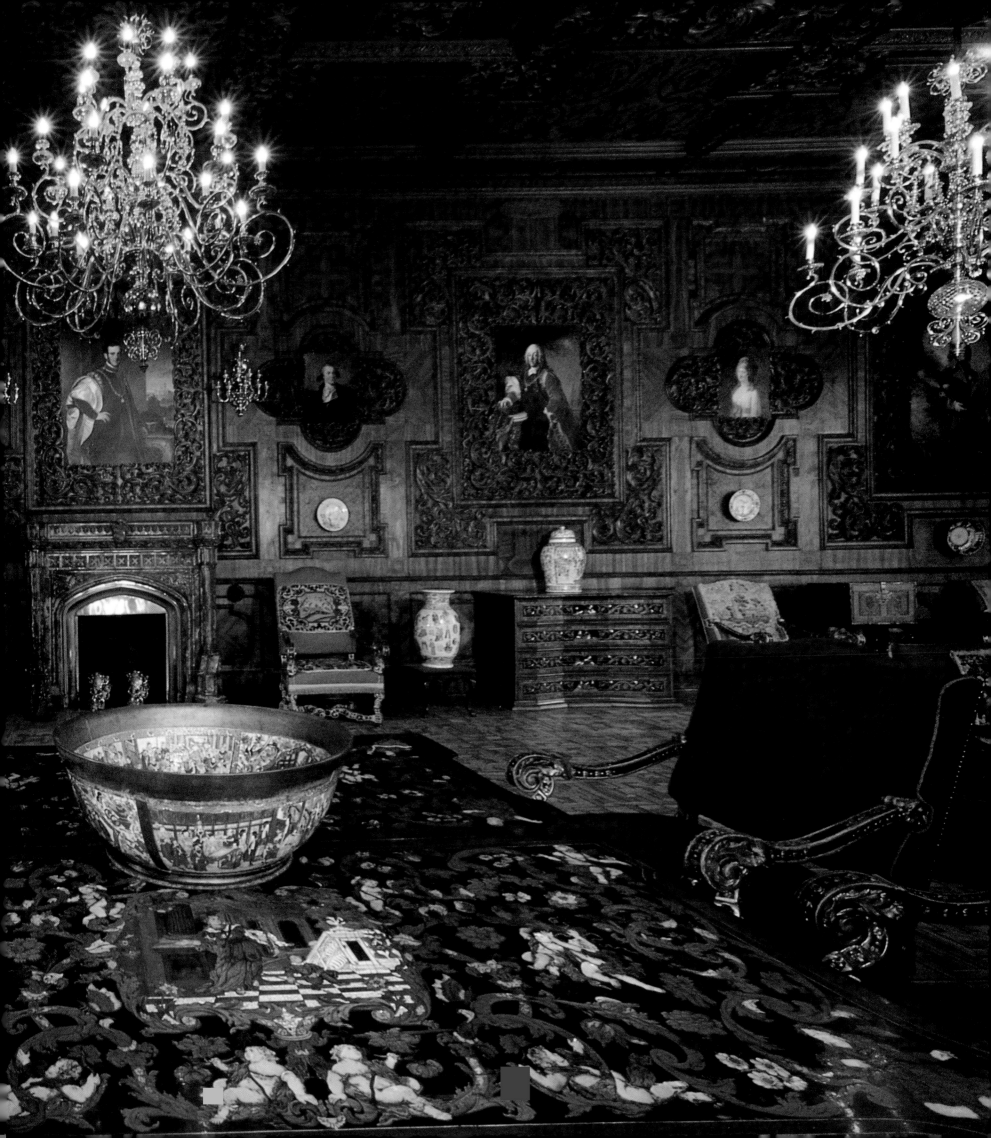

THE TWO WORLDS OF FIJI
October 1995

I always wanted to make a picture of mystics doing impossible things. They always seem to get published. This very handsome Hindu (left) is one of the ethnic Indians who make up almost half of Fiji's population. A high priest allowed me to photograph him and his fellow devotees in a seven-day festival that culminated in a fire-walking ceremony.

OMAN
May 1995

A Brazilian-born belly dancer, Giselle performs a sword dance in the Al Bustan Palace, reputedly the world's most beautiful hotel, which lies just outside of Musqaṭ. I climbed a ladder to set her sinuous dance against the softly lighted floor.

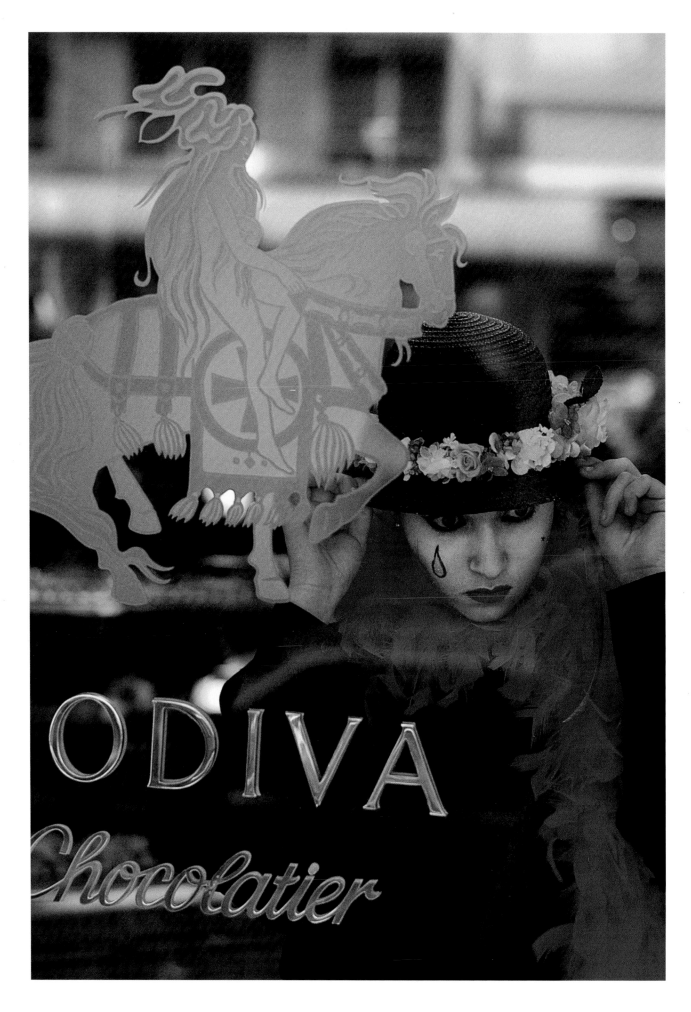

CHOCOLATE:
FOOD OF THE GODS
November 1984

Chocolate took me from the cacao farms of Africa's Ivory Coast to the confectioners of Europe. I hung around the Godiva store in Vienna, Austria, during carnival and photographed people buying chocolates and some just looking, like this young lady. Her picture did not appear in the article. I traveled to Barcelona when I heard about José Balcells Pallarés, who was creating an 8½-foot-tall, 229-pound chocolate Statue of Liberty to honor the beginning of the restoration of the original for its 1986 centennial. A photograph of Pallarés putting on the final touches appeared in the chocolate story, and this one of him sampling his material made the cover.

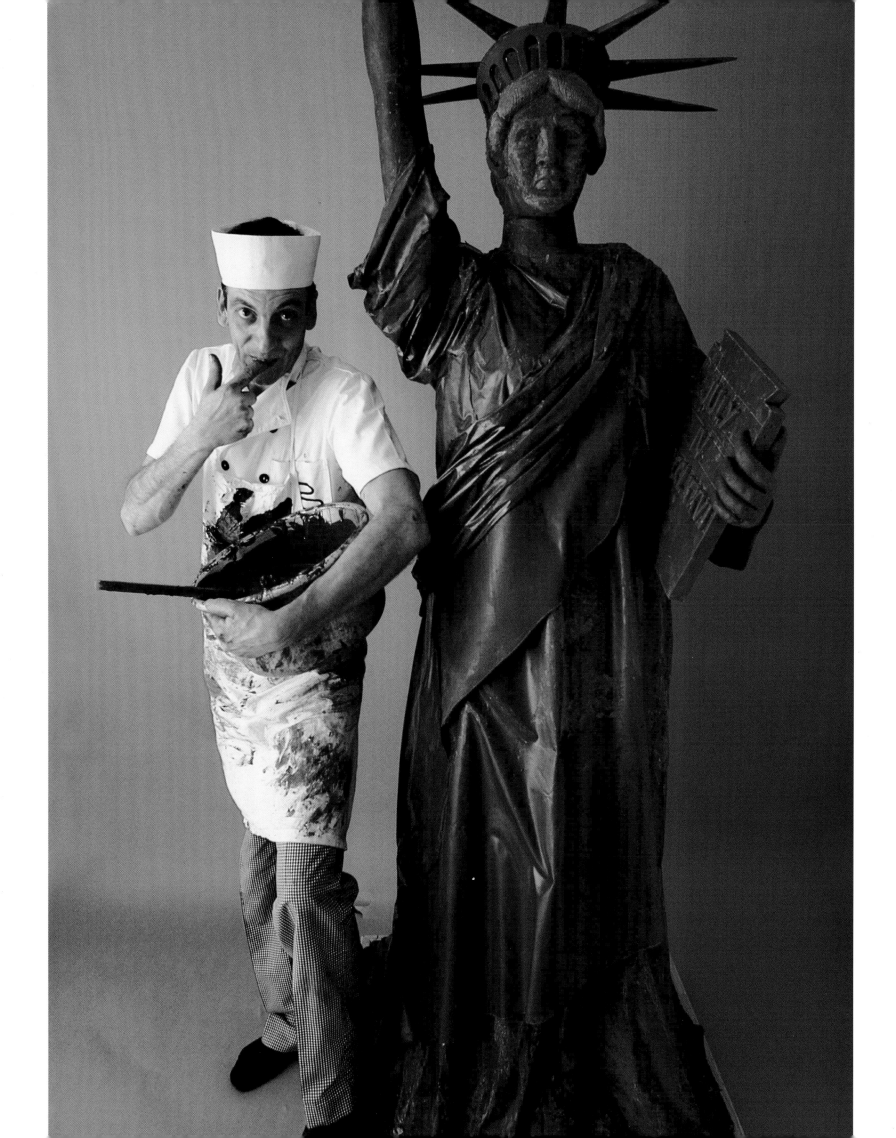

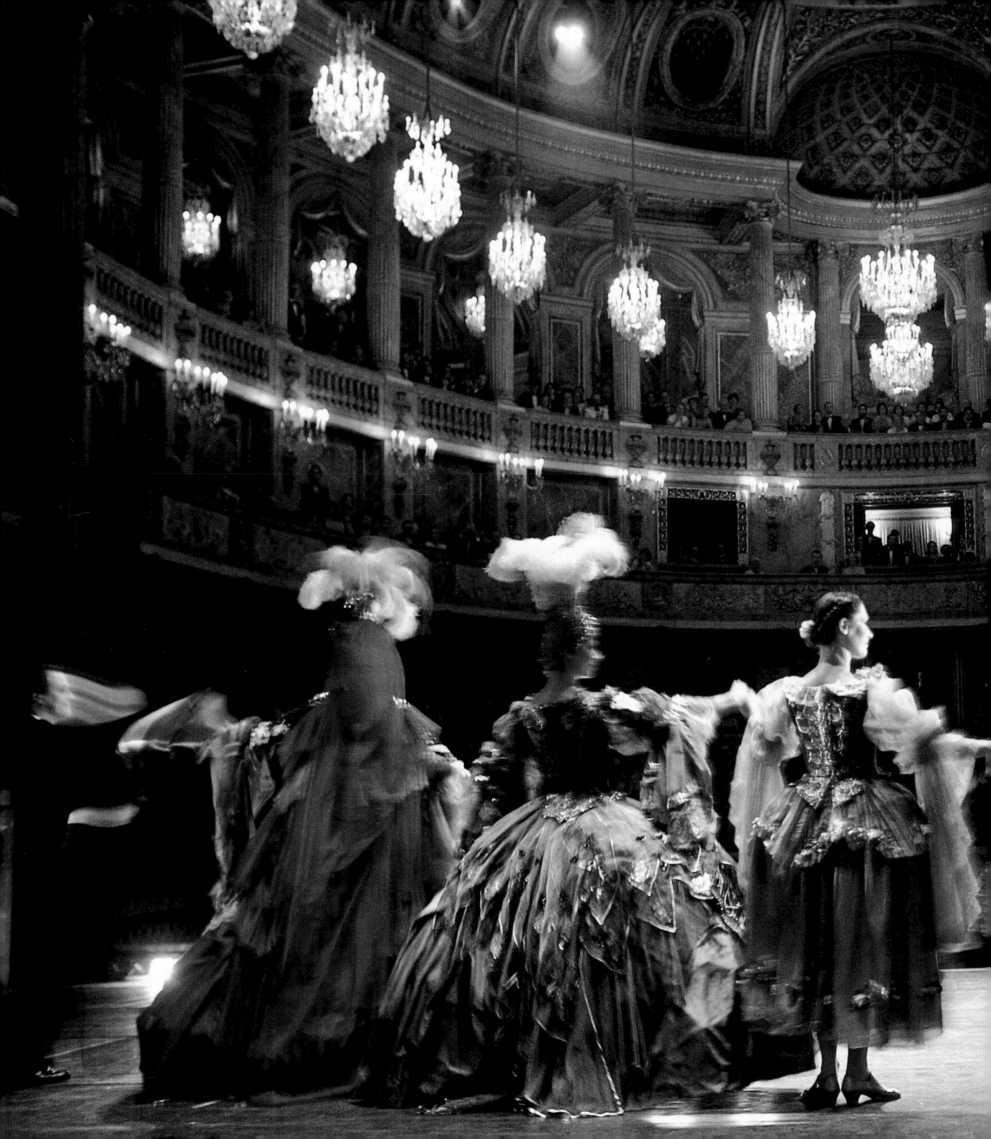

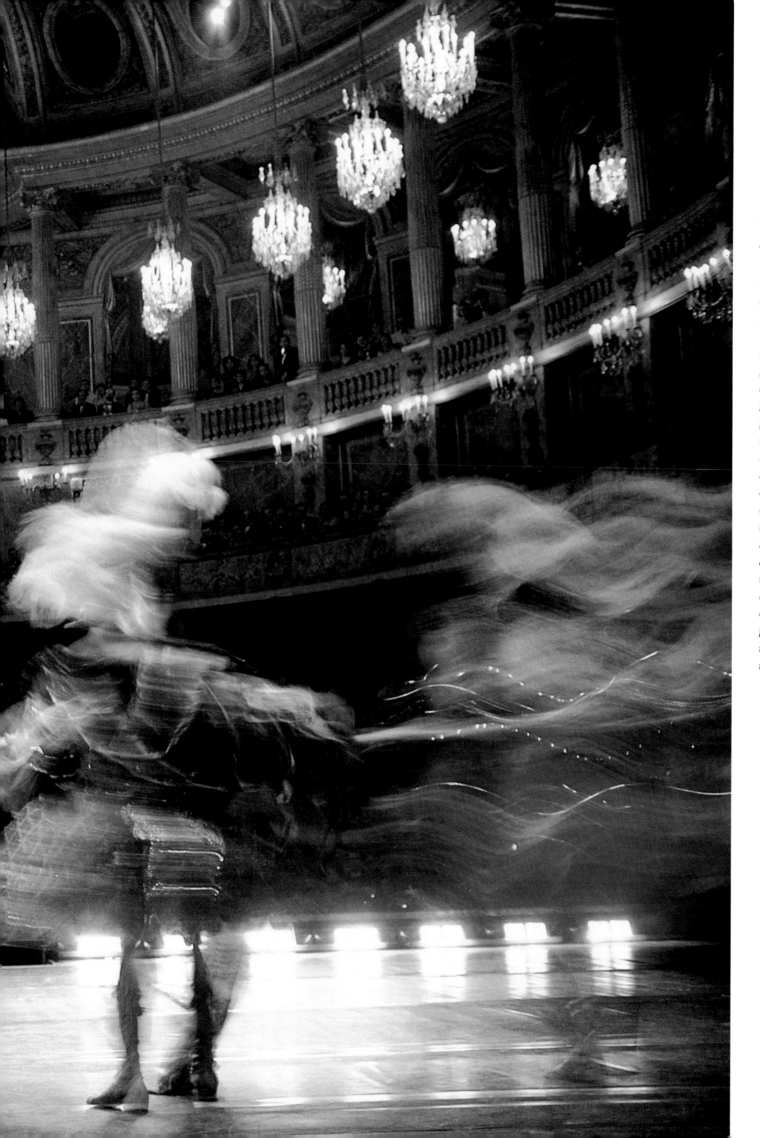

THE GREAT REVOLUTION
July 1989

Glitter to have warmed the hearts of Marie Antoinette and Louis XVI filled the Royal Opera House at Versailles, built to celebrate their wedding in 1770. I found only discouragement as I tried to get permission to photograph a performance from backstage. I always needed one more permit. Finally the stage manager said I could go out when the dancers took their curtain call for Pygmalion, if I would make just as small a silhouette as I possibly could and wear a tuxedo. I had a white shirt and a dark suit, but no black tie. So I made one out of cardboard, painted it with black magic marker, and stuck it on with gaffer tape.

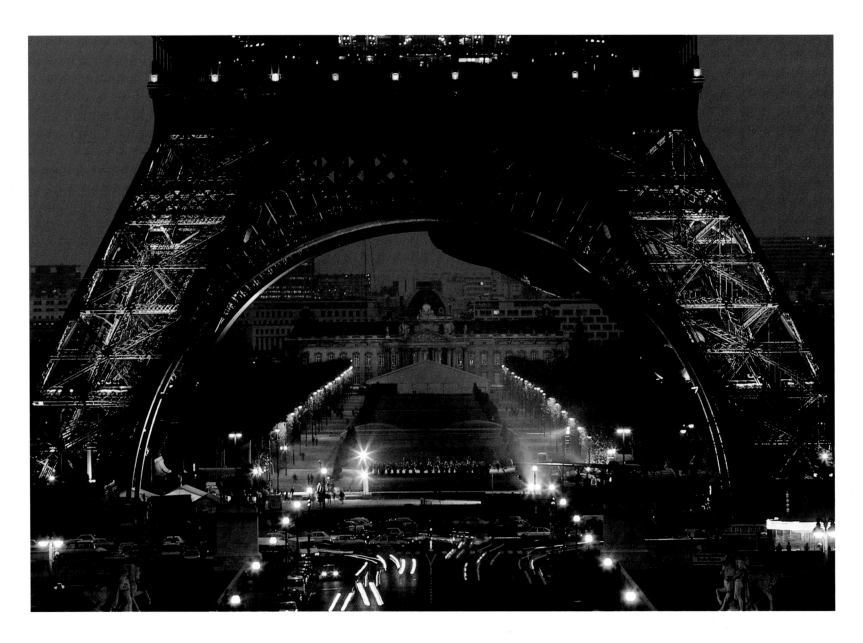

The New, The Enduring Paris
July 1989

Symbols of revolution and remembrance are not easy to photograph. A 600mm lens framed the Ecole Militaire beneath the Eiffel Tower, dedicated in 1889 to celebrate the centennial of the French Revolution. The guillotine was more of a challenge. France did not have one intact. I found one in Liège, Belgium, in a museum. I enlisted the aid of my assistant, whose silhouette is cast on the wall (opposite), then carefully lighted the areas I wanted to stand out. It is the only picture I have ever made that drew me out of my chair when I saw it. Everything was just the way I planned.

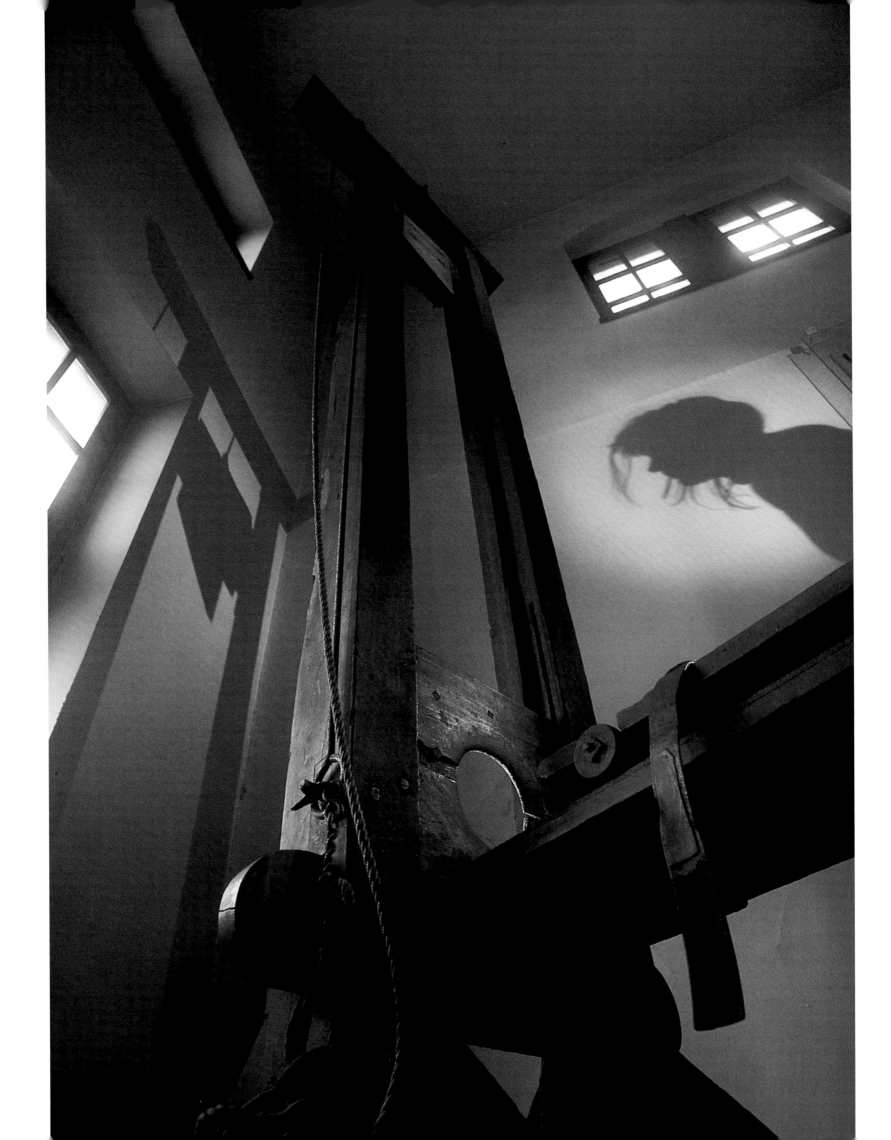

THE NEW, THE ENDURING PARIS
July 1989

A storm rolled into Paris and the sun came out for no more than ten seconds, bathing Paris's Île de la Cité in a golden light. I probably made five to seven photographs and then it was done. It was toward the end of our coverage of France for this special issue, and we needed some special moments. I spend a lot of time just walking the streets, and sometimes I would luck into just the right scene. On this assignment, I had many frustrations and great success.

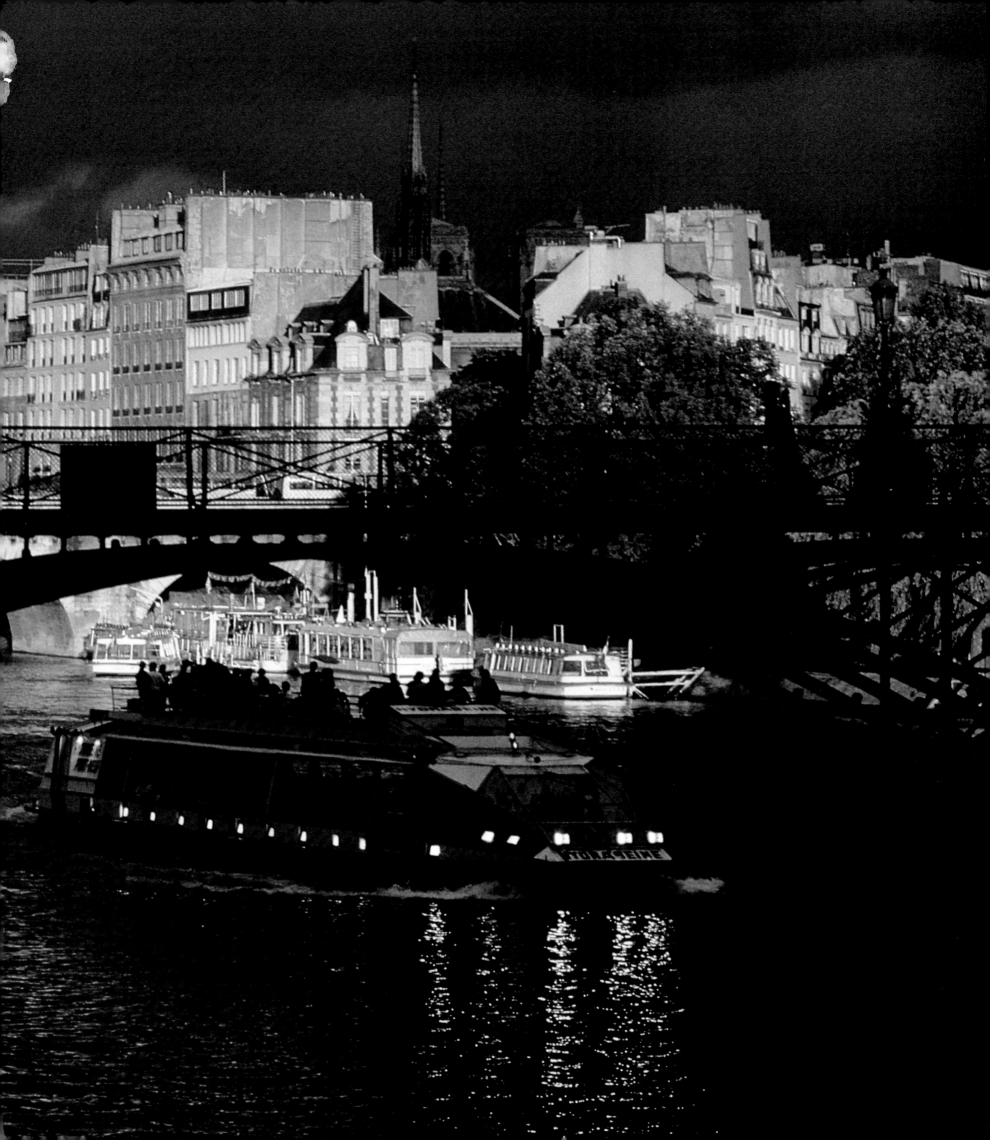

Each country you visit on assignment for NATIONAL GEOGRAPHIC is an adventure, and each culture you learn about is fascinating. It takes research, and it takes time in the field. We don't spend just a couple of days hitting the high spots. The kind of pictures I want to make must grip your imagination and also tell a story. They demand understanding, tact, and patience, particularly when photographing people and the way they live, such as this Bedouin couple caught in a rare public show of affection.

THE HUMAN CONNECTION

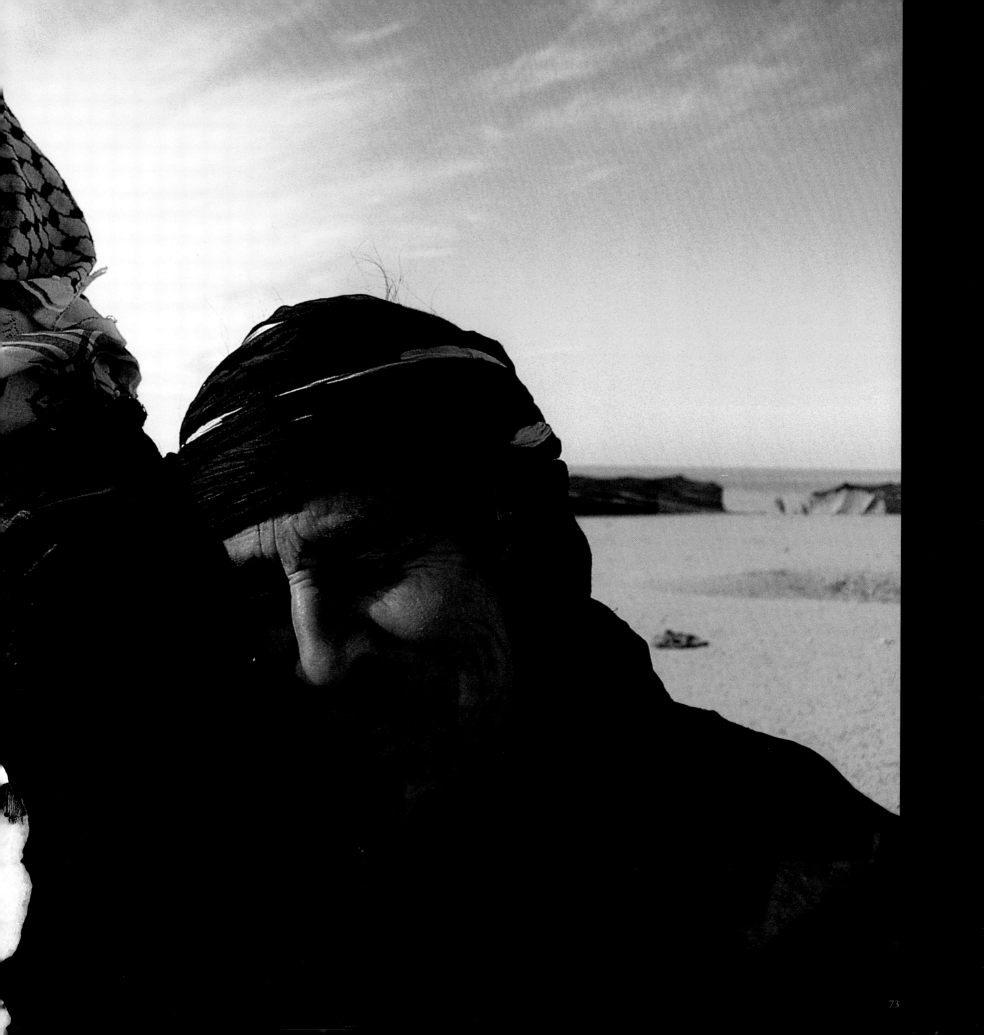

THE HUMAN CONNECTION

Getting to know people, getting them to let you into their lives, is a must for a NATIONAL GEOGRAPHIC photographer. It takes knowledge of their culture and a lot of empathy. When you finally have a handle on it, when you've finally eased your way into their lives, that's the time to bear down. After I took the picture on the previous pages, I realized just how focused I get when I know the possibilities are there for a memorable photograph. I was on the Syria assignment, one I was both happy and sad to get. My office partner, Win Parks, had just passed away, and he had two stories I took over, Syria and Bulgaria. Before I wrapped up my first full coverage in the Middle East, I wanted to live with the Bedouin for about ten days or two weeks. This couple and their family lived in a goat-hair tent in the desert where they tended their sheep. They were typical Bedouin, handsome and proud.

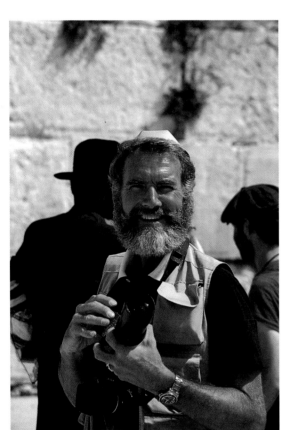

Thomas R. Smith

Visiting Jerusalem is like turning the clock back 1,000-1,500 years. For the July 1985 Israel article, I would often put on a yarmulke and go to the Wailing Wall. It was always fascinating. I felt my photograph of members of Israel's Inbal dance troupe captured them at the absolute peak of action, emotion, and sensuality—something seldom achieved.

My interpreter, Farouk, and I spent four or five hours following this couple. The woman was magnetic, and I kept watching and studying her. Then suddenly there was this fleeting moment late in the day when she went up behind her husband and hugged him. I was able to expose two frames, one with her eyes open, one closed. Shortly after we went back to the tent and had a final cup of tea. "You know," she said to Farouk, "your friend looks at me like he's going to eat me." I realized then how intense I get, how I never take my eyes off a subject. I study their characters and personalities, their moments of joy or sorrow, bearing down continuously so as not to miss the peak of action or emotion. Yet, I know I must never become an intrusive element in their lives.

People ask me how I begin an assignment. First comes the research. Reading books from our extensive library to begin to get an idea of what the assignment is about, looking at other photographic books to get ideas for specific subjects that should be included in the coverage. I usually handle 90 to 95 percent of the research, obtaining visas, organizing equipment, planning an itinerary, and myriad other details that have to be done before you can head for the field. It is kind of disconcerting for secretaries. They undoubtedly are leery of working for me because I'll mention something to them and then ten minutes later I'll run out and do it myself.

I consult with our expert photographic technicians about special cameras or lighting I might need. You can always tell when a GEOGRAPHIC photographer is getting ready to head off to the field: Ten to fifteen battered aluminum cases sit by the front door waiting for a taxi. Before we leave we prepare an international customs carnet, or list of our equipment—including serial numbers, weights, and costs—to avoid duties when we return. My carnet usually lists 10 cameras, 17 lenses, and miscellaneous lighting equipment. And, of course, lots of film—usually 1,000 to 1,400 rolls, depending on the assignment.

I feel electric when I get to a place—but it's probably fear or anxiety. I move fast and I want to see it all. The first month, for the most part, when I am on an average assignment, I'm not making great photographs. I've probably been off for a month or a month and a half, in the office editing film and writing letters, or fixing the roof on the house, and suddenly I'm back in the field. I think we're a little bit like athletes. Believe me, you get rusty in your movements, in your rhythm, and in your confidence. You don't have a handle on it at all. You think you may be making photographs, but for the most part you are filling up your idea bank and getting back into shooting form.

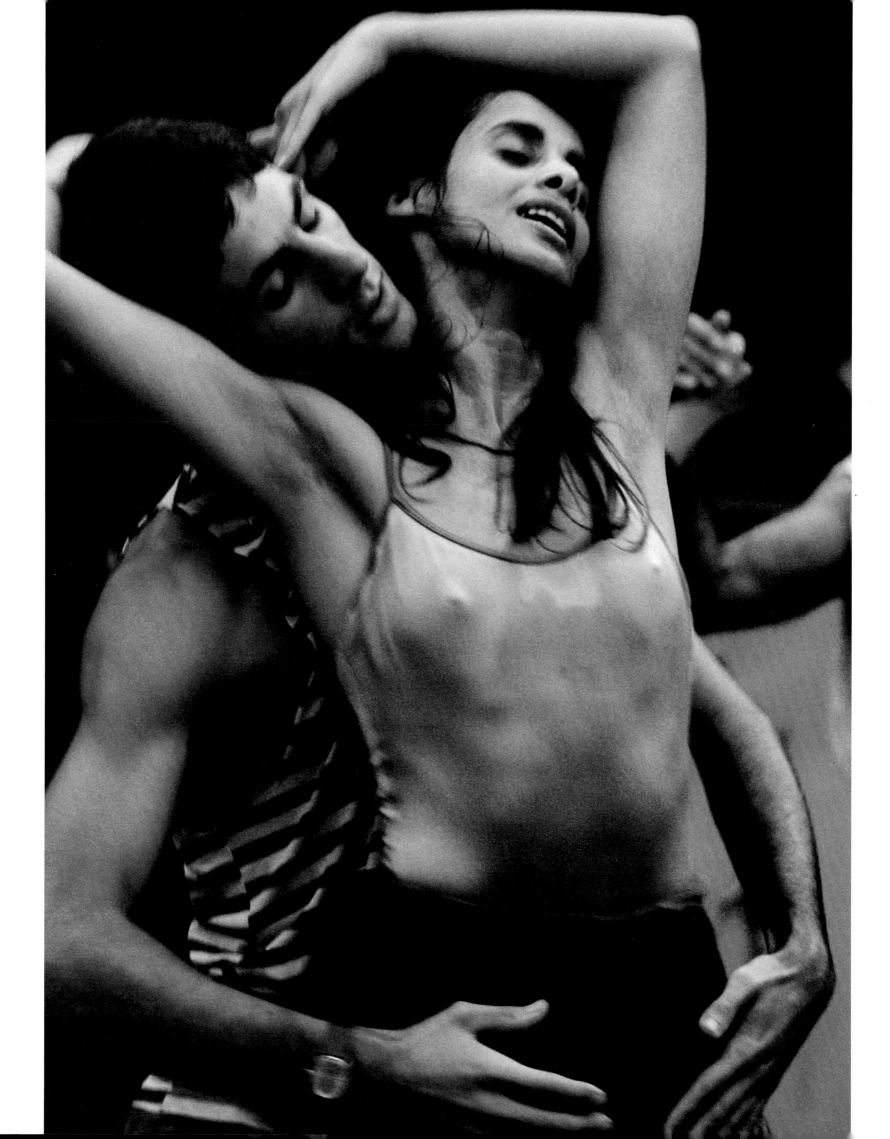

SYRIA TESTS
A NEW STABILITY
September 1978

Light and shadow, old and new come together at Tell Mardikh, a 200-year-old beehive village near Ebla, a 4,500-year-old archaeological site featured in its own article three months after the Syria story. When then-editor Gil Grosvenor came to visit, we wanted to show him the village as well as the ancient city. Our interpreter, Farouk, somehow talked our way into one of the houses where unfortunately only the lady was home. The husband returned while all these strange men were in his house. We had to do some pretty fancy footwork; at least Farouk did.

THE HUMAN CONNECTION

If you have done your research well, you know that there are probably about 20 "must" situations for each assignment. I keep a log of everything that should be done and the things that work out. It's up to me to make it better than it's been done in the past. Sometimes things sound better in the reading than they are in real life, or things have changed—scaffolding is now around a building or electric lines ruin a landscape. Every once in a while you just miss something. I have always said that if I had a book with all of the pictures I have shot on the film leader or when I ran out of film, I would have a hell of a book. I get so involved in my subject that I don't hear the beep at frame 33 of a 36 exposure roll. I have missed some incredible things. Once with the medical corps near Be'er Sheva in Israel we came across a pretty Bedouin woman with a sick baby. She was looking at me; the baby was crying. Then suddenly she took that baby's hand, took its finger and kissed it—just as I ran out of film in both of my cameras. You can't repeat it.

My chances of making a good picture are helped by being always out there from before dawn until after dark. I am not going to miss a sunrise or sunset. I always feel compelled to come back to the hotel at night with a publishable picture. I may go to bed depressed, sure that I have failed, but then I am optimistic enough to get up the next morning and think, today I am going to make the best picture of my life.

And sometimes it happens. When we showed the photographs for our Poland article, everything just fell silent. Then Bill Garrett said, "I have been to Poland, and the magazine has done Poland before, but I have never seen this Poland." It was the greatest pat on the back I have ever received. It brought tears to my eyes. That is what pushes you, keeps you going. It fuels my enthusiasm and keeps me growing.

Someone once asked me if I looked at all 30,000 frames I shoot on a typical assignment. If possible, but that is the illustrations editors' job, and they do an excellent one. If I remember what I think is a better frame, a horizontal instead of a vertical, or maybe something critical going on in the background of one they missed, I will ask that it be included in the selects—the 80 or so pictures that are presented to the editor and then are passed along to the layout and design editors. I am occasionally surprised when I look at my pictures, because at the peak of action or expression—like the dancers from our story on Israel—you don't know what you have. The camera goes dark at that split second. You are fooled sometimes by your imagination and you think you have it, but many times you're wrong. There are surprises in the pictures you make.

I care a lot about what happens to my photographs, which ones are selected, how the layout works, what the legends, or picture captions, say. When I am in the field I consult my notebooks and fill out the caption books about twice a week, usually when plans fall through. Writing good captions was something I learned at the *Milwaukee Journal*. By the time I came to the GEOGRAPHIC I was used to being pretty careful. I don't want to lose a picture because I don't have enough caption information. Sometimes things happen so fast in the heat of working that I am scared I might miss a frame and my notes might be pretty sketchy. But I always try to give the legend, or caption, writer some good leads to get the right story.

Constance Phelps, director of our Layout and Design department, has worked on all of my major stories in the last 15-20 years. She always asks me what photographs I really need to tell the story. We then try to narrow the selection of 80 frames to maybe 40. After all, you can't use three pictures of temples; you have to pick one. Connie's eye for color, composition, story telling, and beauty is brilliant. She can be ruthless—in a very kind way. My 40 frames soon become 30 or whatever the page numbers allow. And I am usually pleased with the final layout.

THE WORLD OF SÜLEYMAN THE MAGNIFICENT
November 1987

A wistful face at a window, a little girl watches a GEOGRAPHIC team beat a retreat. We were in the farming village of Söğüt in the hinterlands of Turkey, where I had at long last come to film a nomad wedding, little changed from the days of Süleyman. A National Geographic Television crew, somewhat more conspicuous than a lone photographer, had arrived to film me at work. The bride's mother finally decided that we had caused enough commotion and asked us to leave. We never saw the wedding or procession—and this picture was never published.

ROME OF THE EAST
December 1983

Following pages: A wedding photographed for our story on the Byzantine Empire was more successful. Near Bukovina, Romania, Simion Boca and his bride, Georgeta Niga, followed Eastern Orthodox rituals. After the ceremony I found them awaiting their reception amid the appetizers prepared in the bride's mother's home.

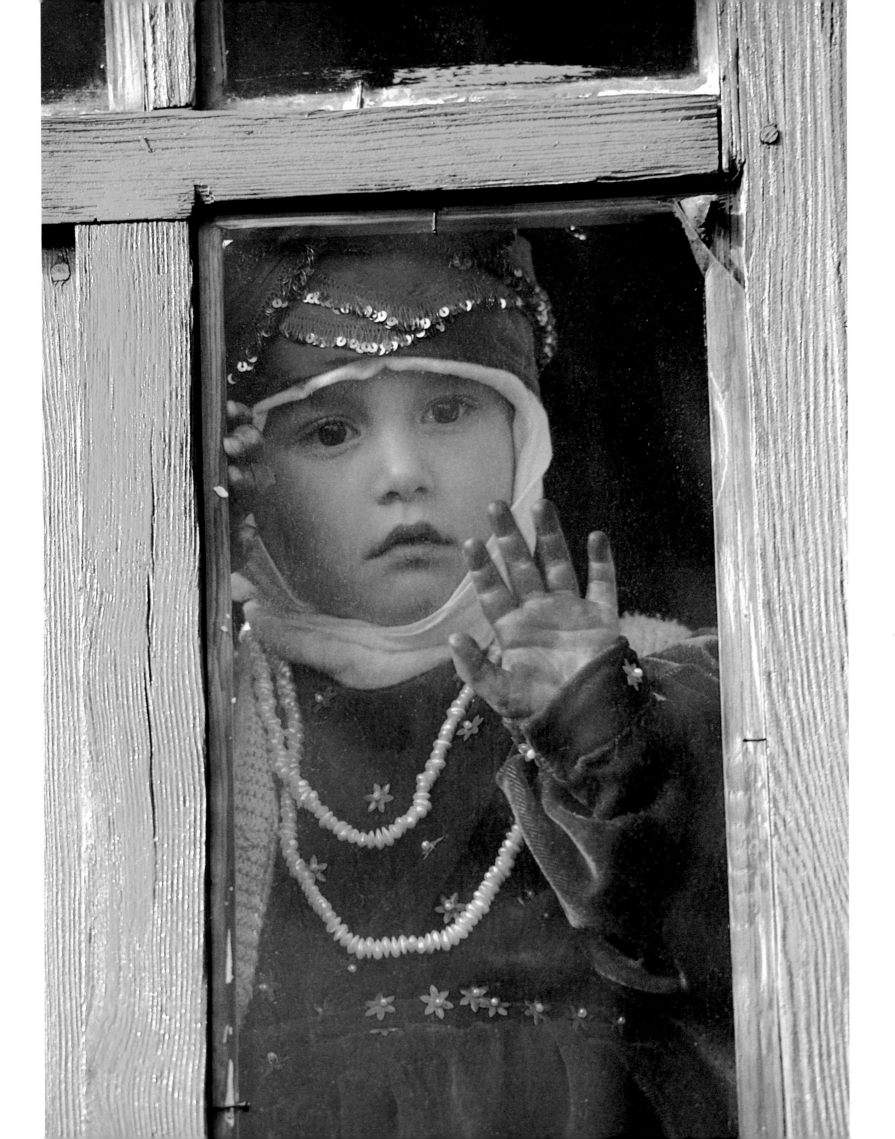

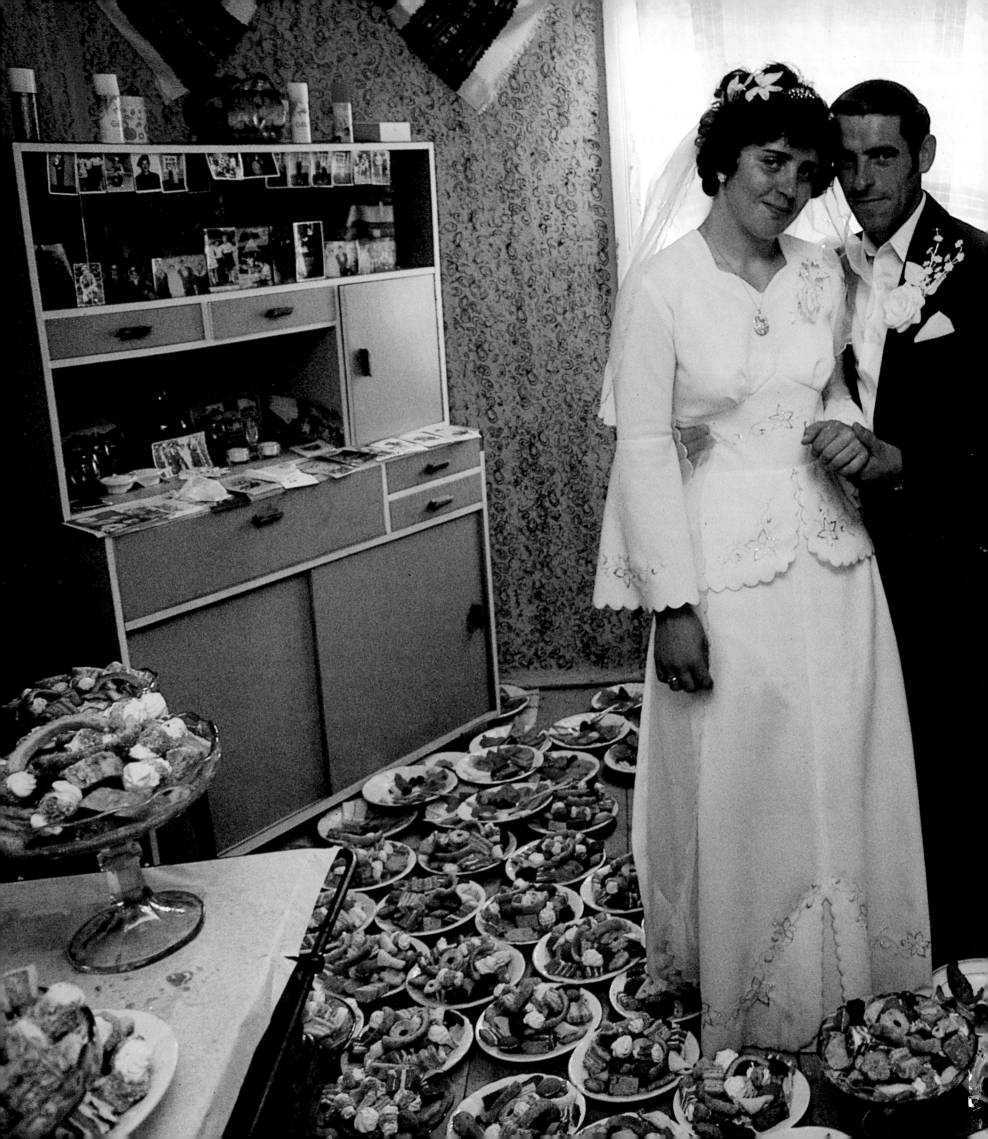

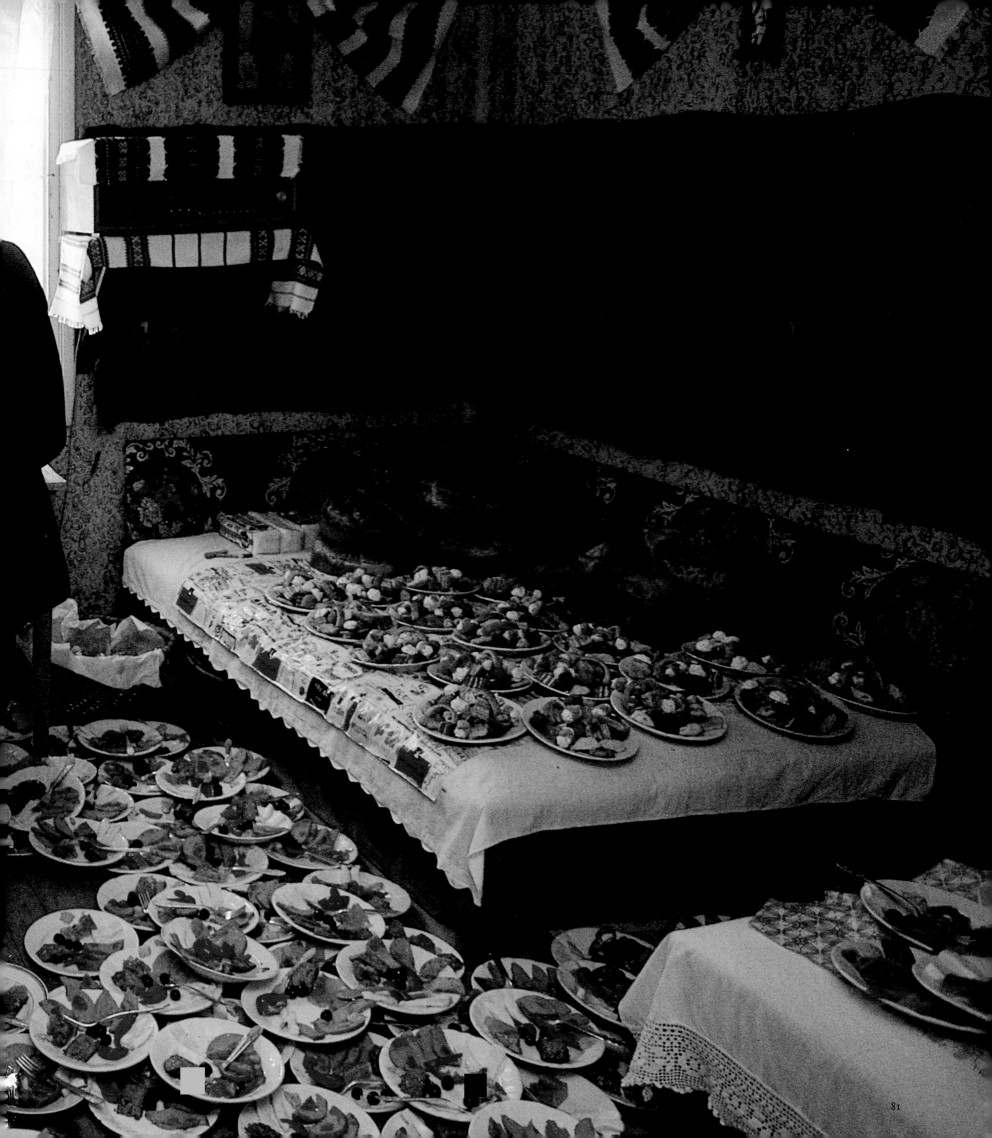

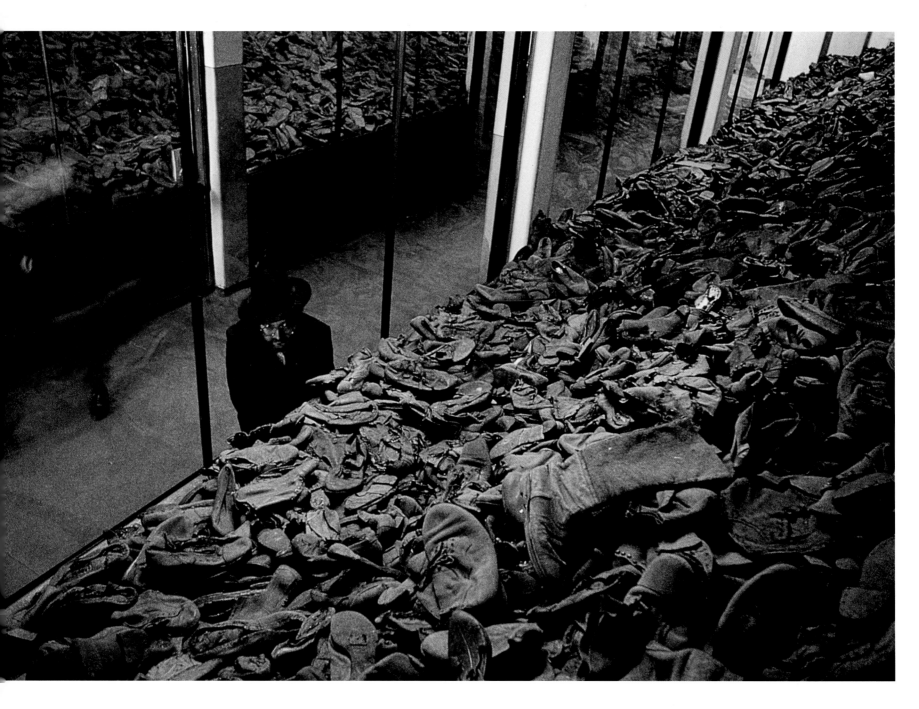

POLAND: THE HOPE THAT NEVER DIES
January 1988

I visited that sea of blue, black, and gray shoes four or five times before I had the picture of Auschwitz I felt it deserved. Relations between Israel and Poland had just eased, and I knew that a group of Hasidic Jews from Brooklyn was in Kraków. I didn't let them know what I was planning, but I found out when they were going to visit Auschwitz. I was allowed to place myself up among the shoes and photographed Rabbi Pinchas Goldberg as he contemplated this terrible symbol of the Holocaust.

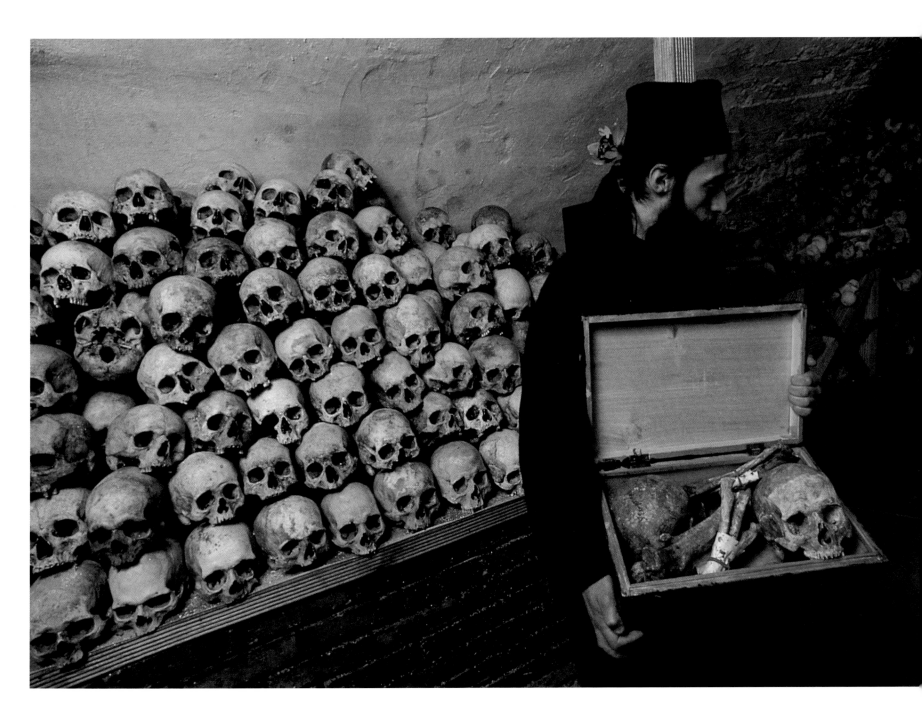

MOUNT ATHOS
December 1983

Revered bones of a former abbot, or Iguminos, are gently cradled in a special box carried by Father Macarius in the charnel house of Greece's Simonopetra Monastery. After three or four days here I was asked if I wanted to visit these catacombs, where many monks come to pray among the skulls of deceased brothers. Trekking steep trails that connect one monastery to another, I photographed 7 of the 20 Eastern Orthodox retreats in the Mount Athos region for a short picture story that accompanied our Byzantine Empire article.

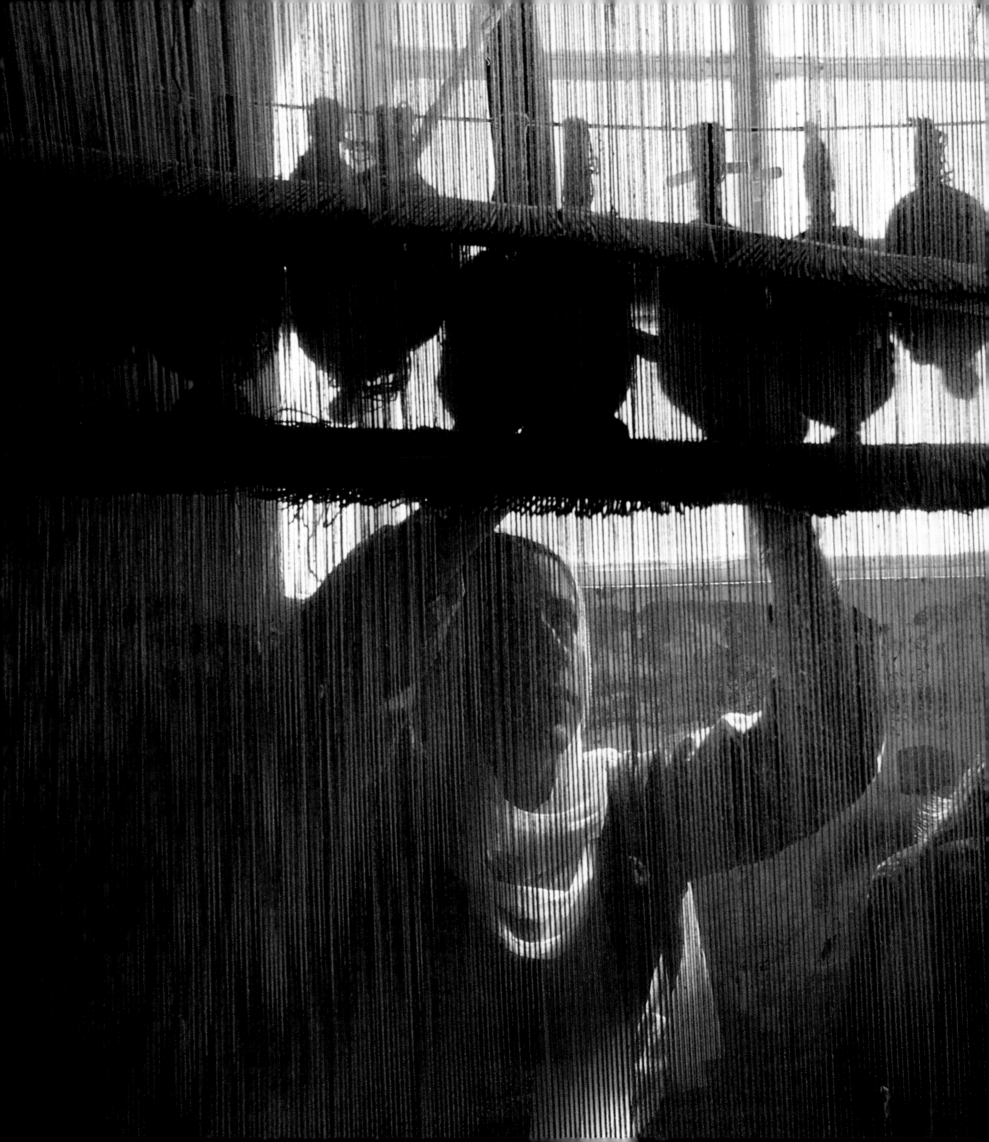

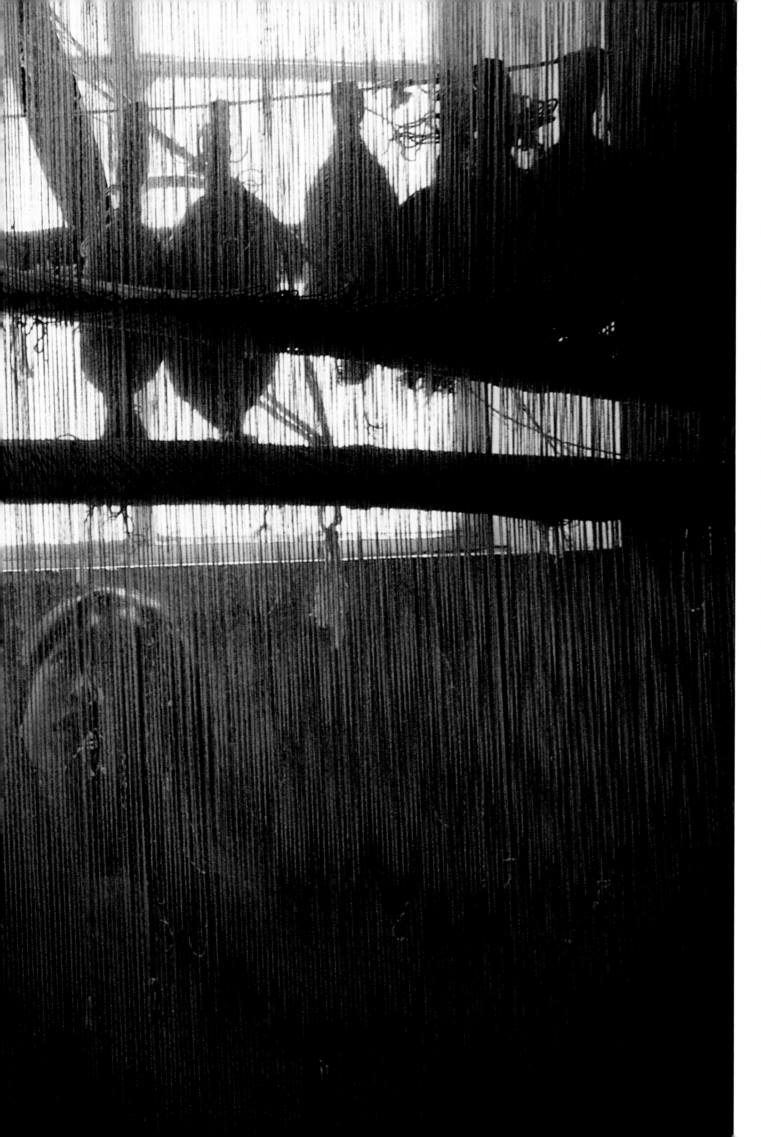

PAKISTAN
UNDER PRESSURE
May 1981

Nimble-fingered children tend the looms at a Pakistani government weaving cooperative. When Iran's carpet exports declined after the 1978 revolution, Pakistan hoped to fill the demand. There were probably 40 to 50 children working in the factory when I was there, most of them 11, 12, or 13 years old. It is always difficult to see child labor, although I know that the income they earn is usually desperately needed by their families. Of the numerous weaving photographs I have taken, this is my favorite: a fairly modern factory with the light coming through the threads and shining on their faces.

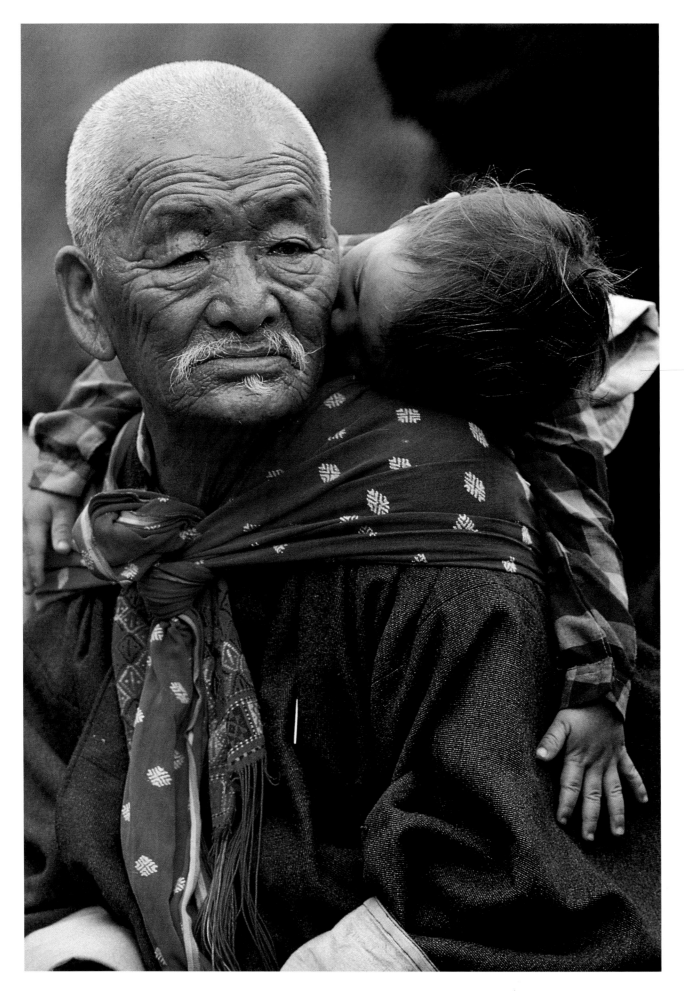

BHUTAN, KINGDOM
IN THE CLOUDS
May 1991

*The national sport of archery
earns the keen attention of a
grandfather in the Himalayan
kingdom of Bhutan. Although
this picture with his grandson
did not make the final article
selection, I liked it so much
that, when I returned some
months later, I brought a
selection of black-and-white
prints, but I could never
locate this gentleman.*

ROME OF THE EAST
December 1983

*Photographs like this don't
just happen. With the help of
two assistants I made three
exposures on a single piece of
film. Using a 400mm lens,
the first long exposure drew
in the magenta that remained
after sundown; the second
and third captured first one
monk's cell and then the
other, both lit by flash—
otherwise you could never
stop the action and get that
amount of clarity in the dark.
It's painting with light.*

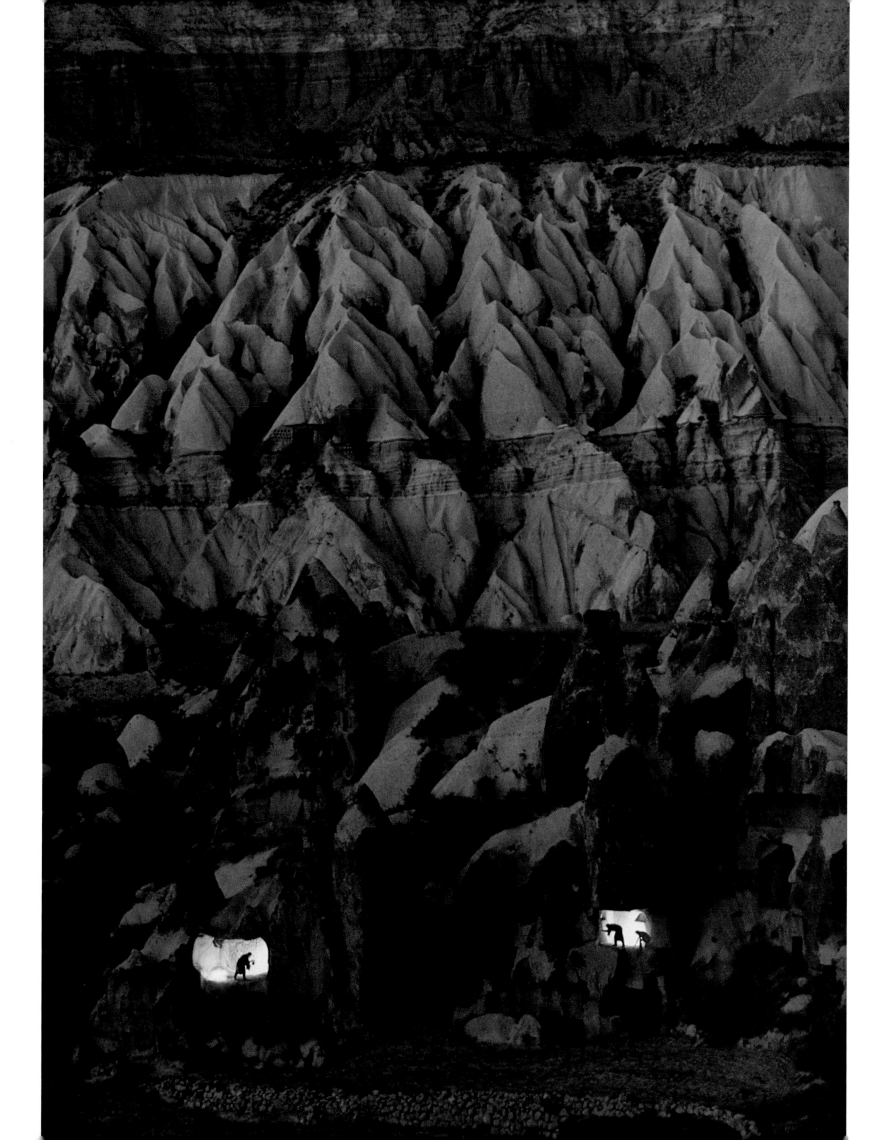

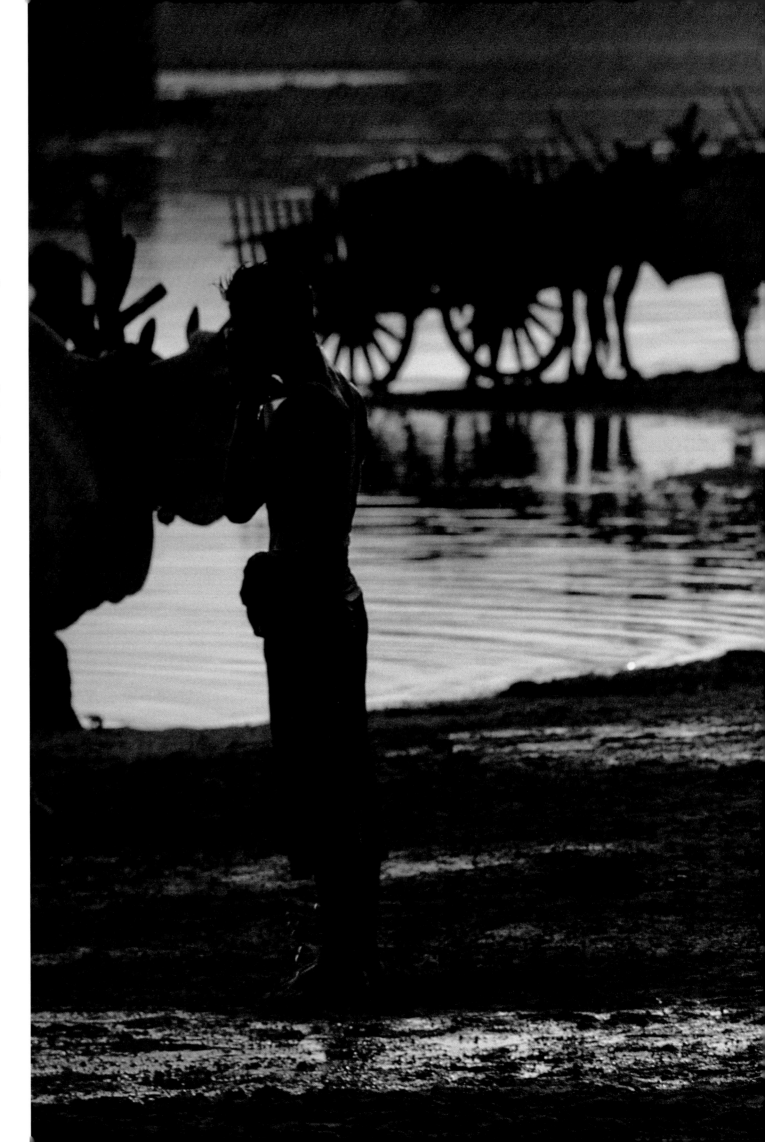

TIME AND AGAIN
IN BURMA
July 1984

Near Mandalay, in the village of Meiktila, I saw this young boy bathing by a river bank. I am always looking for faces, light, some kind of mood, something that will move the reader. Very seldom do they come together in one frame, but every once in a while you think, I have it this time. But the photograph must also tell an integral part of the story. Although this one was just beautiful, it did not appear in the magazine.

PAKISTAN
UNDER PRESSURE
May 1981

Following pages: After the 1979 Soviet invasion of Afghanistan, refugees were pouring across the border into Pakistan. This small bazaar is in Kohat. Rather than constantly raise and lower my camera, which I felt might attract attention, I walked through with it held to my face. Later the photograph sparked my memory, bringing back the smell of the spices and the cries of the water man.

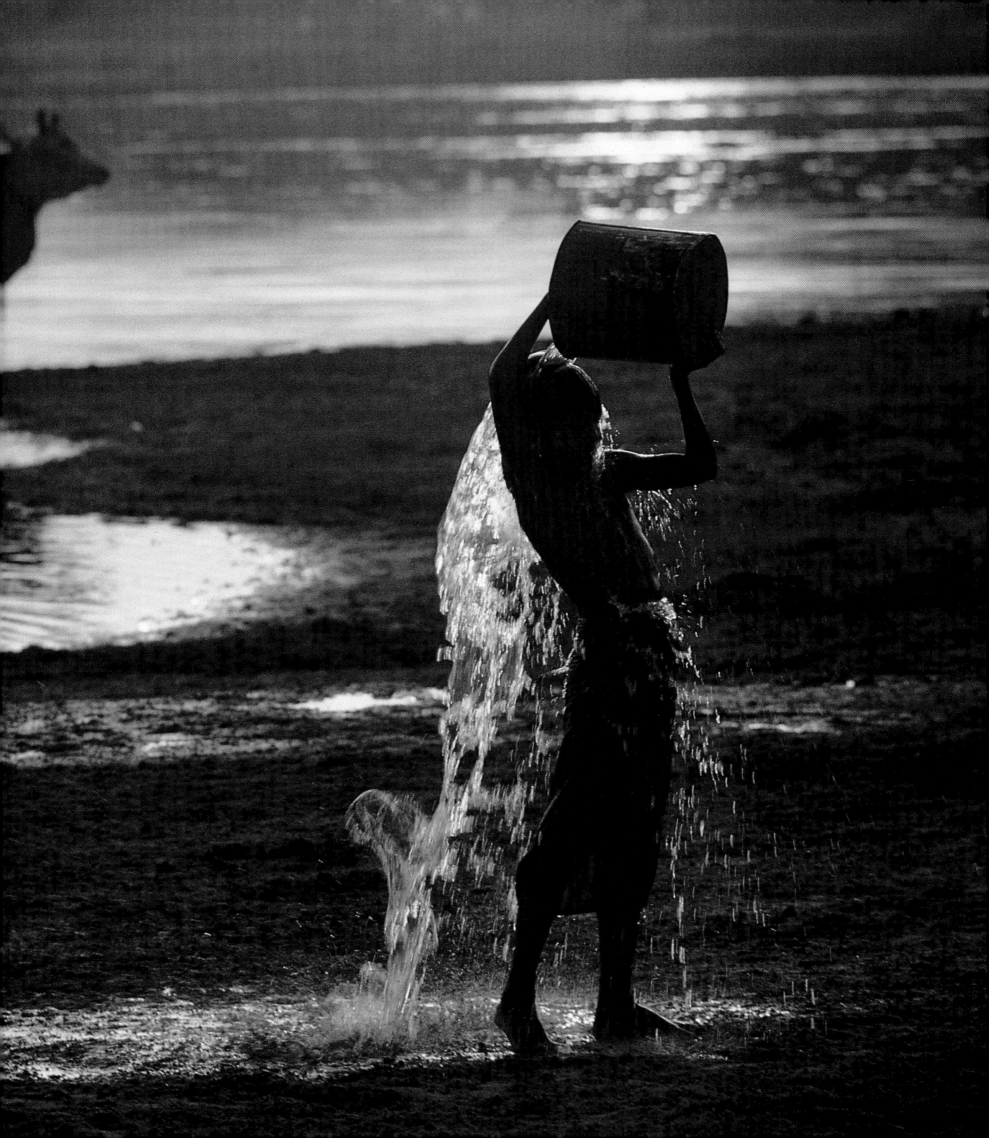

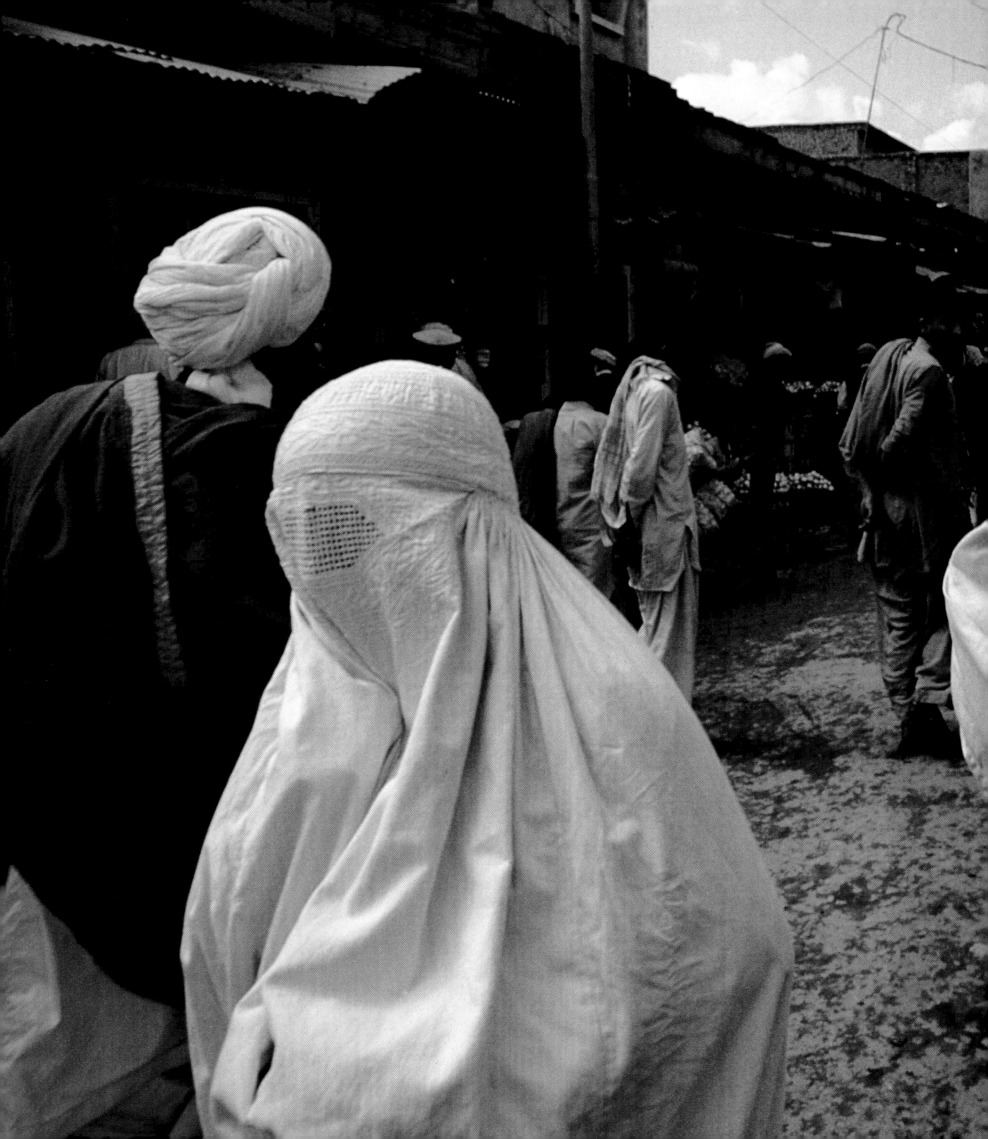

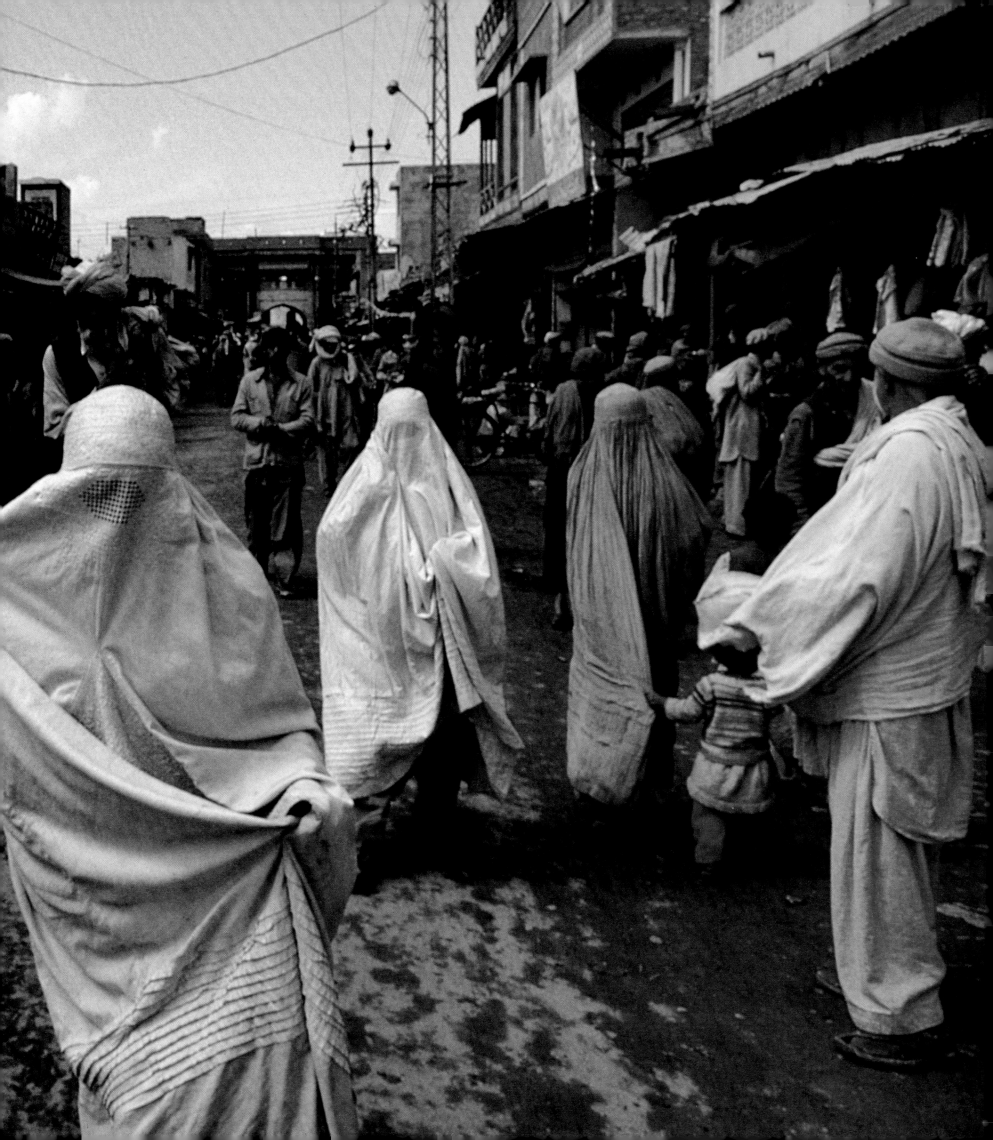

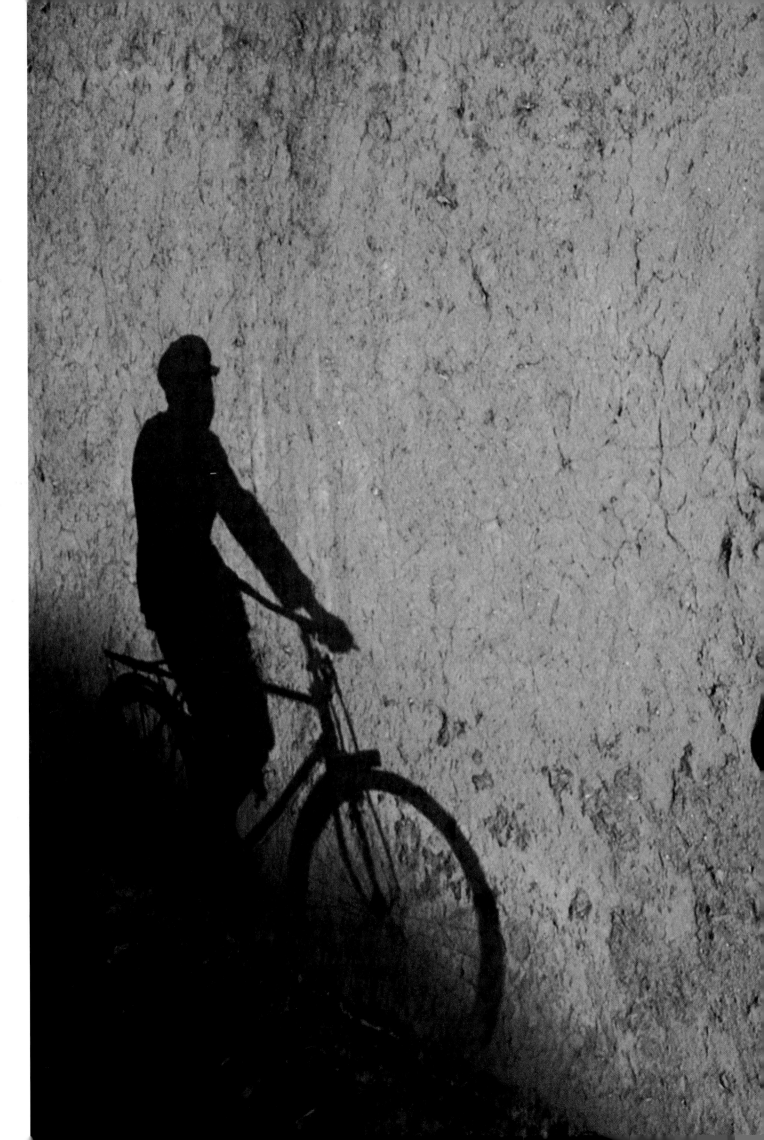

Journey Into China
1982

In the early 1980s officials in China were still suspicious of foreign journalists; they wanted nothing to go wrong. We thought we could quietly do a "day in the life of the Mongols" for our book on China, but the next thing we knew we were part of a convoy of 13 four-wheel-drive vehicles racing across the desert. In the village of Bayan Ovoo I followed this lovely woman from yurt to yurt, and then in the late afternoon I made this photograph of her where sun met shadow. Suddenly this guy on a bicycle rolls by and I have my moment—but it was unpublished.

Oman
May 1995

Following pages: Tuna, fresh off the boats, pile on the shore at Sur, Oman's chief fishing center. I went down to the shore three sunrises in a row to watch fishermen unload and auction off their catch. The attitude of the man in the background adjusting his loin cloth or wrap makes the picture.

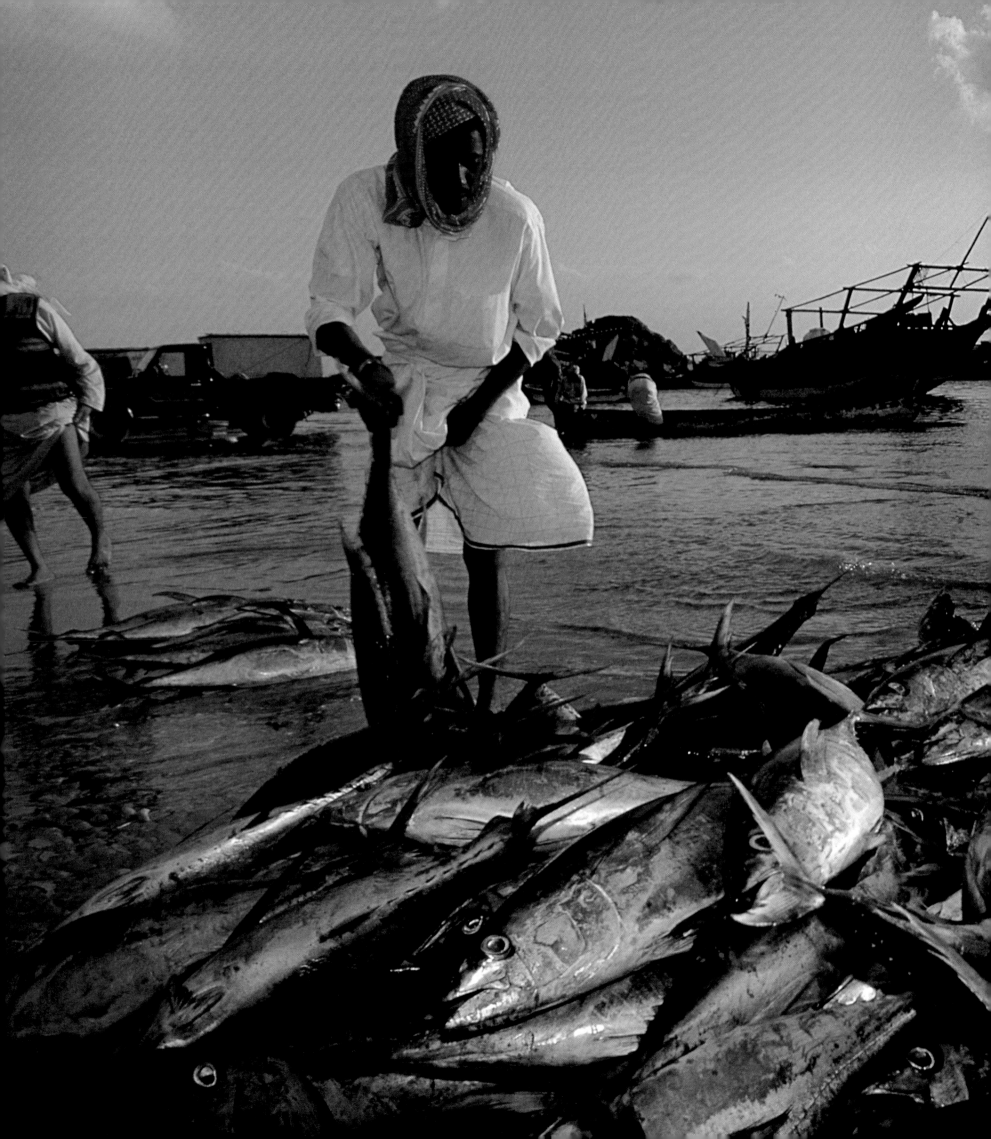

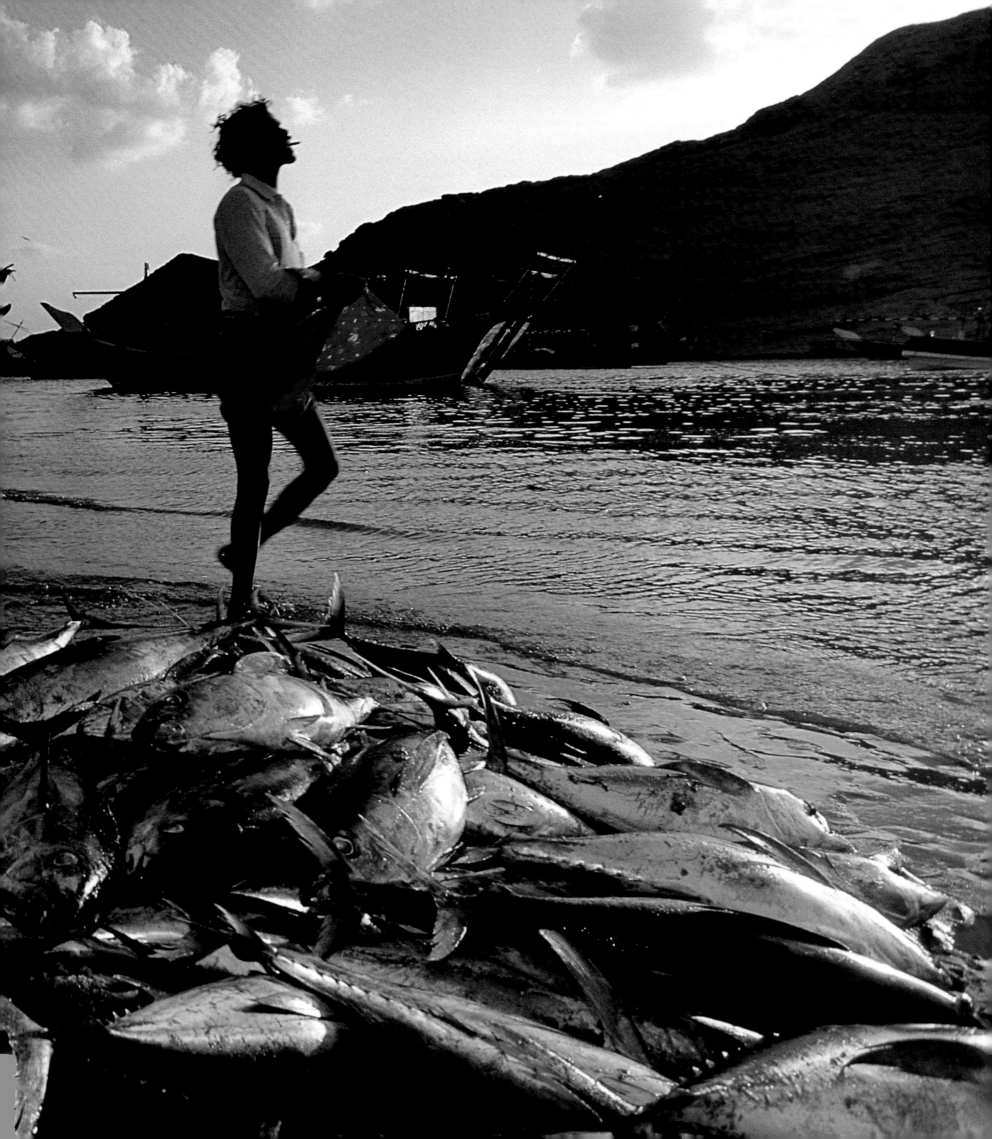

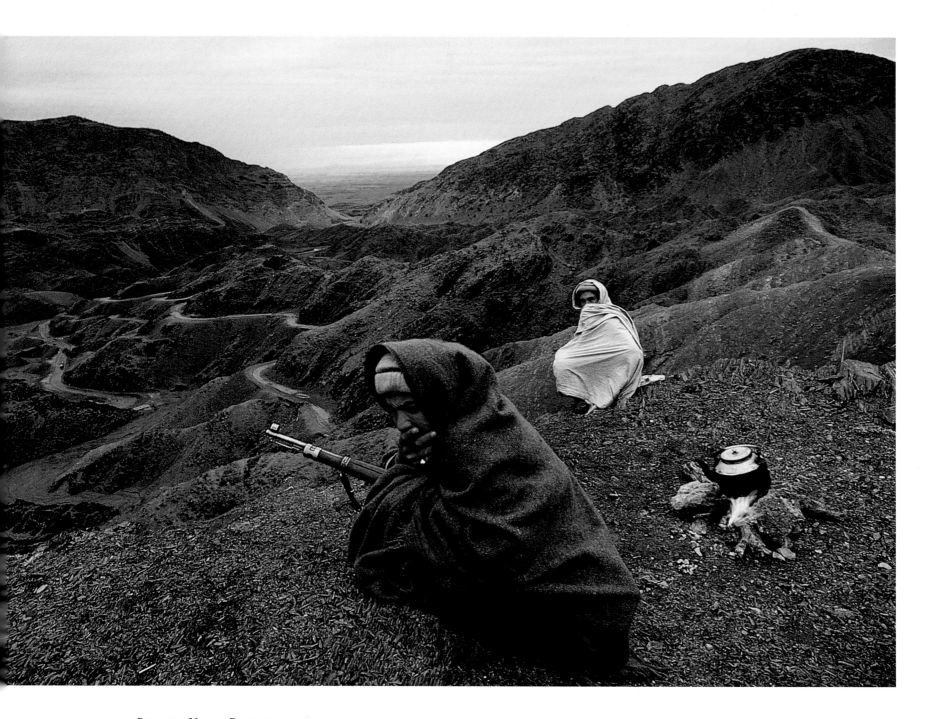

PAKISTAN UNDER PRESSURE
May 1981

In the chill atop the fabled Khyber Pass, Pathan tribesmen from Pakistan stay bundled up and keep a sharp eye on the roads—one for cars, one for camels. Here pass Afghan refugees, smugglers, and soldiers. You try to re-create the old sketches and atmosphere as best you can. You watch and you wait, and if you look hard enough you can find a vantage point that creates a little bit of mystery. Pakistanis are a very amiable people. I like their work ethic. If things aren't working for them, they will always find a remedy.

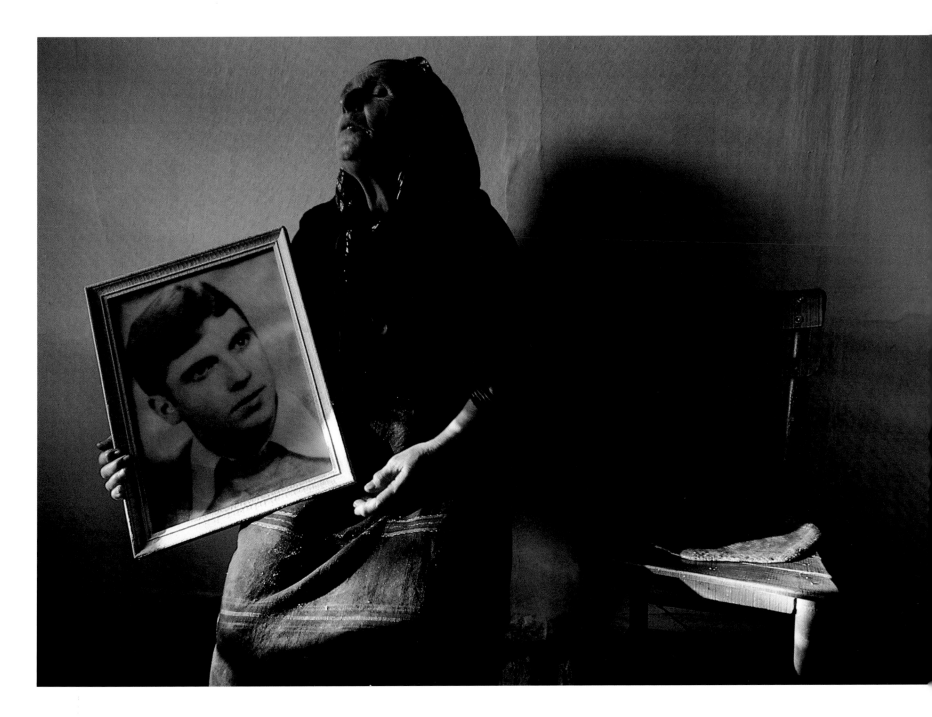

THE BULGARIANS
July 1980

It is the same the world over: Young people leave and go to the city, and the old-timers stay in the decaying village. In Bulgaria's Pirin Mountains we were invited to a house for feta cheese and wine. After a short while this woman went into her bedroom, grabbed this photograph, and told how her son had gone to the capital, Sofiya, where he became involved in a love triangle and within a year was murdered. I was honored by her trust and desperately wanted this photograph in the article, but it was not published.

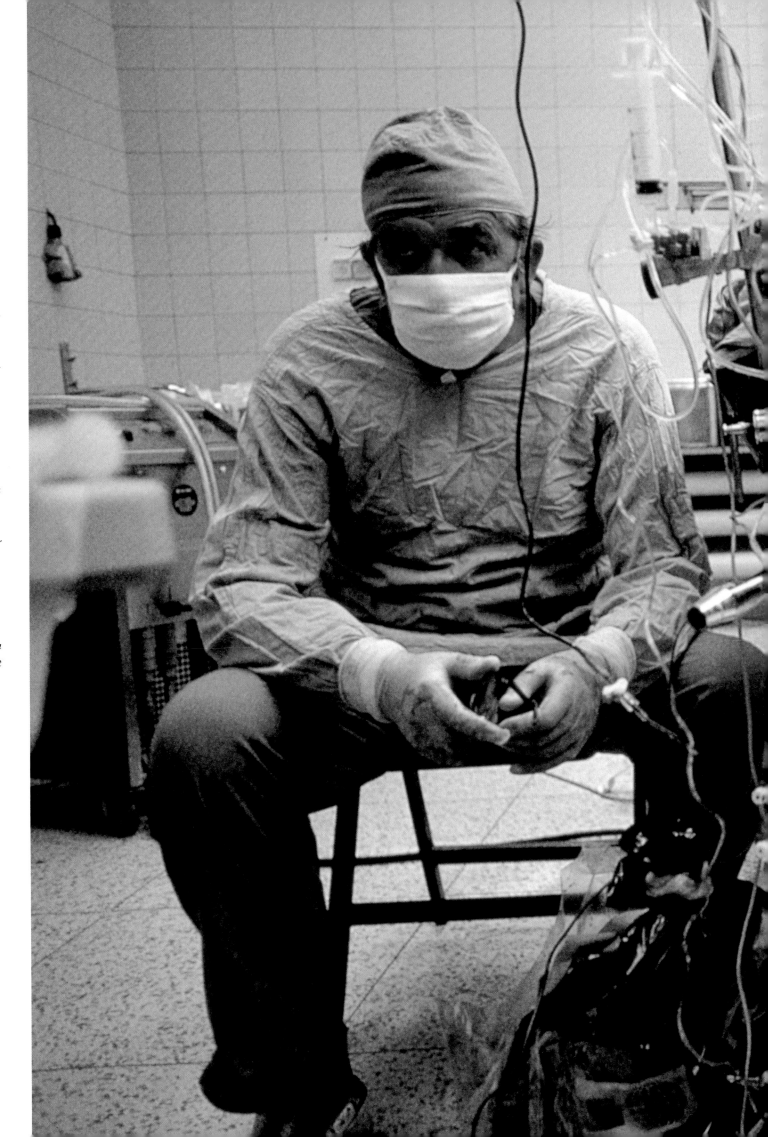

POLAND: THE HOPE
THAT NEVER DIES
January 1988

*When I heard about a self-
taught heart surgeon, I knew
that was the high-tech picture
I needed for the Poland
coverage. Dr. Zbigniew
Religa of Zabrze told me that
he had learned how to do a
transplant procedure by
reading the papers of Dr.
Norman E. Shumway, the
noted American heart
surgeon from Stanford,
whom I had photographed in
1969 for a story on San
Francisco. I was with Dr.
Religa at his cardiac clinic for
22 hours while he performed
two successful transplants. I
stayed with him to the end.
My interpreter wanted to
leave; members of his staff
lay crumpled with exhaustion
on the floor. As Dr. Religa sat
monitoring this patient, who
almost died, I saw the care
and the anxiety in his eyes. I
knew I had the memorable
picture I needed.*

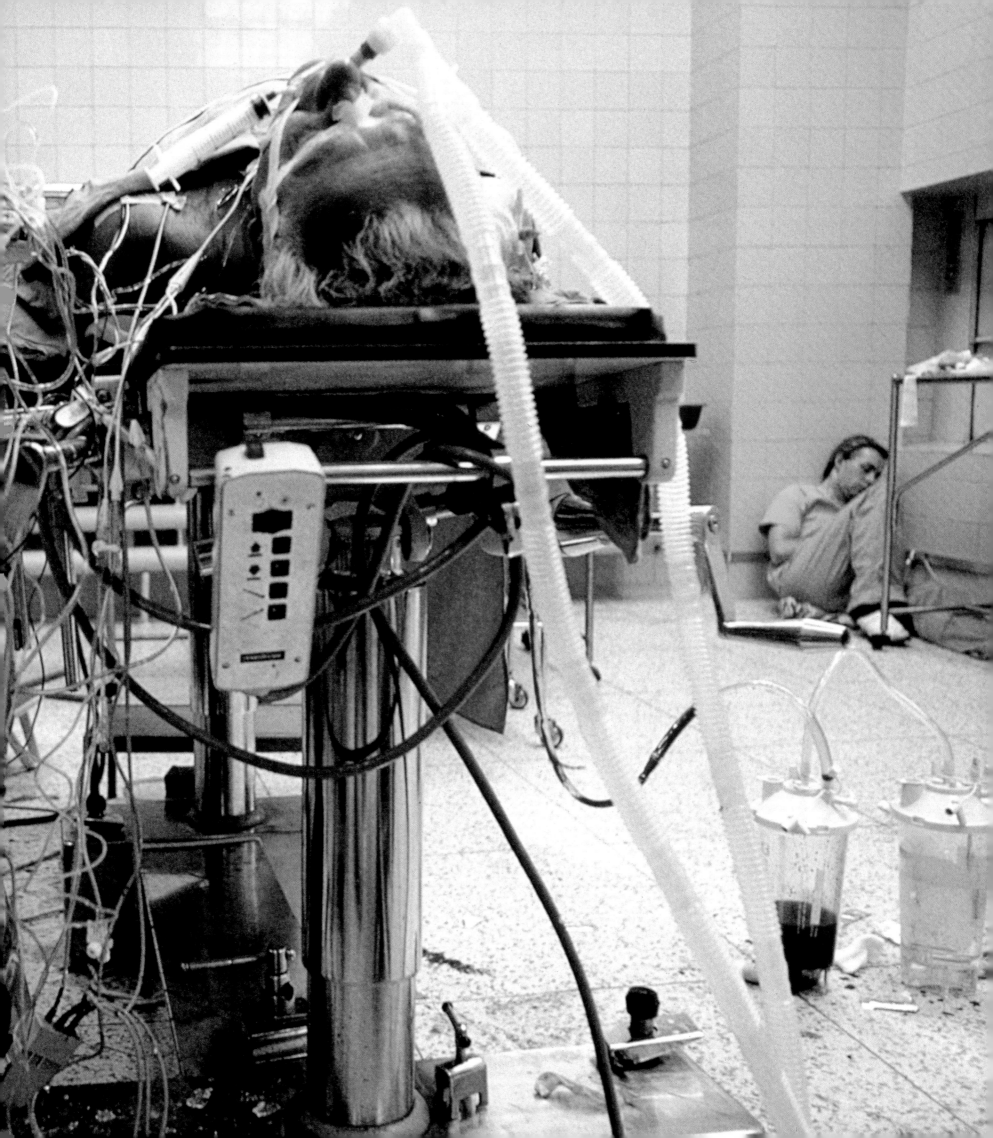

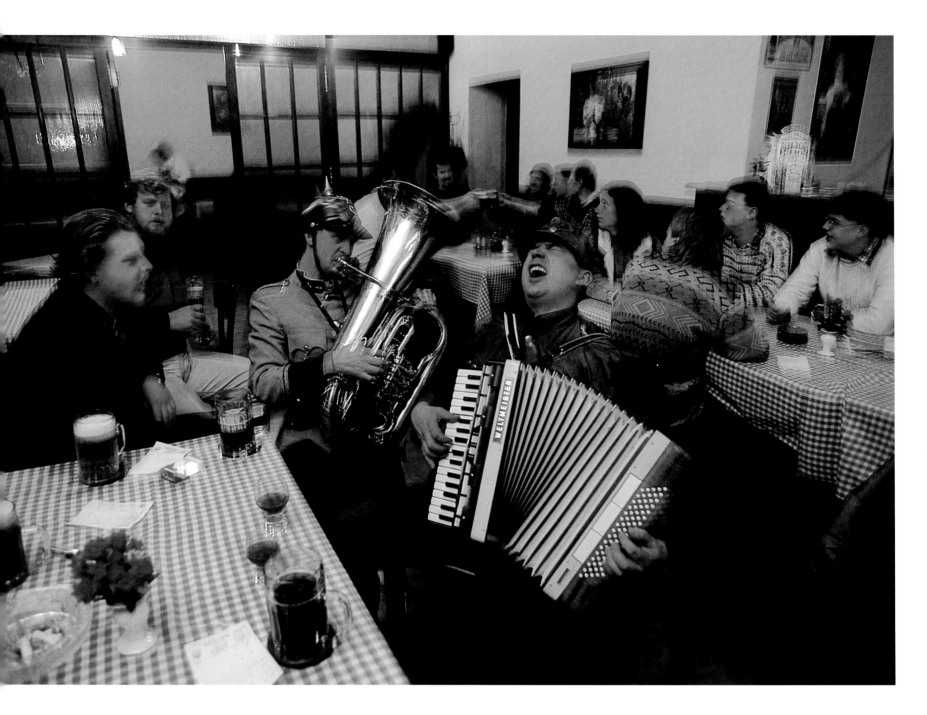

CZECHOSLOVAKIA: THE VELVET DIVORCE
September 1993

The embodiment of the fictional Good Soldier Schweik, this accordion player and his tuba-playing mate perform for handouts. Tom Abercrombie, author of our article on the division of the Czechs and the Slovaks, loved the story of Schweik, and I knew I had to find someone to personify the Czech antihero. This fellow patterns his entire program on Schweik, so I followed the two-man band from pub to pub and finally caught his exuberance in a pub in Prague. I still get Christmas cards from this guy.

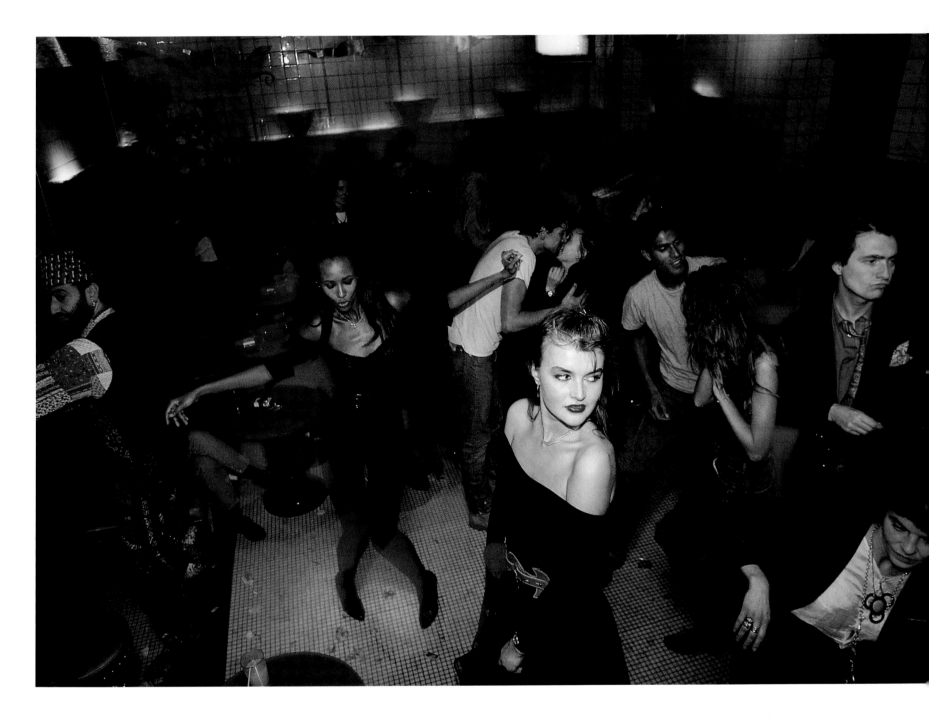

LETTERS FROM FRANCE
July 1989

The glitterati gathered at Les Bains in Paris at the invitation of fashion designer Christian Lacroix, who had reserved the famous nightclub for the entire evening. This is one of those magical photographs where many moving parts come together in one exact fraction of a second: the Somalian model Imam and the Soviet-born singer Iness dancing and the embracing couple in the background. Even when the club is open to the public, the doorman will turn you away if he doesn't like your looks.

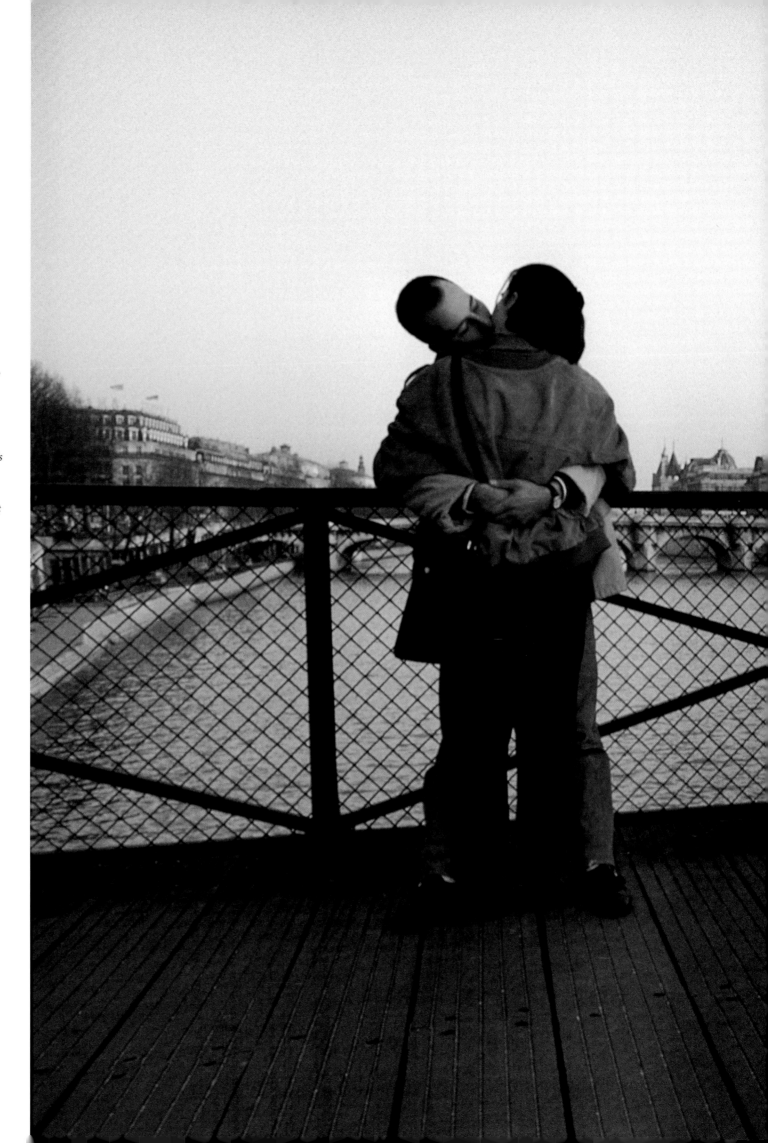

LETTERS FROM FRANCE
July 1989

When you walk the streets of Paris, there is always a picture around the corner or on a bridge. Here on the Ponts des Arts, near the Île de la Cité, people gather on weekends, selling jewelry, art, souvenirs, even offering a chance to be the Mona Lisa. I followed this chap carrying this faceless picture and watched him set up. When his girlfriend came along, they took time out for a kiss—an event of absolutely no interest to the two little girls.

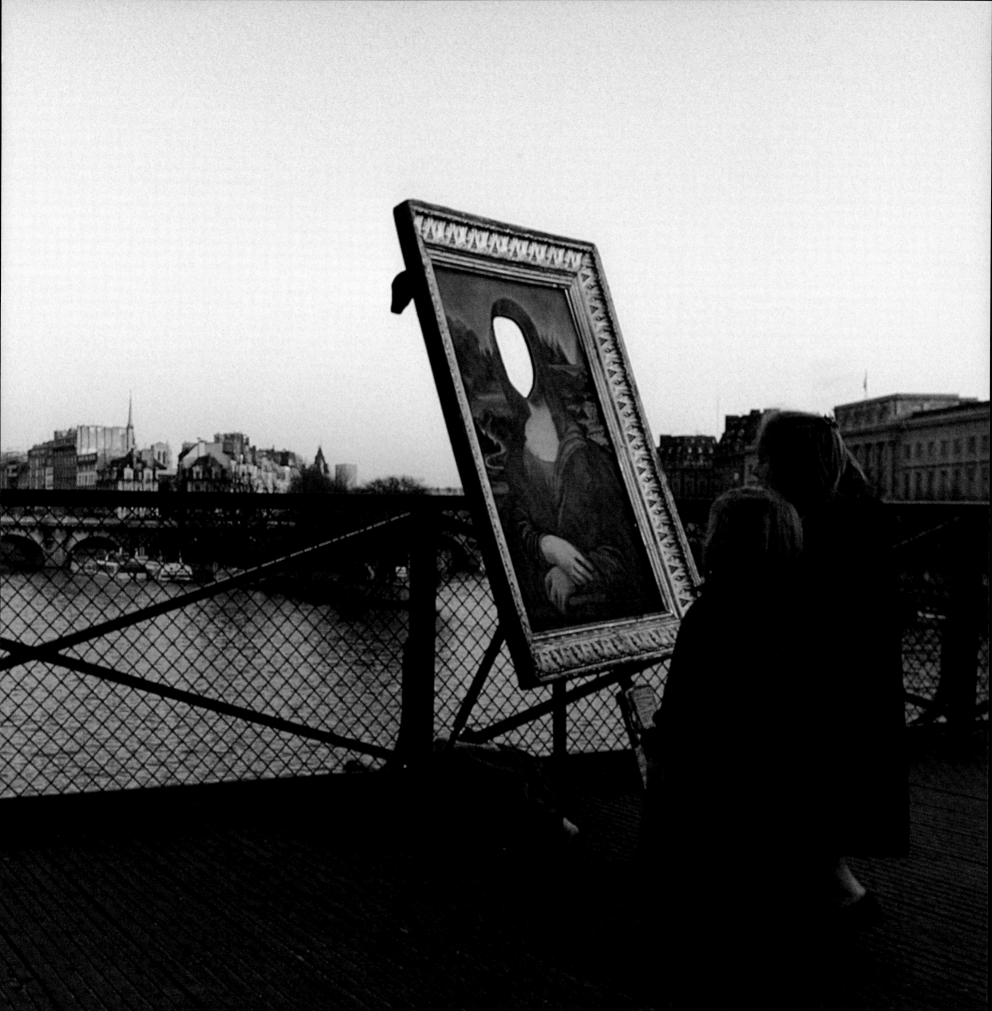

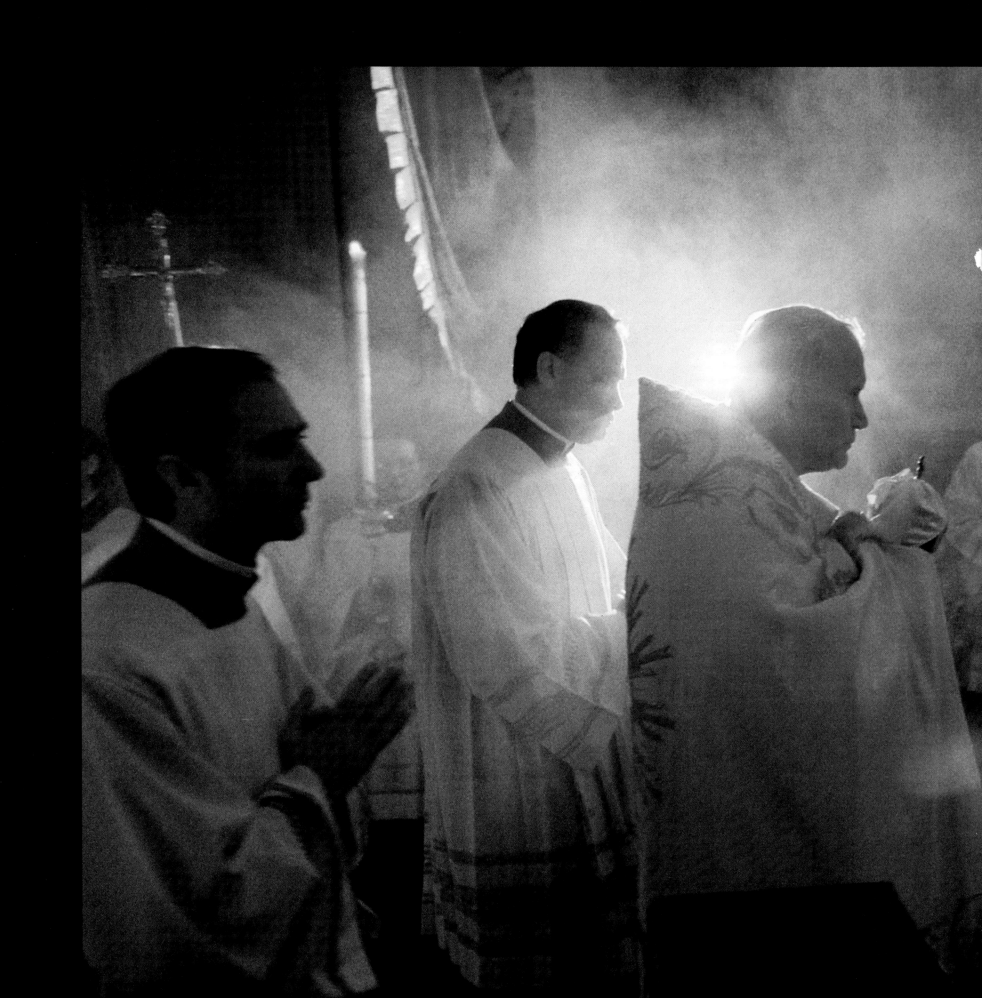

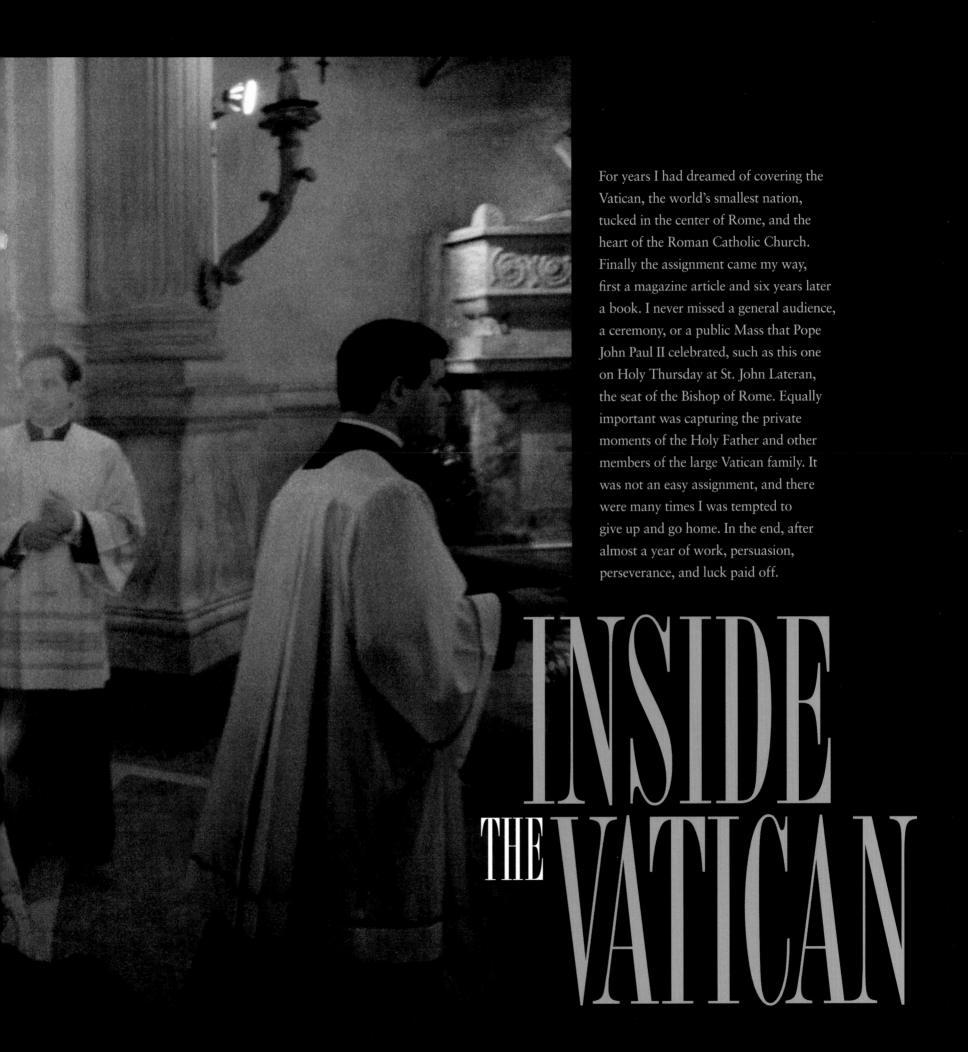

For years I had dreamed of covering the Vatican, the world's smallest nation, tucked in the center of Rome, and the heart of the Roman Catholic Church. Finally the assignment came my way, first a magazine article and six years later a book. I never missed a general audience, a ceremony, or a public Mass that Pope John Paul II celebrated, such as this one on Holy Thursday at St. John Lateran, the seat of the Bishop of Rome. Equally important was capturing the private moments of the Holy Father and other members of the large Vatican family. It was not an easy assignment, and there were many times I was tempted to give up and go home. In the end, after almost a year of work, persuasion, perseverance, and luck paid off.

INSIDE THE VATICAN

INSIDE THE VATICAN

"I hope you are patient, because that is what it will take," an adviser told me shortly after I began my coverage for the magazine's December 1985 story on Vatican City and our 1991 book *Inside the Vatican.* Those words couldn't have been more true.

My frustrations began when I realized that all of the high-speed film I shot in the first month of the assignment was blank. I had traveled to Rome from Israel and the airport x-rays had ruined the film. Fortunately a colleague soon brought me 800 new rolls and I began again.

I had looked at many books on the Vatican, and generally they covered the same rooms, statues, treasures.

Arturo Mari

I received a warm welcome from Pope John Paul II when I returned to the Vatican at the start of the 1990 Christmas season to begin coverage for the Society's book, Inside the Vatican. *It had been six years earlier when I photographed the Holy Father for the magazine as he delivered his Easter address in 56 languages from a balcony of St. Peter's. I took this picture and another of the multitude in the piazza by hurrying back and forth atop Bernini's colonnade.*

For almost six months—the time I had been given for the magazine assignment—I had photographed the museums, the altar boys, the Swiss Guards, weddings, audiences, everything that made up the personality of the Vatican. To remain as unobtrusive as possible, I carefully painted remote-control cameras to match the wall color and mounted them high in St. Peter's. The GEOGRAPHIC's master museum photographer, Victor Boswell, came from Washington with his impressive equipment and know-how to help me photograph the huge chambers of the Vatican Library, Sistine Chapel, and the Sala Regia, with their walls painted by old masters, as well as the gleaming marble "Pietà" and jewel-encrusted treasures. But I knew that was not enough. Editor Bill Garrett would insist on something different, more memorable. I didn't have the picture that was going to put this story over the top. I wasn't even close.

I realized if I was going to get an intimate portrait of the Holy Father in his daily life, I was going to have to try a different tactic. I had a good friend who was in the Swiss Guards. "Why don't you write a letter to the Holy Father and give it to me," he said. "It might be nice if you included some of the photographs you have made so that he gets some idea of the quality and also the direction you're going." I followed his advice and sent 25 photographs with a note to Monsignor Stanislaw Dziwisz, saying that I did not want to break the Holy Father's train of thought or his stride, I just wanted to record a day in his life. Within 36 hours I was standing in the Pauline Chapel when the Holy Father entered, dressed in the black vestments of a priest. Monsignor Dziwisz headed right for me and said, "The Holy Father and I think your photographs are splendid. Meet us at four o'clock at the helipad," and he turned and followed the Holy Father to Mass.

The Pope was leaving for Castel Gandolfo, his summer retreat, and here was my opportunity to capture his private moments. I was the first one at the helipad, hours ahead of anyone else. I didn't want to miss anything and I wasn't sure what was going to happen. All the altar boys, some of the nuns, and members of the curia were there to say good-bye. The Holy Father shook hands with this entourage and then with the firemen who were standing by. I found myself between the Holy Father and the helicopter and began walking backward. I was watching through the viewfinder, not with the naked eye. All of a sudden I see this hand being extended to me. When I looked up he said, "Mr. Stanfield, so you're the one who's trying to do things differently around here. Well, God bless you." And he gave me a knowing smile.

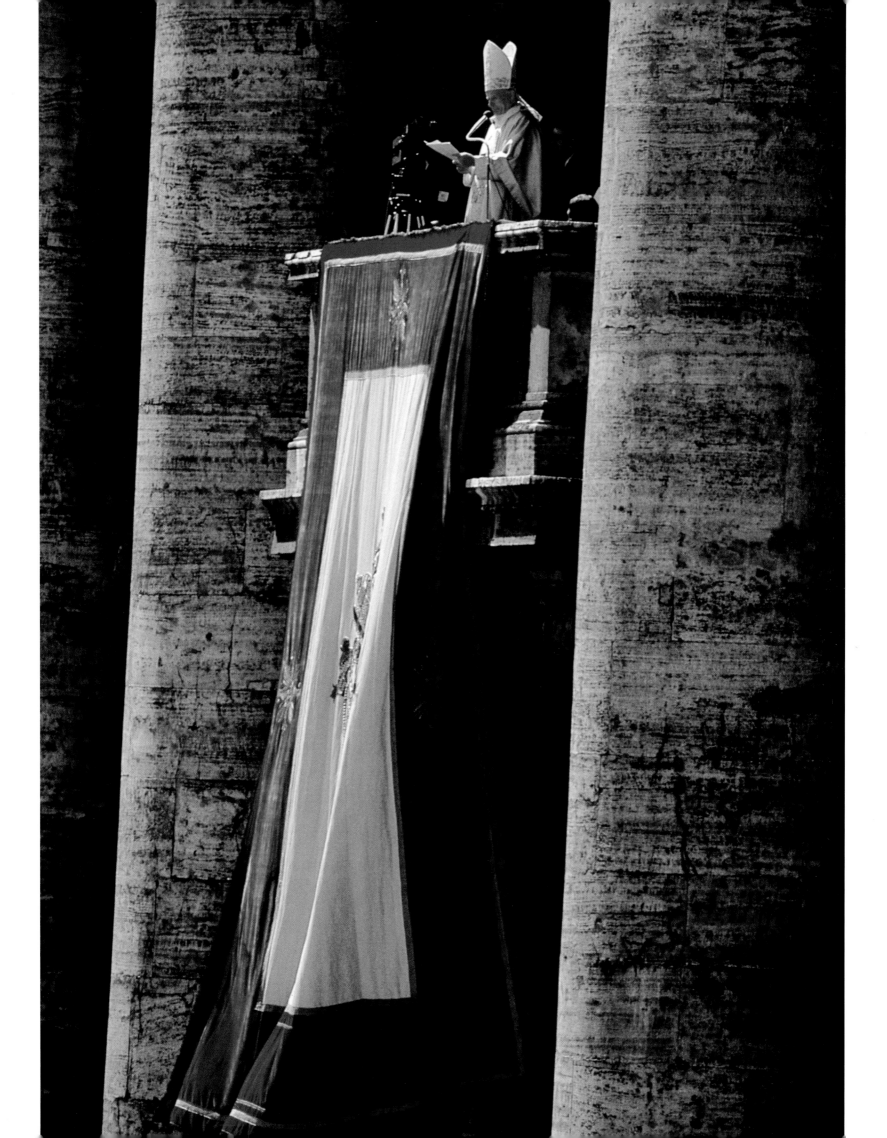

There is no doubt of the faith of this woman in St. Peter's Square, bringing her crucifix to be blessed by the Pope at Christmastime. I constantly walked through the crowds that would gather here whenever the Holy Father would appear, or I would come in the afternoon after the Vatican closed. There would be kids playing with the pigeons, groups of nuns strolling by, tourists with their cameras. I shot many photographs here, but this one that I took for the book captured a special mood.

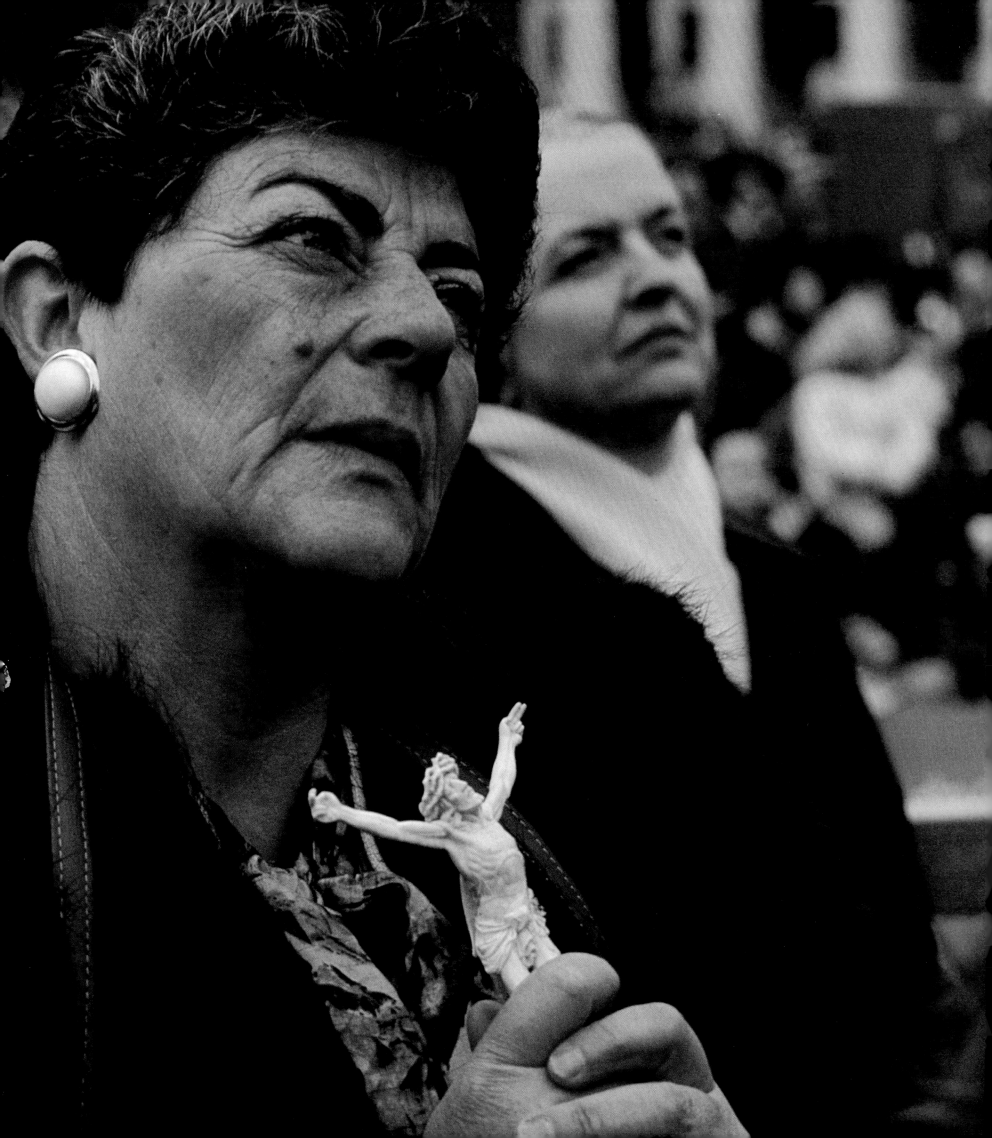

INSIDE THE VATICAN

I returned time and time again to the statue of St. Peter, believed to have been created by the 13th-century sculptor Arnolfo di Cambio. I must have photographed it 40 times for the magazine and the book. The light coming through the window into the basilica only strikes in this manner in winter, and then only for about 15 minutes around two in the afternoon. Then, one day, at just the right moment, this nun came to kiss the foot of the first bishop of Rome, the bronze worn smooth by the lips of countless others before her.

As usual, traveling with the Holy Father was Arturo Mari, his private photographer and also a good friend of mine. He had taken me under his wing so I would be in the right place at the right time. He knows the Holy Father so well and never misses a breath. I had studied this guy and how he worked, for I always seemed to be in the wrong place at the important moment. He always made the smallest silhouette possible with his arms at his side and his feet tight together. He would pop out, make a photograph, pop in, and you didn't even see him.

After the helicopter arrived at Castel Gandolfo, we drove down a road and stopped at a dirt path with steps carved into a hill. Arturo Mari pushed me ahead and said, "Get close, make this picture. I've done this before." I followed the Holy Father up this rustic stairway through the hedgerow, and there was the Garden of Our Lady. He went to the shrine of the Virgin Mary and knelt before the statue for maybe five minutes. I really didn't know which way he was going to turn when he did get up, but for once I picked the right way. He came right toward me. It was just a split second, a tilt to his head and his arms, the attitude of the entire photograph was kind of magic. You know when you captured the moment. I flew back to Washington the next day.

Six years later I returned to work on the book *Inside the Vatican*. I had kept in touch with the staff members in the communications office who had helped me, with Mosignor Dziwisz and others close to the Holy Father. Now there were occasions when being recognized was something of a hindrance. I remember when I was allowed to photograph the Pope delivering the Angelus. They invited me to come at quarter of twelve; I came at ten after eleven. I had never been in the Pope's study. I didn't know the light, I didn't know anything. They made me sit in an anteroom, and pretty soon the big clock in the Vatican struck one, struck two. They allowed me to enter and they pointed, "He is going to deliver the Angelus out that window." The Pope came from his bedroom and said, "Mr. Stanfield, how are things?" I couldn't start blazing away with my Nikons or even study the room for a vantage point. Then at the eleventh stroke he turned to the window and I had only a moment to locate a chair to stand on, remove my shoes, and create a publishable picture. It appears at the end of the book, just before the picture of the Holy Father in the garden at Castel Gandolfo.

Another picture that appears in the book was, I believe, the first of its kind: a photograph of John Paul II arriving from the papal palace via his private elevator to say Christmas Mass in St. Peter's. I made my first attempt on Christmas Eve. When the flash went off, I saw him blink and that was my only frame. So I asked permission to do it again, which is usually the kiss of death. But they agreed to let me try Christmas morning. Actually, it was better because there was more light coming through the stained glass windows. That time I kept watching and I knew when he turned toward the main light that we had the picture.

There were only two requests that were refused. One, to photograph the Holy Father at work in his bedroom late in the evening, the other to spend the day with four Polish nuns who had come with the Pope from Kraków. No matter what influence I brought to bear, the nuns turned me down. They said they did not want to be in the spotlight.

When I was working on the Vatican projects, I often remembered a time early in my career. My parents were not particularly religious, but we did go to church a lot after I was nearly killed in a serious car-bike accident when I was eight years old. The first time I left home was to go into the Army, and I was naturally lonely and needed something to grab on to. I remember praying, even though I'm not a praying kind of guy. But over the years, I've asked for one blessing pertaining to the job—for help in making the pictures the Lord wanted the world to see. I hope I've done a little of that.

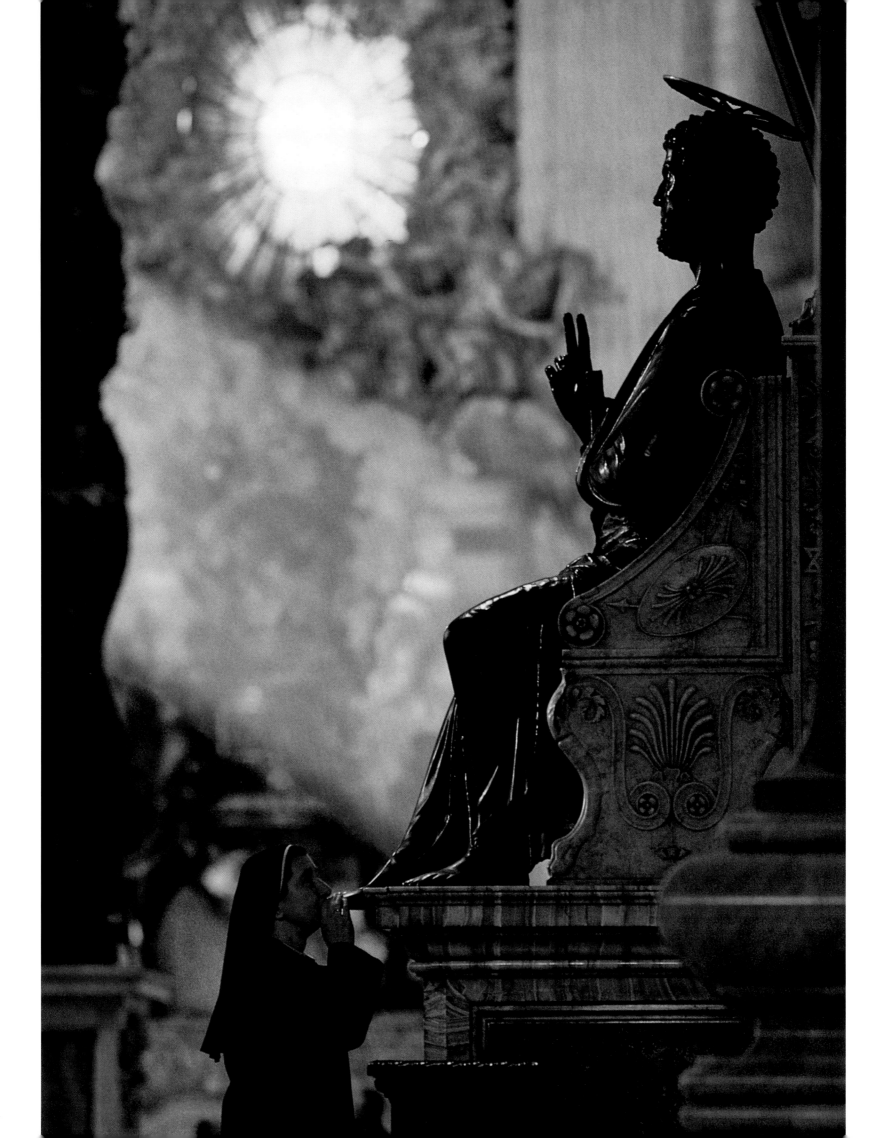

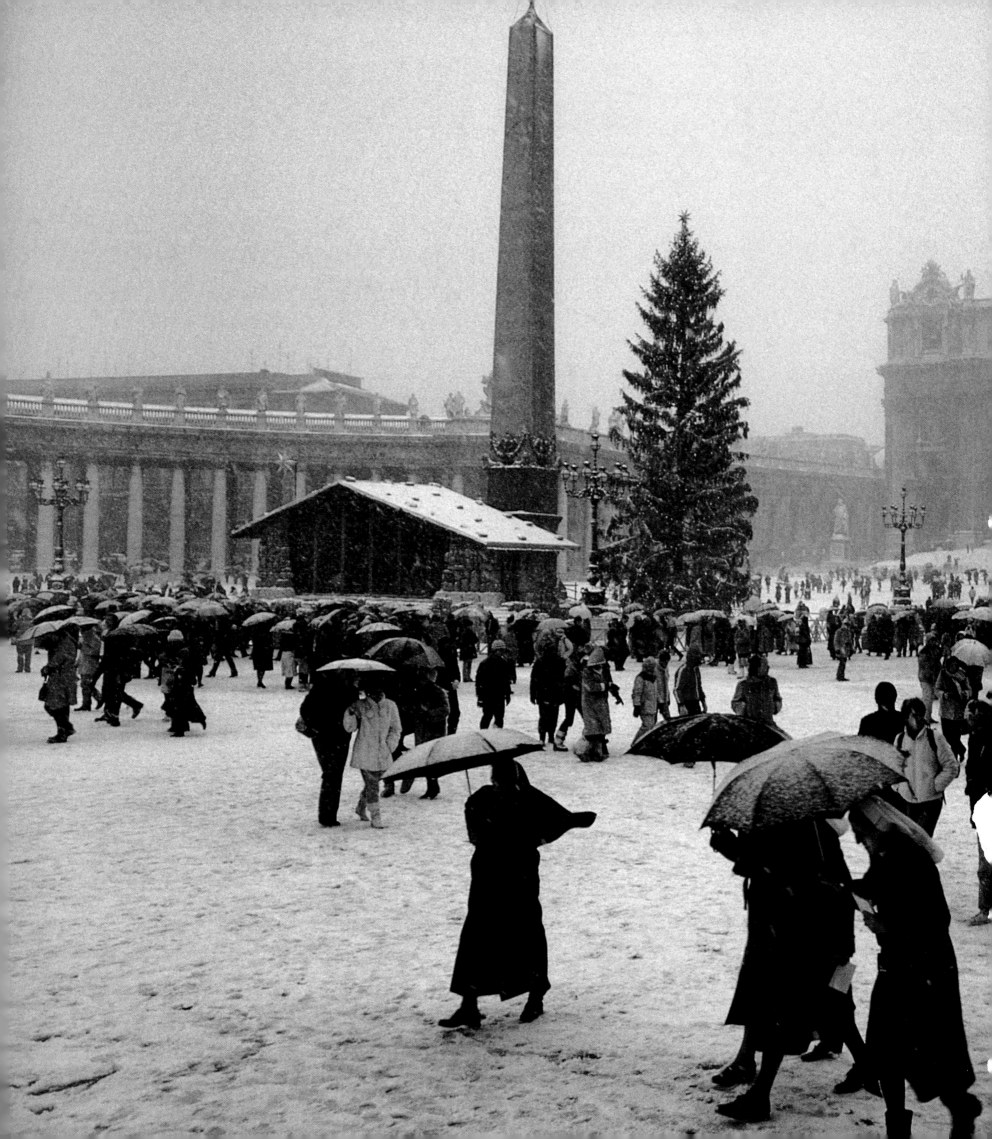

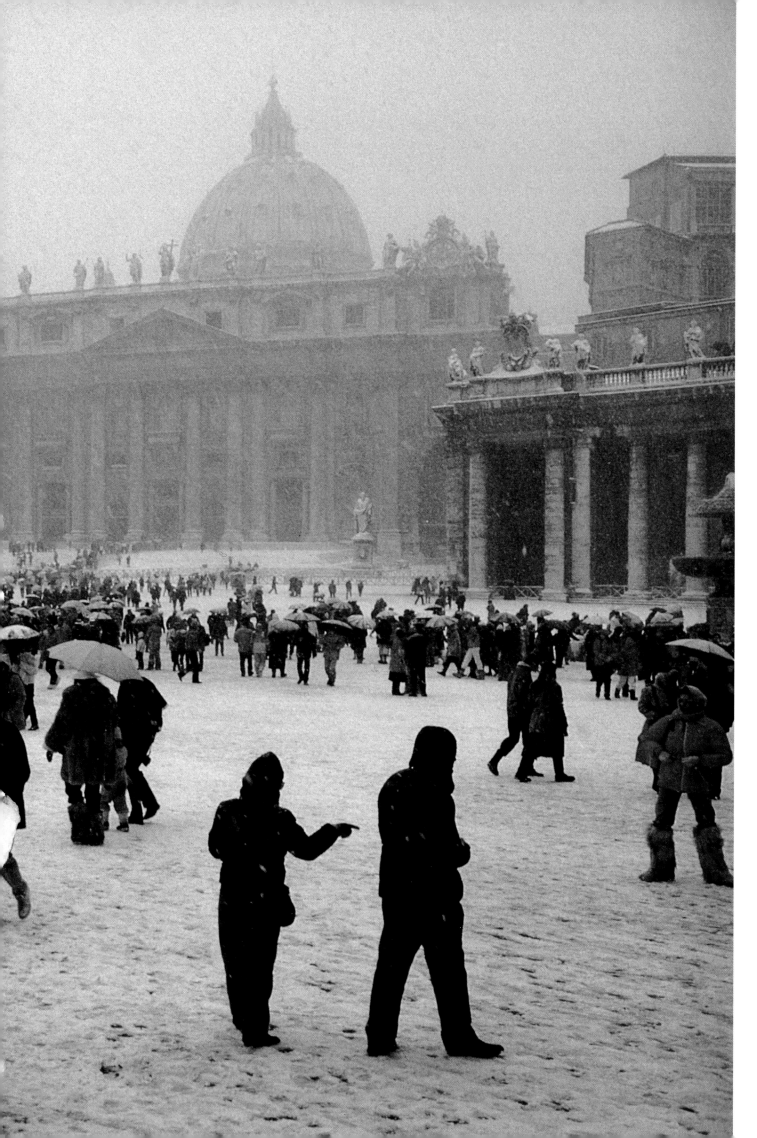

A rare snowfall dusts St. Peter's Square on January 6, 1985. It is Epiphany, the feast day that celebrates the coming of the Magi to visit the Christ child. A Christmas tree and nativity scene have been placed near the Egyptian obelisk that rises from the piazza. This was also the day when the bishops were being ordained within the basilica. I kept running back and forth, carrying my camera and a 600mm lens. This photograph appeared in both the magazine article and the book.

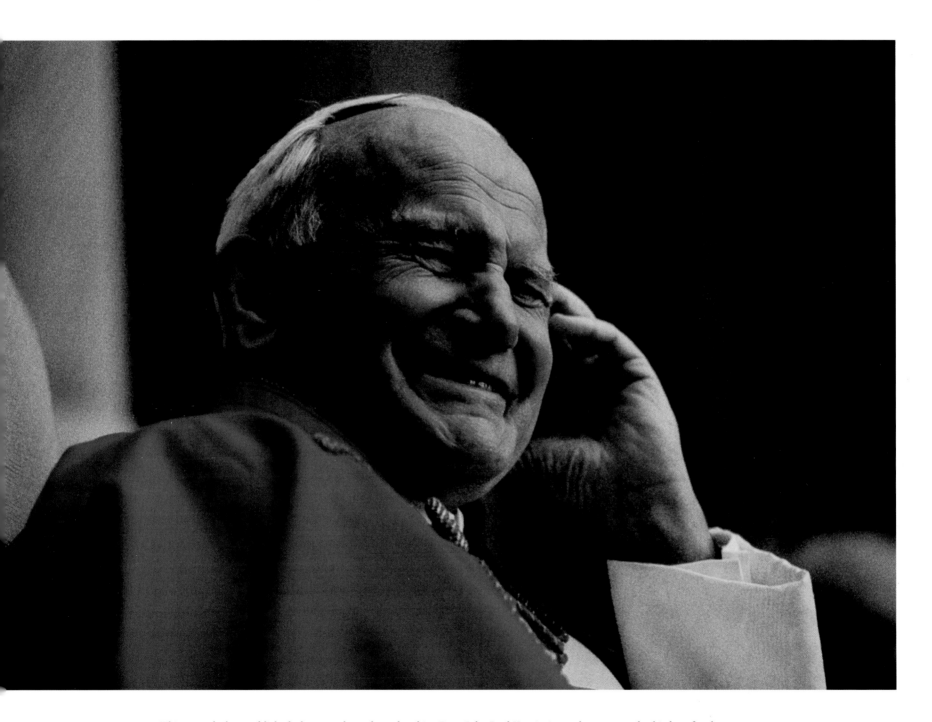

This never-before-published photograph catches a laughing Pope John Paul II enjoying a show put on for his benefit after the many events that tax his strength during Easter week. I was looking through the camera and had no idea what was going on behind me, but I do know there was a lot of whipped cream flying around. I had been told that the Holy Father loved slapstick, and this proved it.

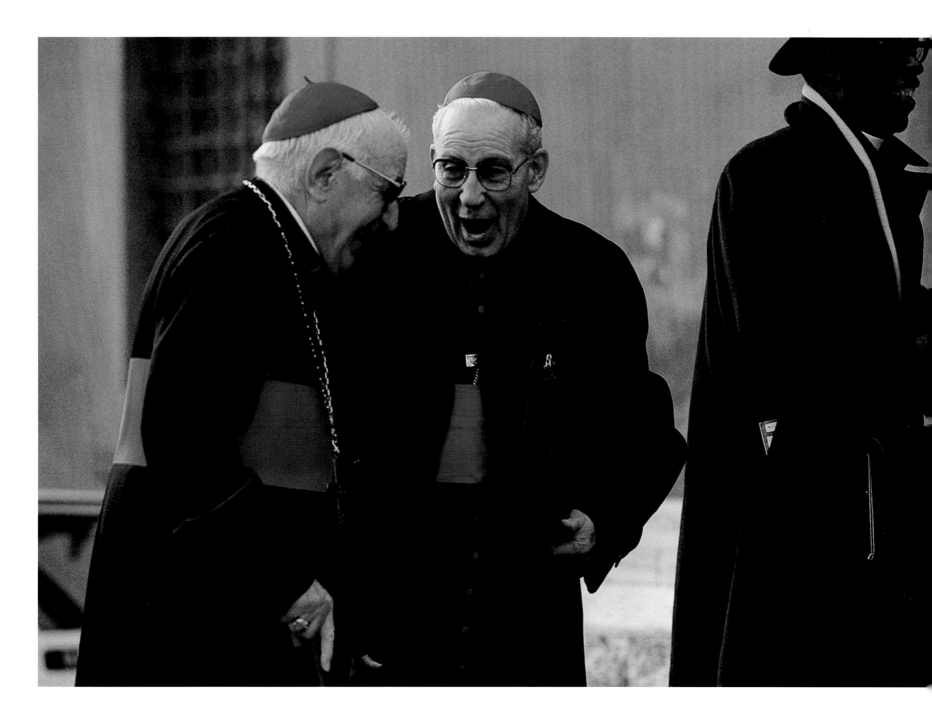

This delightful, lighthearted moment appears in the Society's Vatican book. The two cardinals are on their way to a consistory, an assembly of advisors to the Pope, held in the Synod Hall. I never found out what the joke was, but while I was shooting six or seven frames, they never stopped laughing. The consistory took place just a month after the cardinals had met with the Pope on the Middle East crisis of 1991.

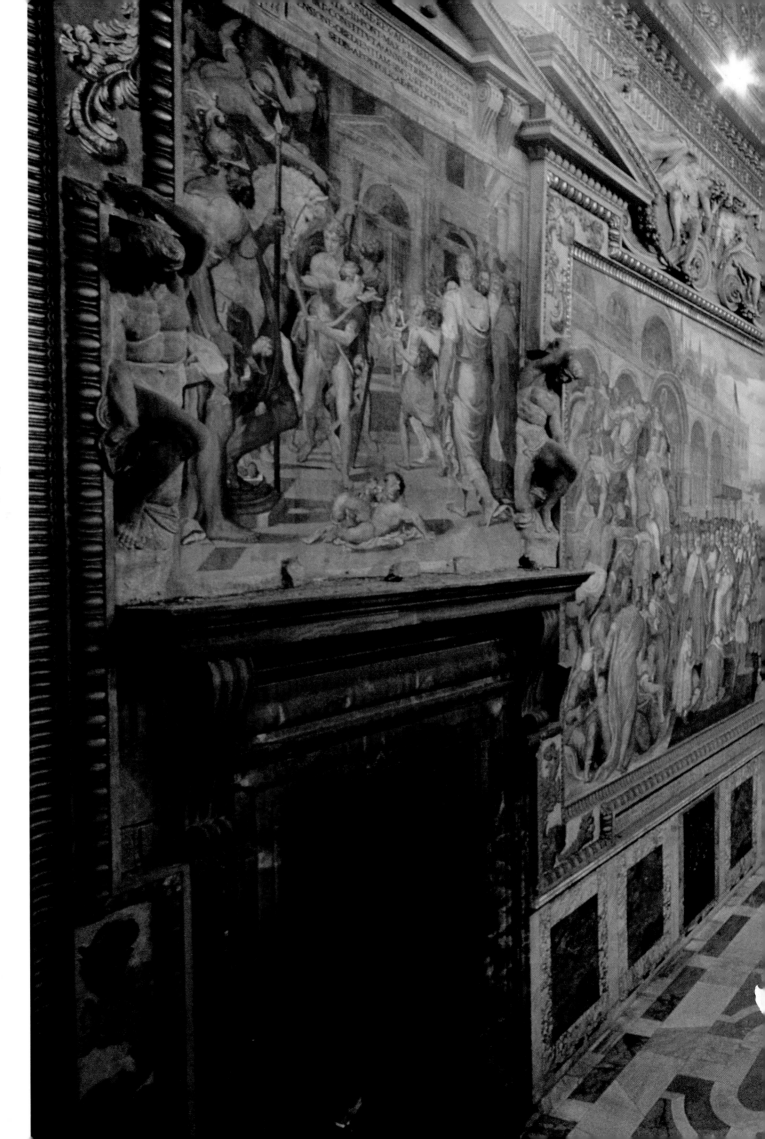

Crossroads of the Vatican, the Sala Regia glows with the frescoes of Giorgio Vasari and other artists of the Renaissance. The door to the right leads to the Sistine Chapel with its glorious ceiling, the door at the rear to the Pauline Chapel where private papal masses are said, and the door to the left to St. Peter's Basilica. Here in this grand audience hall, diplomats and dignitaries are greeted by Vatican officials. Geographic photographer Victor Boswell and I collaborated to produce this encompassing view with passing Swiss Guards and a priest.

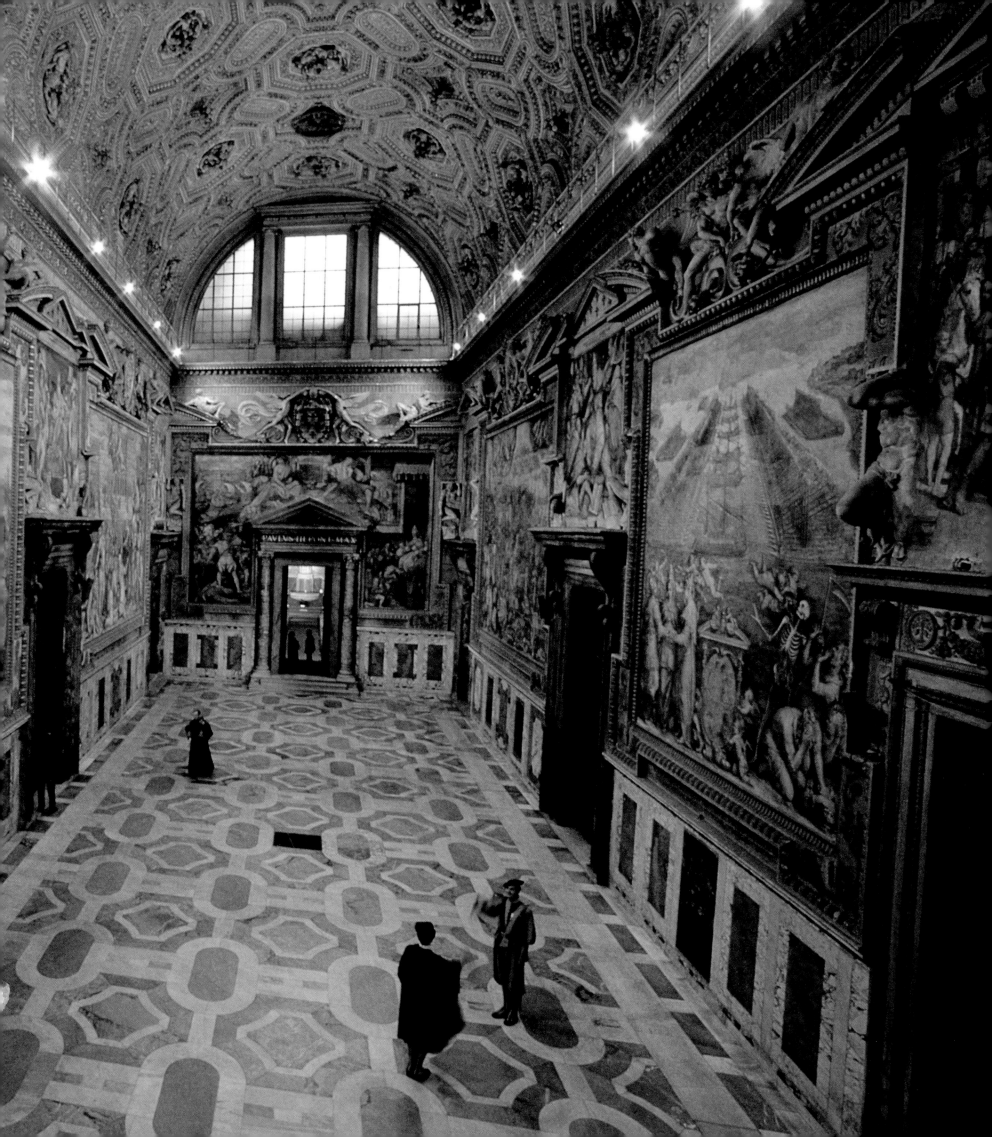

Diamonds encrust a chalice made from horse trappings given to Pope Pius IX by a Turkish sultan. His face adorns a diamond ring. Several months passed before officials were at ease with our photographing items from the treasury. After we had selected the objects we wanted to include, we were allowed only a certain number of hours to complete our photographs. The ring with the cross belonged to Pius XII, whose embroidered silk slippers and vestments (opposite) are kept in a closet below the treasury.

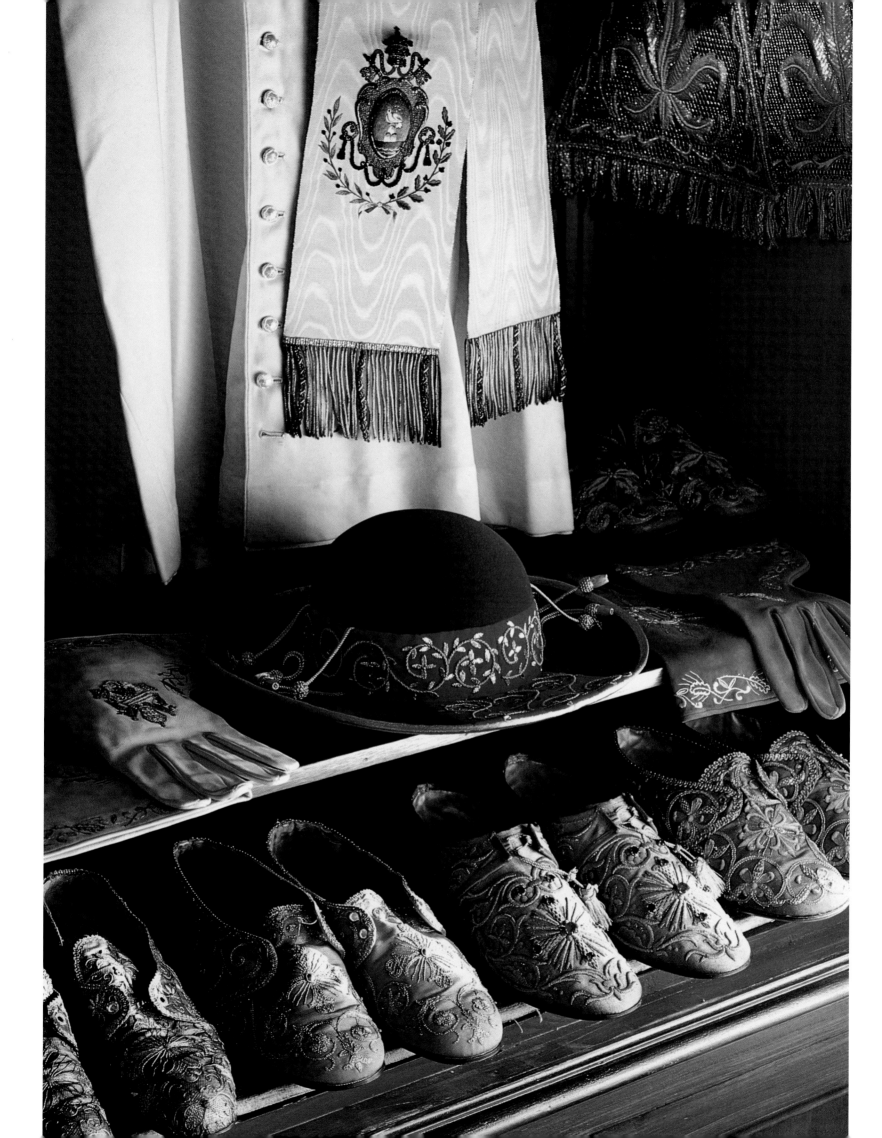

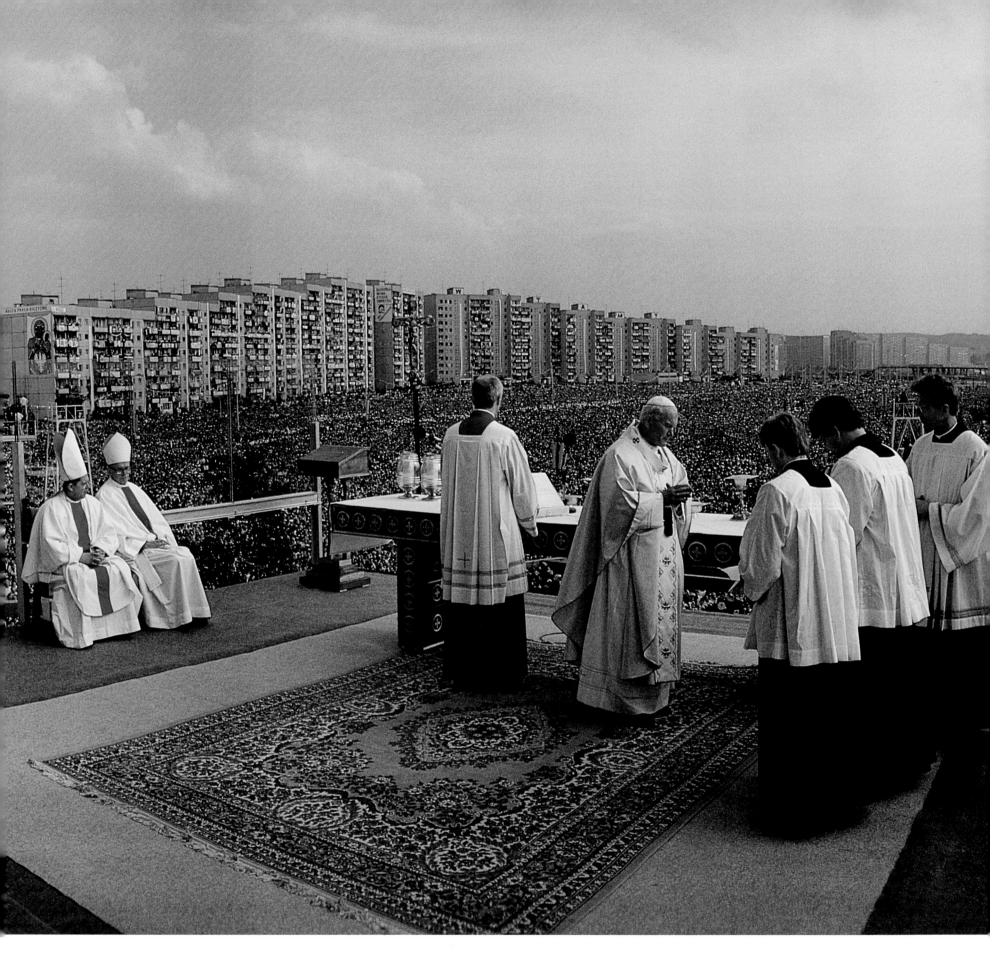

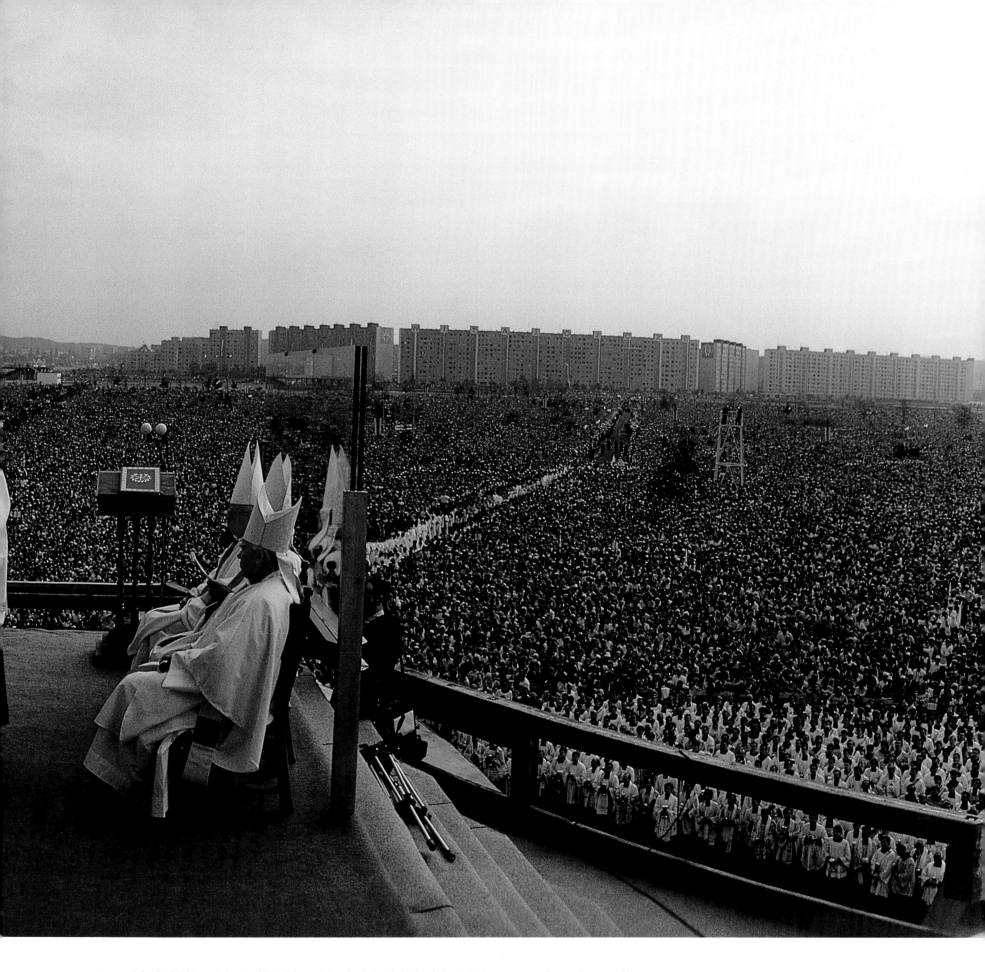

A sea of the faithful hear John Paul II celebrate Mass in Gdańsk, Poland, in 1987. I was assigned to a photographic pool that was allowed on the dais briefly before the Pope arrived. Old friendships paid off when the other photographers were ushered out. An official who had seen the Vatican article pushed me into a corner and told me to stay there "until you want to make your picture." Patience paid off. I felt this panoramic view was the most informative image made on the trip.

Gowned in cassock and surplice, an altar boy prepares communion chalices for resident and visiting priests in St. Peter's sacristy. This is the first duty of the day for the 30 to 40 young boys who attend a three-year preseminary school at the Vatican. The students come from all over, although most are from northern Italy; one American family sent all of their sons when they reached the age of 11. The Holy Father is always interested in what the altar boys are doing, and they always come to see him off when he takes a trip.

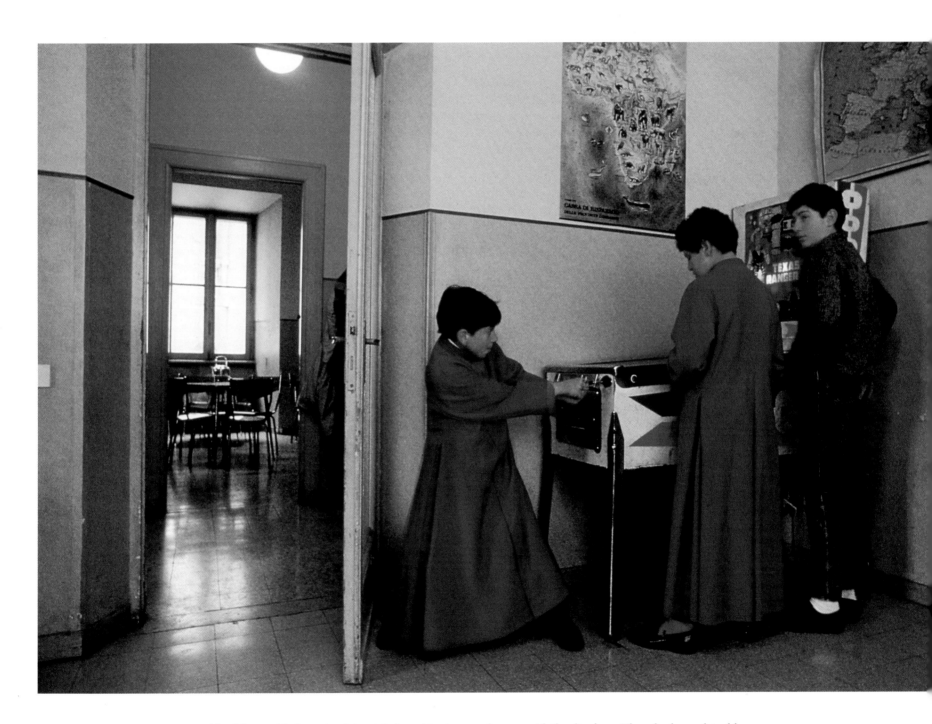

After Mass and before school the pinball machine is a popular spot with the altar boys. They also have a lot of fun trading soccer cards and playing the game in the Vatican gardens. I spent a lot of time with the altar boys because they always knew what was going on: When various priests were coming, what the Pope was doing, when their parents were coming, when the pageants were to be held. They were very mature and respectful, and although not many spoke English, they were great guides.

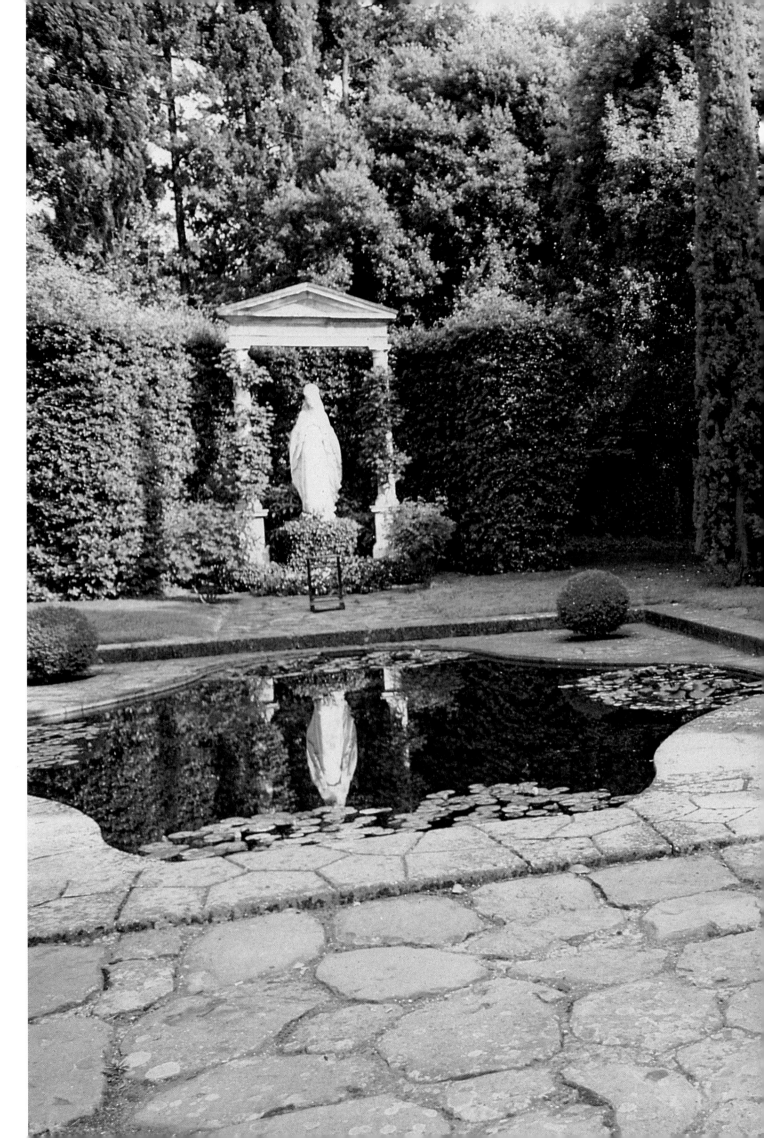

This is my favorite picture of the thousands I made at the Vatican. It shows both the spiritual and human side of the Pontiff, and it shows him at a private moment rarely seen by the public. It also marked a breakthrough for me personally, the time when I was no longer kept at a distance, but finally allowed to witness such moments and photograph them for posterity. I remember the Garden of Our Lady at Castel Gandolfo so well, the serenity of the pond, the rich green of the grass and trees. When the Holy Father finished praying at the shrine, he came right toward me. I just backpedaled for the next 100 yards or so. He is very spiritual and he can concentrate like no one that I've ever seen. He didn't know anyone else was there. Then he left and walked all the way to the palace.

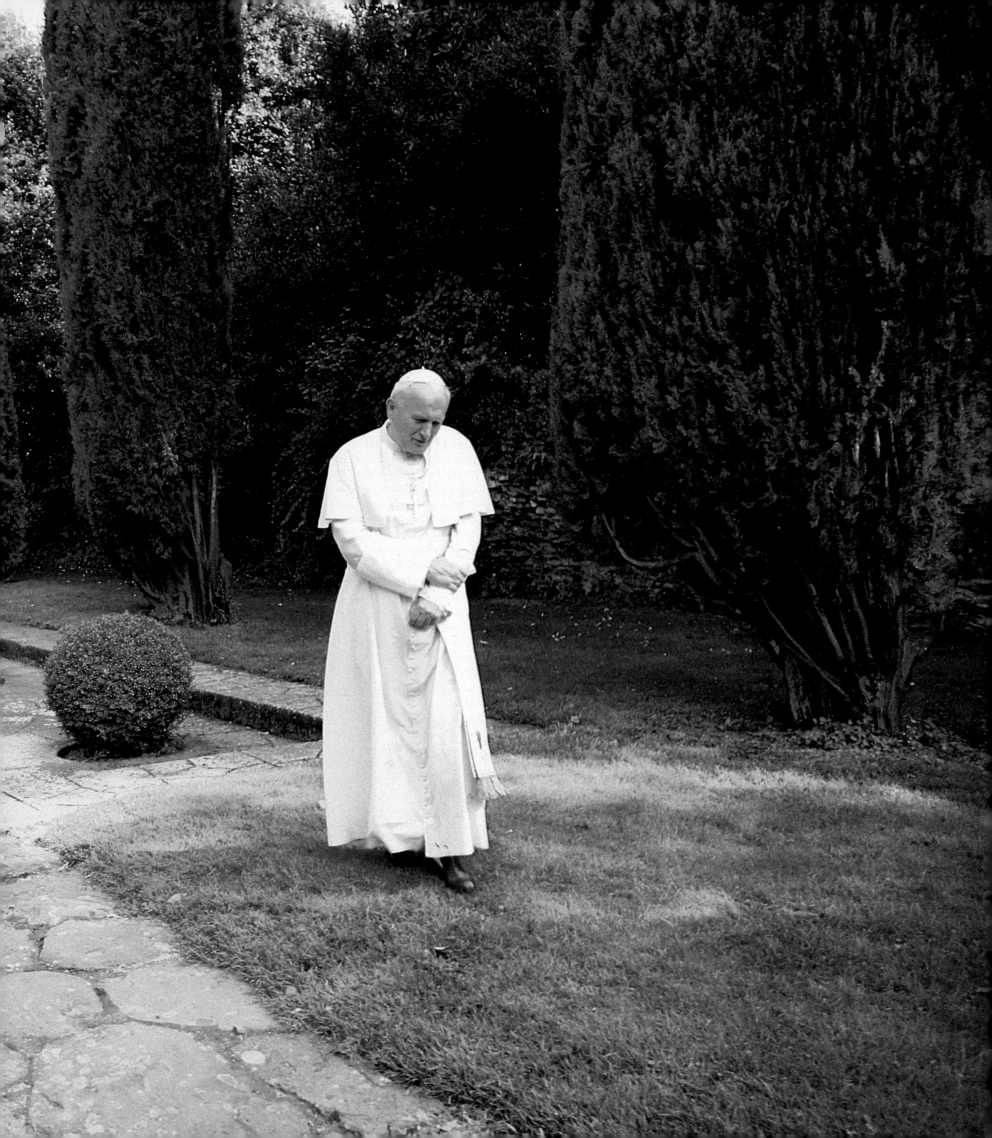

Bringing the past to life has been my major challenge for the last ten years. I have followed in the footsteps of conquerors and adventurers and tracked empires and ancient cultures, visiting dozens of countries for many months on each assignment. From remote villages in Turkey to the outskirts of Vienna, I tried to recapture the brilliance of the Ottoman Empire's Süleyman the Magnificent. I found descendants of the hordes of Genghis Khan and his heirs still galloping on horseback across the Mongolian steppes. The legacy of the Roman Empire lives on in elegant ruins, as well as in language and law. That most intrepid of travelers, the Muslim scholar and pilgrim Ibn Battuta, led me to 17 countries, far short of the 44 he visited. In a more modern adventure, I joined the team re-creating the 1919 historic first flight of the Vickers Vimy biplane from England to Australia. After an eventful five-week journey, I photographed the plane approaching Darwin in triumph. This frame was not published.

GREAT JOURNEYS

THE VIMY FLIES AGAIN

"Are you going to get in that thing?" a colleague asked me when she saw the Vimy replica under construction in California. I never thought of any danger when then-editor Bill Graves gave me the assignment. Peter McMillan and Lang Kidby, his Australian copilot, were competent and confident. My worry was getting coverage for our May 1995 article that would measure up to the 110-page NATIONAL GEOGRAPHIC story by Ross Smith and his brother Keith, who made the original flight in 1919. They left at the wrong time of year, and they just about froze to death over the Alps in November. They never should have made it. We almost didn't. When one of the engines stopped over Sumatra, we desperately sought a landing spot. A road proved too narrow and we ditched in a rice field. Fortunately, none of us was hurt. After repairs and the construction of a runway, we took off and landed safely in Australia.

Other great journeys were not so event filled, but each had its challenges—and its rewards. These projects take planning and an immense amount of research. It may take two or three months to get everything in order: Arrange for visas, find contacts in each of the countries to be visited, plan itineraries, book hotels, and hire guides and interpreters. If they are dedicated, they are invaluable. Sometimes they think I am a little bit crazy—but by the time we finish we are good friends and they have truly enjoyed it. It also helps when you have an expert who can point you to the right museums, the most interesting sites, and the most important subjects. For the December 1991 article on Ibn Battuta, we had a professor at San Diego State University who had just completed a book on this "Prince of Travelers." He came with writer Tom Abercrombie and me to Morocco to get us off on the right foot.

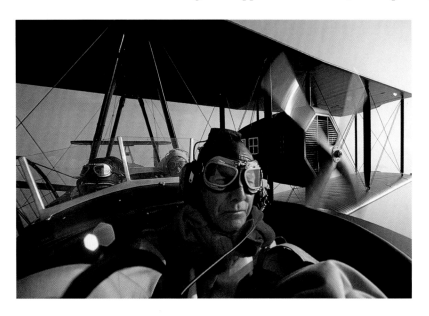

"Mayday, Mayday," those words from copilot Lang Kidby rang in my ears as I strained to see through the smoke of burning rice straw in Indonesia. I was tucked into the nose of the Vimy, a replica of a World War I biplane. Engine trouble was forcing us to land. This was not what I had foreseen many months earlier, when I was hauled on a surfboard to the ceiling of a hangar in California to photograph the Vimy under construction.

When I am finished planning my coverage, I have a day-to-day schedule I try desperately to stick to. If anything goes wrong, the domino effect takes over and it's very costly to change airline reservations and hotels and to reschedule appointments. For the Roman Empire, a two-part article that appeared in the July and August 1997 magazines, I stayed with my schedule all the way through—although things didn't always work out photographically. Algeria has the most beautiful ruins, but I couldn't get to them because of the danger from pockets of fundamentalists that were terrorizing the countryside. I did visit one ruin about 50 kilometers east of Algiers, but I had to travel with 16 national police.

Süleyman the Magnificent, published in November 1987, seemed to go like clockwork. Genghis Khan, in the December 1996 GEOGRAPHIC, had its difficulties. Mongolia is the only place I have had to fire guides and interpreters. I went through three sets and finally realized the first set had been the best. Getting to the place believed to be Genghis Khan's birthplace on the Onon River seemed impossible at times. Not long after we finally crossed on the ferry, we heard the captain had been swept overboard and drowned. There are no roads and the Russian jeep didn't work very well. We were constantly stuck with the monsoon rains coming early. When we got to the last bridge, there was a truck and a hay wagon in front of us. Suddenly the bridge crashed and fell in the river. After a long detour, we finally reached his birthplace—and, miraculously, after that everything seemed to go smoothly. There were no more failures.

It was like history repeating itself. Seventy-five years before, the Smith brothers had run into a storm in Pisa, Italy, and now the Vimy crew struggled to hold down our plane as a major squall threatened to flip it over. During a lull, the plane was pushed into a hangar; otherwise it surely would have been destroyed. At one point I looked out of a window in the mess hall and watched a tree sucked out of the ground.

Following pages: One of the great scenes you will ever see in your life, I thought, as I shot this ethereal view of the Pyramids looming through ground fog with the biplane flying by. I am lying down in the little baggage compartment of the chase plane. Unlike the storm at Pisa, this tranquil scene did not reveal the peril we were in. We could have ended the flight here in Egypt. Little did we know that antiaircraft weapons were trained on us, due to a permissions snafu.

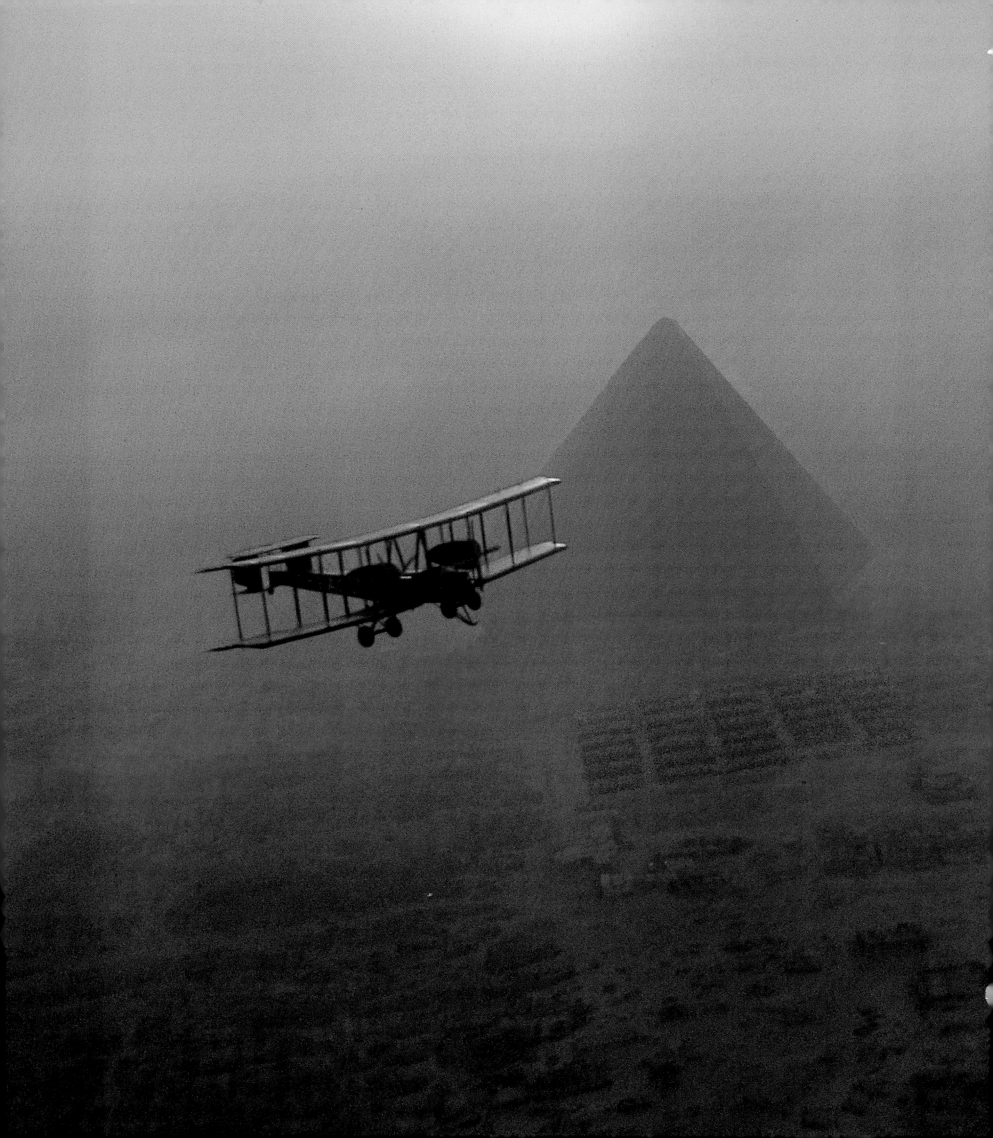

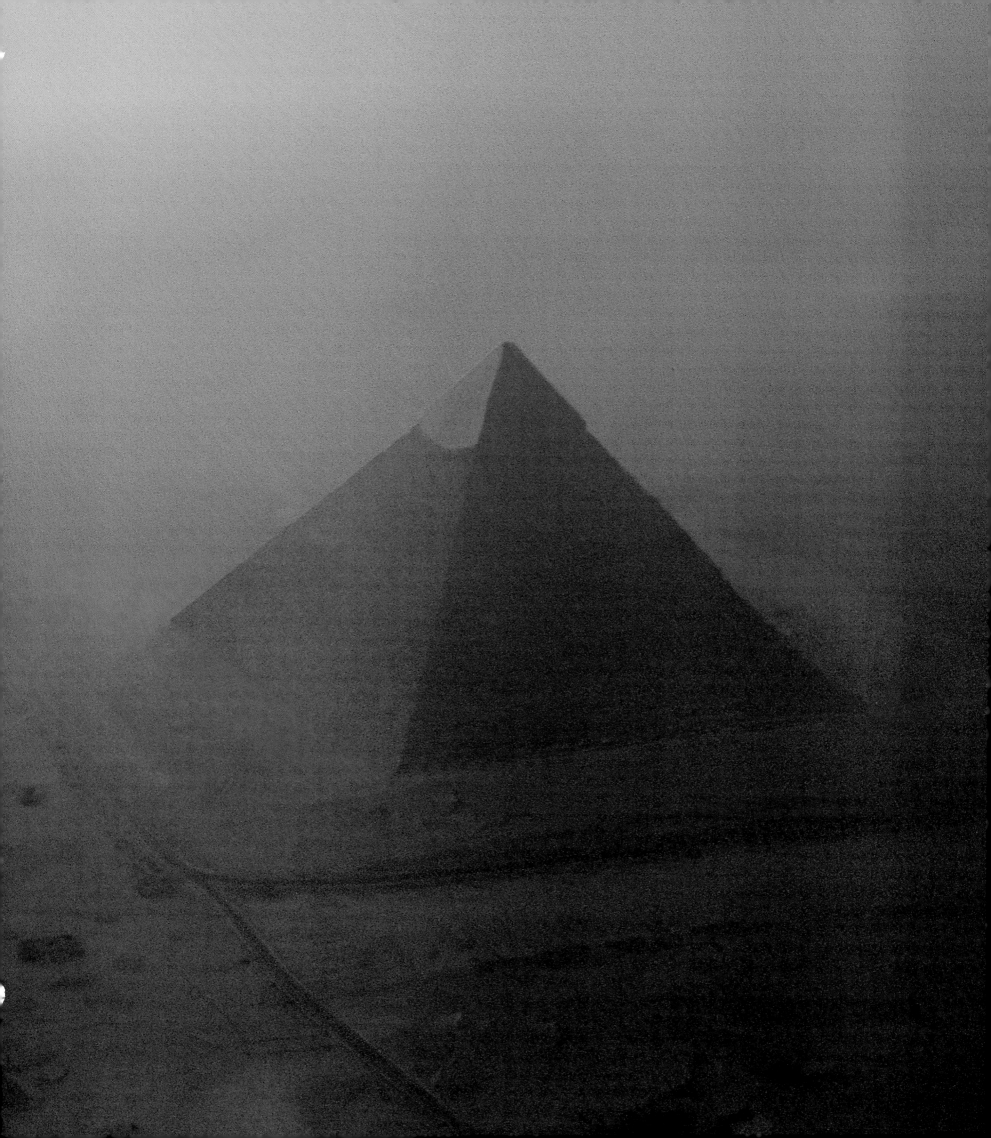

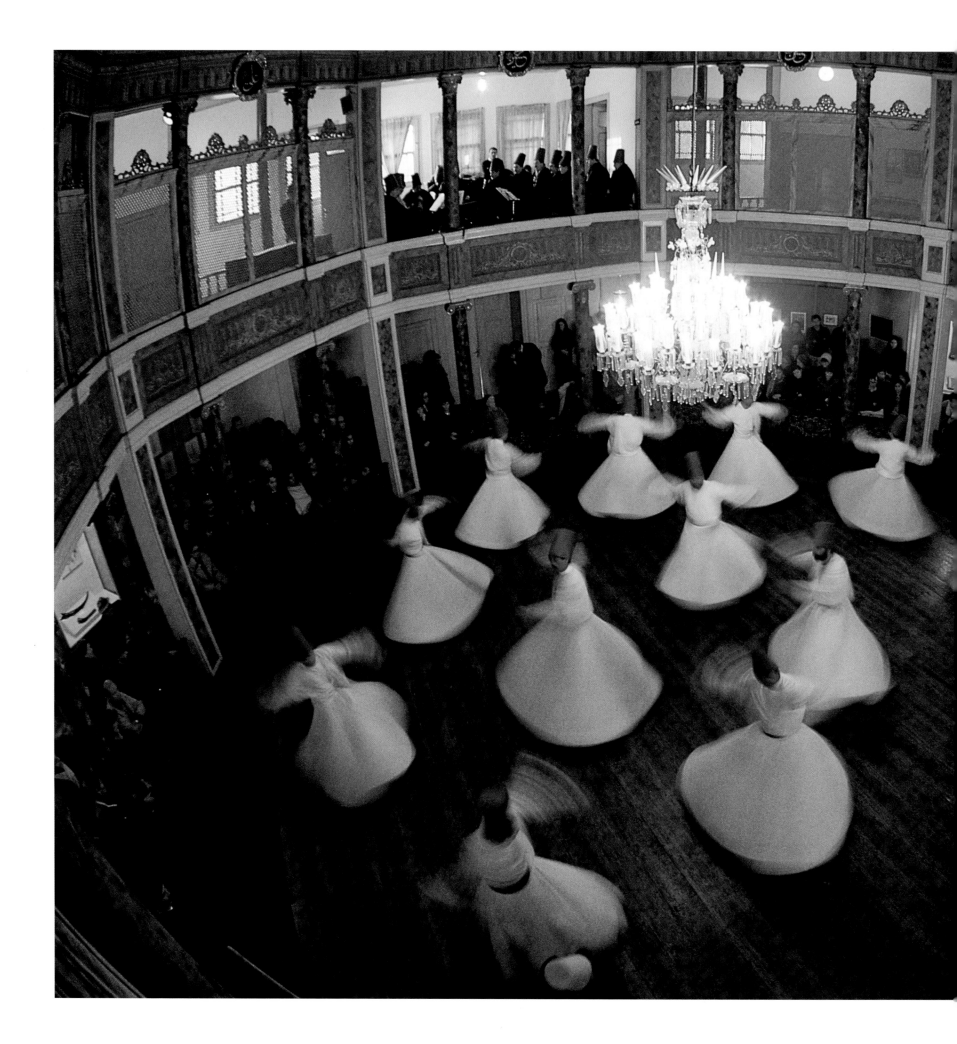

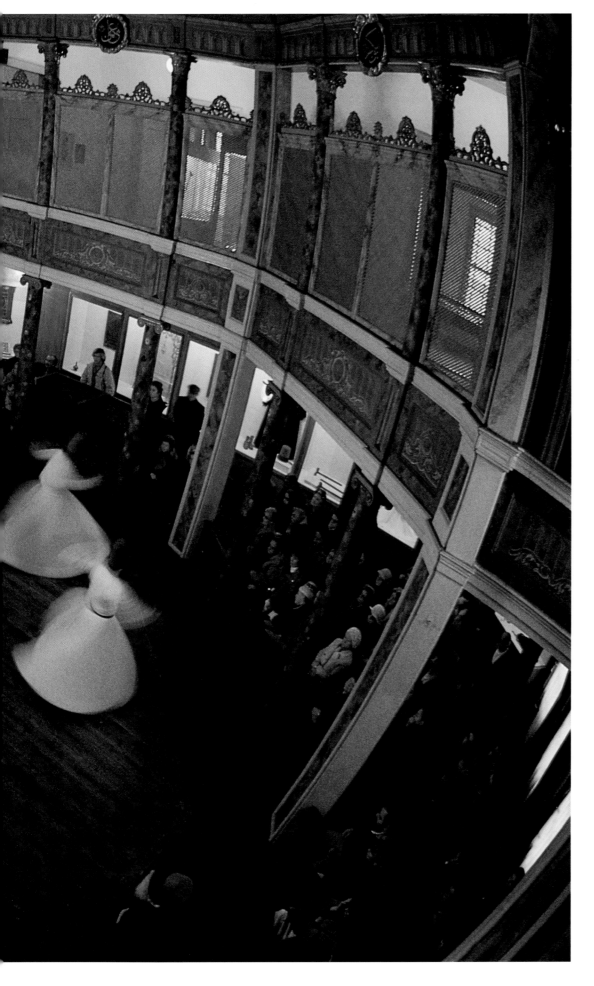

SÜLEYMAN THE MAGNIFICIENT

Culmination of my coverage for the November 1987 article on Süleyman the Magnificent was photographing the dervishes of the Mevlevi Order in Istanbul, Turkey. Süleyman and his family, devout Muslims, highly respected the dervishes. Each December the group commemorates the death of their founder, Rumi, in 1273 by performing this ritual dance with the right hand facing heaven, left hand facing earth. Their spinning symbolizes the planets revolving around Allah. It took almost three months of effort to secure photographic permission from the proper dervish authorities. I knew it was going to be spectacular, and I didn't want to miss it. On the whole, Süleyman was probably the easiest story I ever worked on. Four years earlier on our Byzantine Empire article, I had had a hard time with some officials. But they were interested in the Ottoman Empire and doors opened. When I first took on Süleyman, illustrations editor Charlene Murphy and I called him Süleyman the Vague, because it didn't seem we had much to work with. After I photographed the paintings, Turkish miniatures, and illuminated manuscripts in Istanbul and Vienna, I had a good idea of how to portray this elegant and ruthless man. The GEOGRAPHIC is sometimes accused of making even the brutal seem beautiful. I think you portray how crude or how ruthless certain people are, but you do it in a telling and tasteful way.

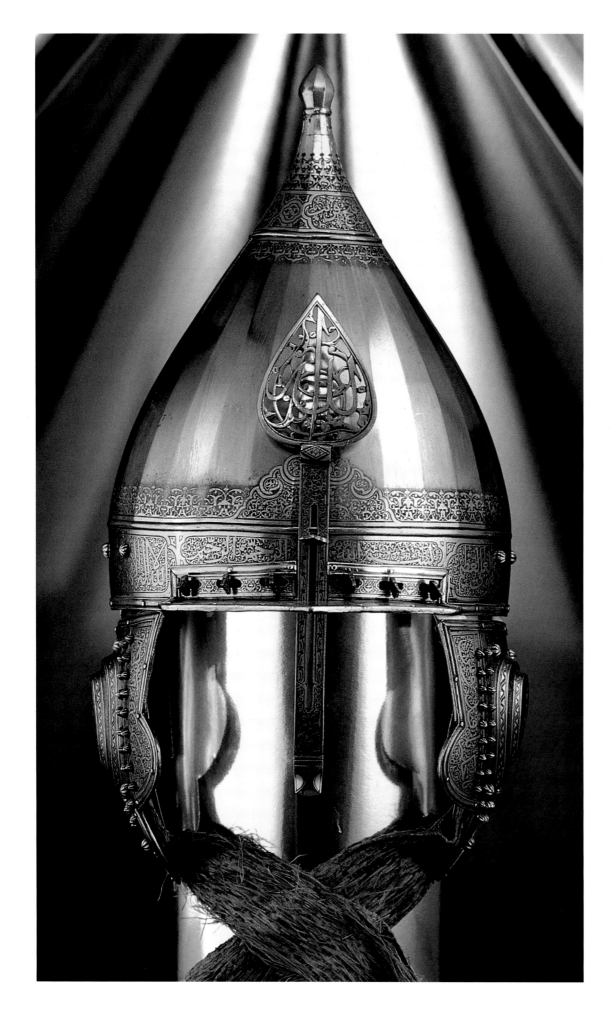

Gleaming helmet of a grand vizier, with its ornate Islamic design, and the feared recurved bow of Süleyman's archers are preserved in a museum in Vienna, the Austrian city that defied Ottoman attack. Süleyman's forces had already enveloped Hungary, burning Buda in 1526. I was looking for a way to photograph both Buda and Pest, across the Danube, when, to my surprise, I swiveled opened my hotel window and the mirrored reflection gave me just the view I was hoping for (opposite).

Bending his back to an impending sandstorm, shepherd Amhet Blibita Mumdi huddles in front of a mosque on Jerba, an island off the Tunisian coast. Süleyman's admiral Barbarossa, using the island as a stronghold, raided shipping in the Mediterranean. The Ottoman navy defeated the Spanish here in 1560. I was intrigued by the shape and architecture of the mosque, one of 213 on Jerba, and had arrived a few hours before sunset when the storm came up. It lasted only about 20 or 30 minutes.

Grizzled beard and fierce eyes mark a nomad in the village of Söğüt in Turkey's Anatolia region. He and his fellow tribesmen, armed with pistols, knives, and grenades, gather in honor of their ancestor Ertuğrul, whose son, Osman I, founded the Ottoman dynasty. There were thousands of nomads taking part in athletic games, dances, and horse races. This fellow seemed a worthy descendant of Süleyman's warriors—and he looked like he could eat me for breakfast.

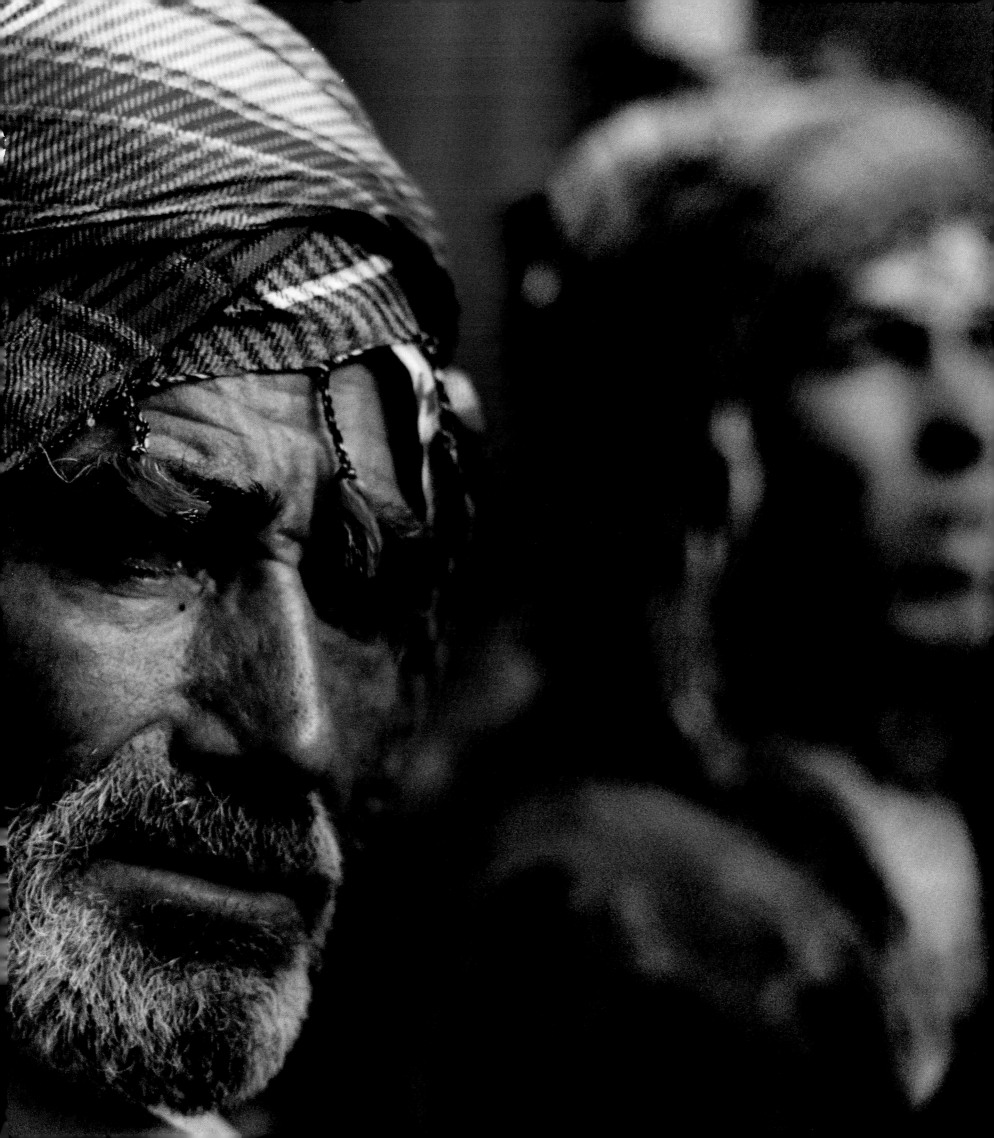

A devout Muslim sitting in his window in Safranbolu, Turkey, bows in prayer to Allah in a frame that was never published. I spent the better part of three or four days photographing coppersmiths, blacksmiths, bakers, and other artisans in this small Ottoman village. Hundreds of the devout gather in the Selimiye Mosque (opposite) in Edirne, Turkey. Its magnificence attests to the genius of Süleyman's architect, Sinan, who also designed the great Süleymaniye complex in Istanbul, as well as numerous caravansaries, aqueducts, bridges, baths, and markets.

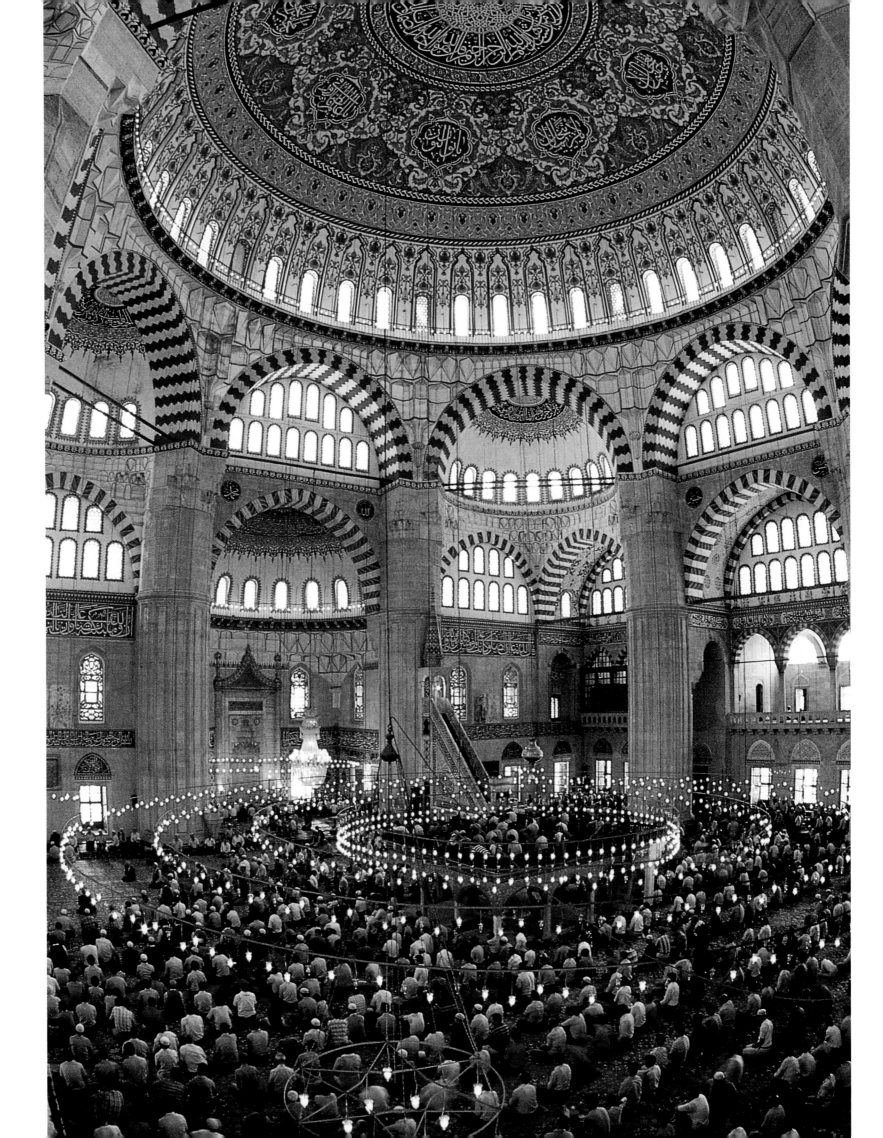

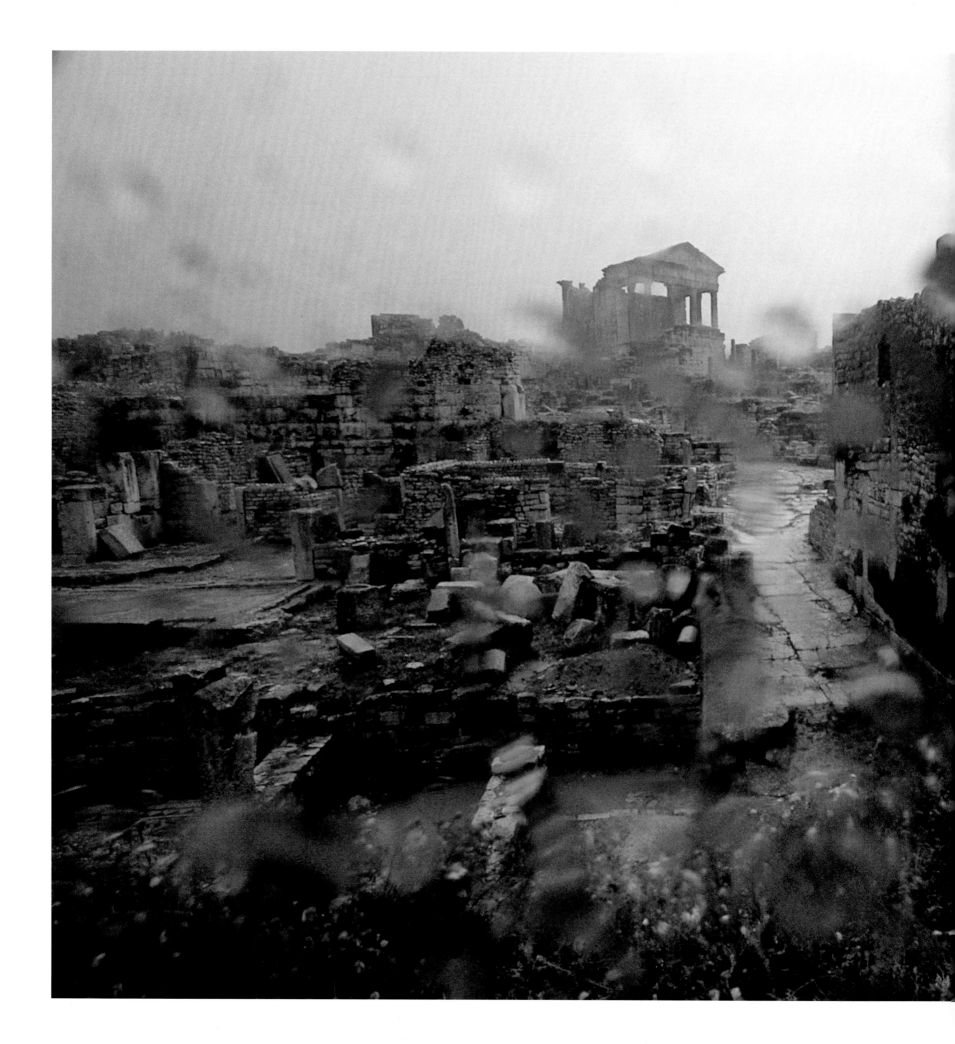

ROMAN EMPIRE

There was something about the Roman Empire that was magic when I first learned we were going to tackle such an immense subject. Everyone knows something about the Roman Empire, maybe because of movies, maybe books, maybe the historical characters we grow up hearing about—all of the Caesars. Art, mosaics, statuary, and, of course, the ruins still remain. Editor Bill Allen had decided to publish a two-part series—the first in July 1997 on the growth of the empire, the second in August 1997 on the legacy of Rome. With the help of architectural historian Bill McDonald, I carefully planned my attack. I would mark ideas in books; then I would go to Bill's house and we would narrow them down to the best subjects. Sometimes we even had an idea of where my vantage points might be. However, at Dougga, in northern Tunisia (left), this was not the initial spot I had chosen. It was such an important site and I wanted a great overall panoramic view. I had scheduled three days there and ended up spending six. We had bad weather, but weather is not an excuse. Sunny days become boring. Give me fog, rain, snow, or hurricanes anytime. That old excuse of waiting for the weather doesn't work anymore. It is too expensive.

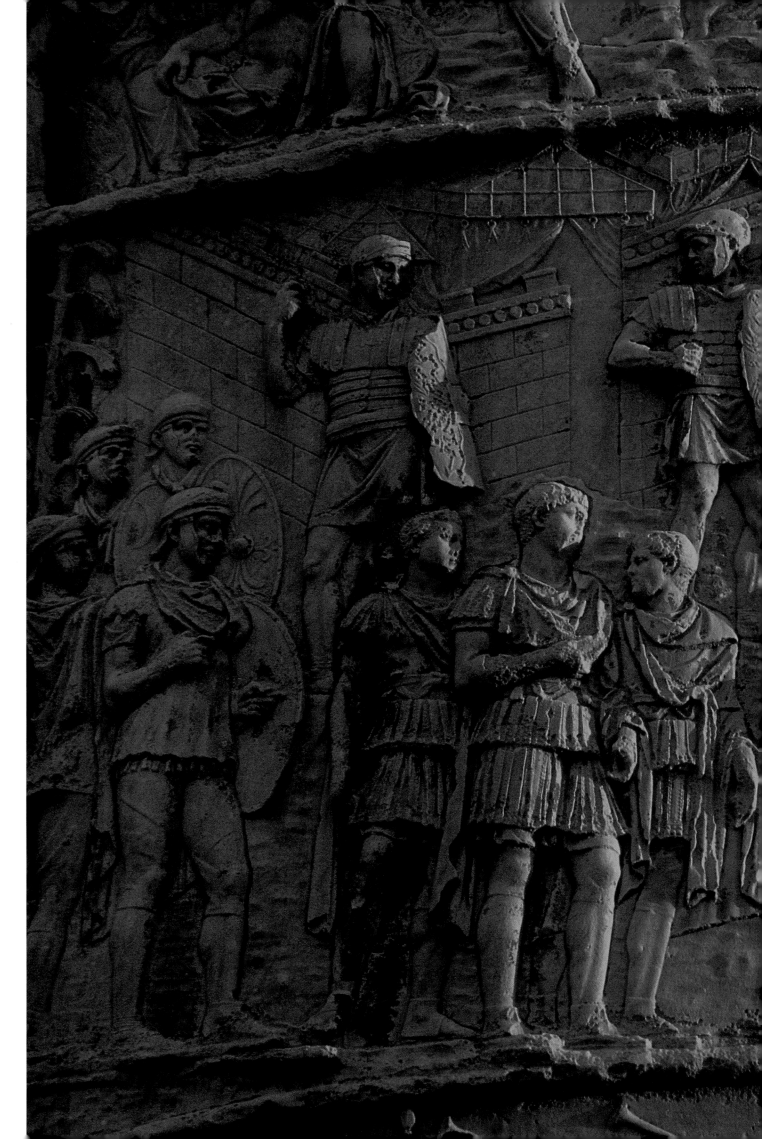

An illustrated primer of
Roman military might,
Trajan's column in Rome
depicts the conquest of the
Dacians in present day
Romania in A.D. 101-106.
This one not only shows a
captured prisoner being
brought to the emperor but
also depicts the legionaries
building the structures that
helped secure Roman rule.
Frames taken from ground
level tend to distort the
sculpture. So I found a priest's
bedroom in a church that
would put me level with this
panel. At first the priest was
reluctant. I don't think he
wanted a telephoto lens
pointing out of his bedroom.
He completely relaxed when
he saw me mount the camera
on a tripod inside his room
out of sight, and rest the lens
on the windowsill.

Capital of ancient Gaul, Arles preserves its superb Roman amphitheater where bullfights are still held. I went there to photograph the amphitheater and several other remnants of the empire. Always on the lookout for people to add life to these historical articles, I was delighted to come upon this couple at a festival celebrating traditional French costumes. They were on horseback on their way to the bullfight. The man was very much aware of the number of exposures I was making and he was not terribly pleased. After the photograph was published in the August issue, I received quite a few letters sparked by the woman's beauty.

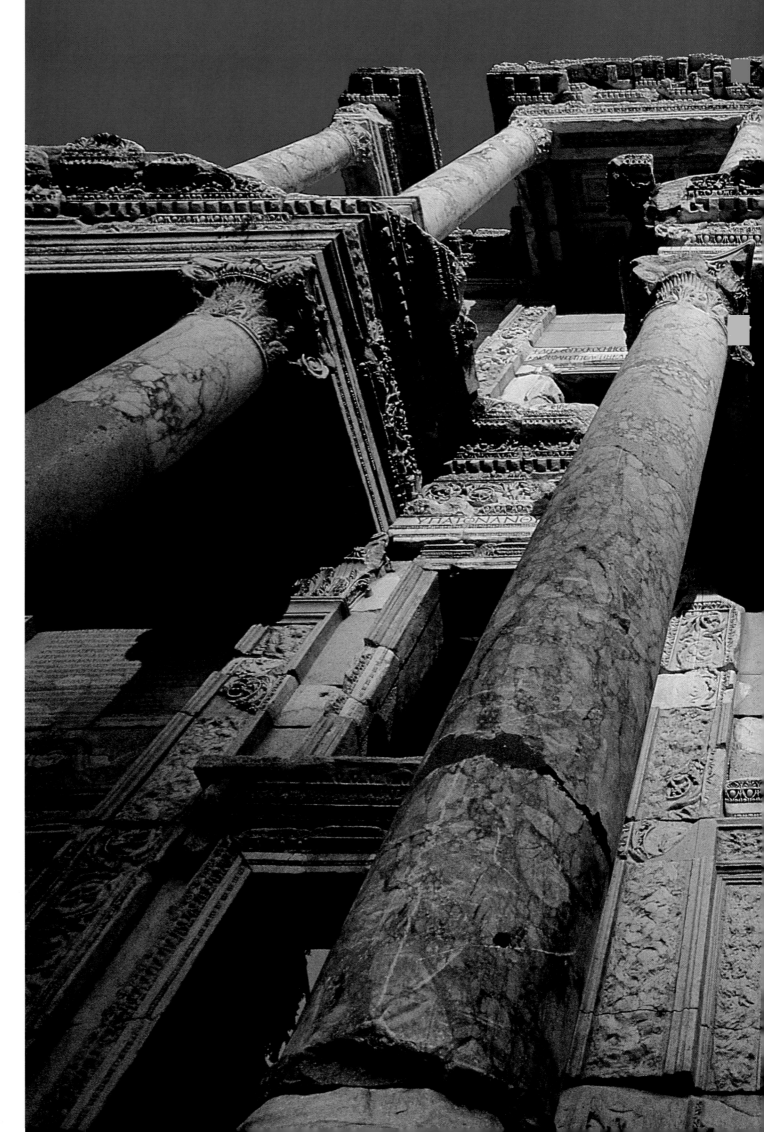

Ephesus, Turkey, was one of the great cities of the Roman Empire. The Apostle Paul preached here, almost causing a riot; he later wrote his Epistle to the Ephesians. This photograph of the magnificent Library of Celsus, built after Paul's time, opened the August 1997 article on the legacy of Rome. I wanted to be there before sunrise, which required special permission. Visitors are usually not permitted until the sun is too high in the sky and loses that warm, mysterious glow. Authorities were very cooperative, and I took this frame when the sun had not yet touched the hem of the statue's dress.

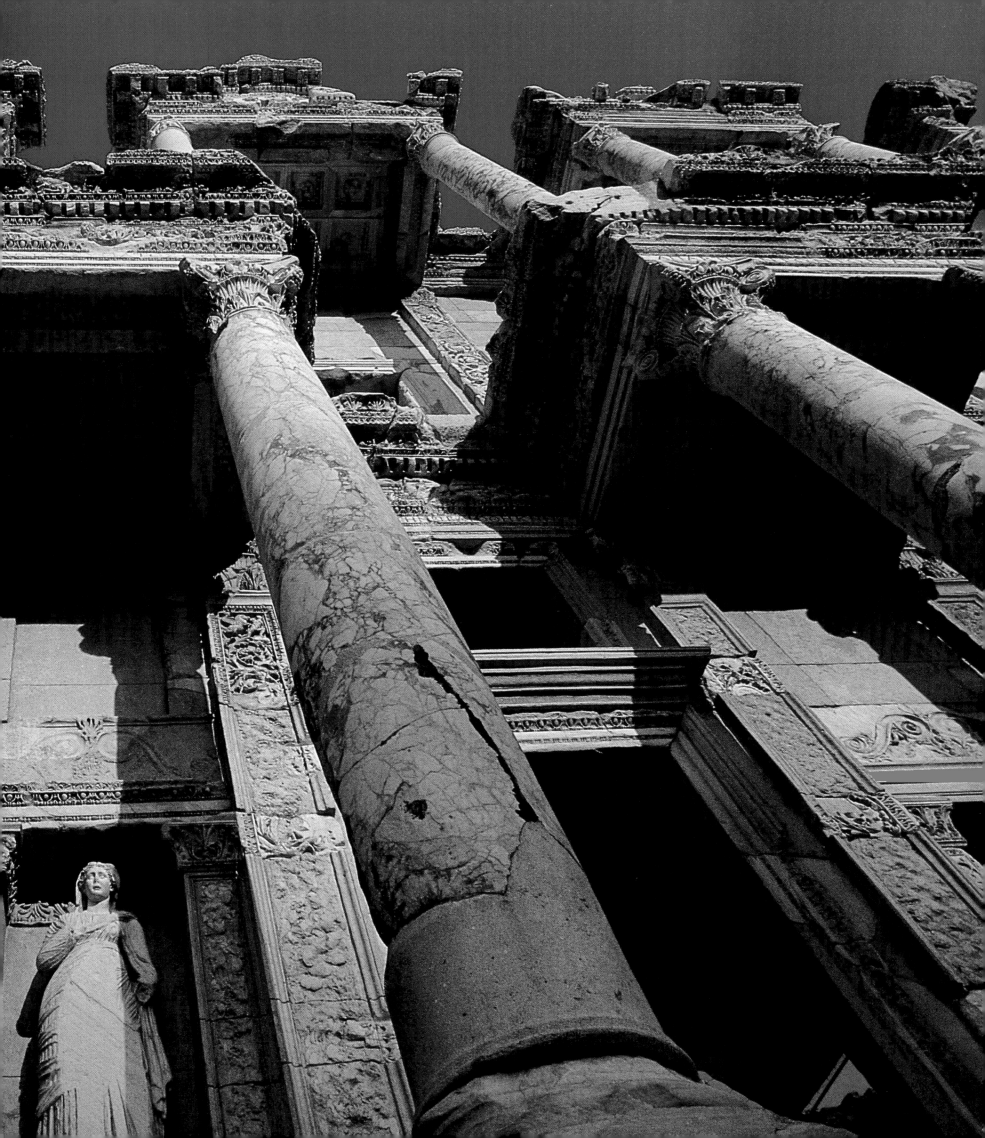

LORDS OF THE MONGOLS

I once again followed ravaging conquerors from the east with Genghis Khan, published in December 1996, and his successors, the Great Khans, in February 1997. Artifacts are few, since the huge contingents that followed the armies retrieved arrows, armor, helmets, and other reusable items. Even the museum in Mongolia's capital of Ulaanbaatar has little to preserve—but that might also be attributable to the Soviets who suppressed adulation of Genghis. You make the best out of what is left, whether it is artifacts or geography. Fortunately many of today's Mongolians still preserve the traditions of their ancestors. The Mongols reached Eastern Europe in 1241, as the graveyard in Muhi, Hungary, attests. When I came over the hill and saw this huge mound, it took my breath away. I returned with a ladder and my interpreter and taxi driver, as a storm was brewing. I strapped myself, tripod, and camera to the ladder and asked my assistants to hold the strobe lights. I wanted lightning and kept saying, "Let's wait just a few minutes more." As the storm grew closer, a lot of throat clearing signaled the uneasiness of the men, who knew the aluminum stands would act as lightning rods. Finally the skies let go, the camera was ruined, the lights shorted out, and we ran for cover. But the image worked. Never pass up a monument in Hungary.

In a history subject, contemporary scenes never fit in the rhythm. One of my biggest challenges is to find people who fit the role and the time period. To me, this infant represented young Temujin, destined to be named Genghis Khan. The village of Bayan Ovoo claims to be the birthplace of Temujin. Here I found young Buddhist novices chanting their prayers in the rustic temple. One of these kids had been a real hellion when I had seen him in the streets, but inside the temple he was an absolute angel.

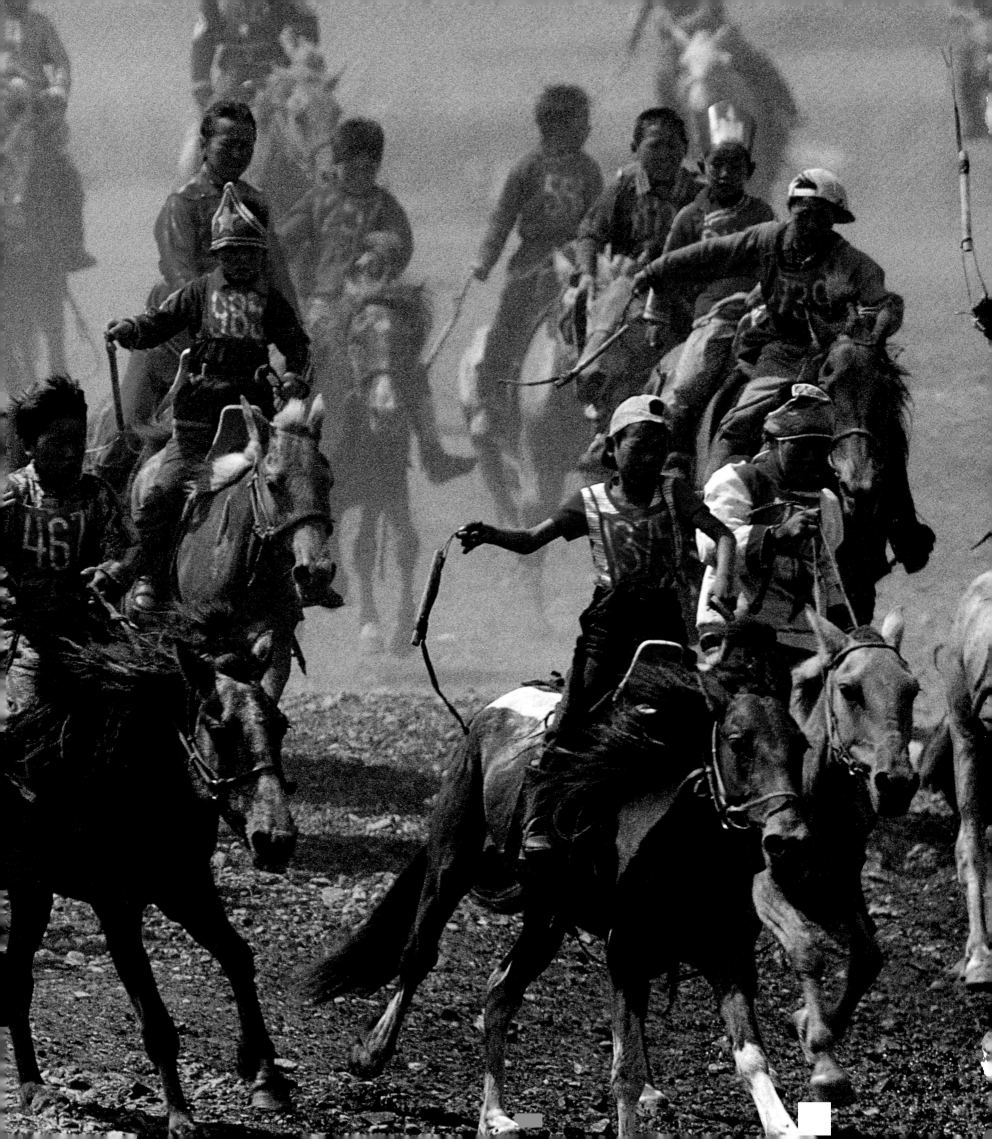

A horde of youngsters, ages 5 to 12, gallop full out at the Naadam festival outside the Mongolian capital of Ulaanbaatar. It is a two-day event, including archery and wrestling. Like their forebears, they seem to be born to the saddle, spending 15 to 18 hours a day on horseback. Both boys and girls participate in a society where gender means little. They walk their horses nearly 20 miles and then, after officials try to line them up at some sort of starting line, they take off for the finish. It is quite a sight to see 300 to 400 kids barreling across the steppe.

Monuments to Genghis Khan are found throughout Mongolia. A modern bronze plaque bearing the fierce conqueror's face is near Blue Lake where, tradition holds, a great assembly proclaimed him "strong ruler," as some translate "Genghis Khan." During the Soviet era, reverence for Genghis was suppressed. Now the Mongolians even put his face on their currency and their vodka bottles. A full figure of the conqueror carved on a stone memorial in the heart of Mongolia drew the immediate homage of my driver (opposite). When we drove up, he went right to the monument, drew out this blue scarf, and offered prayers to the man honored as the father of his nation. Genghis Khan's legend gives the Mongolian people a sense of identity.

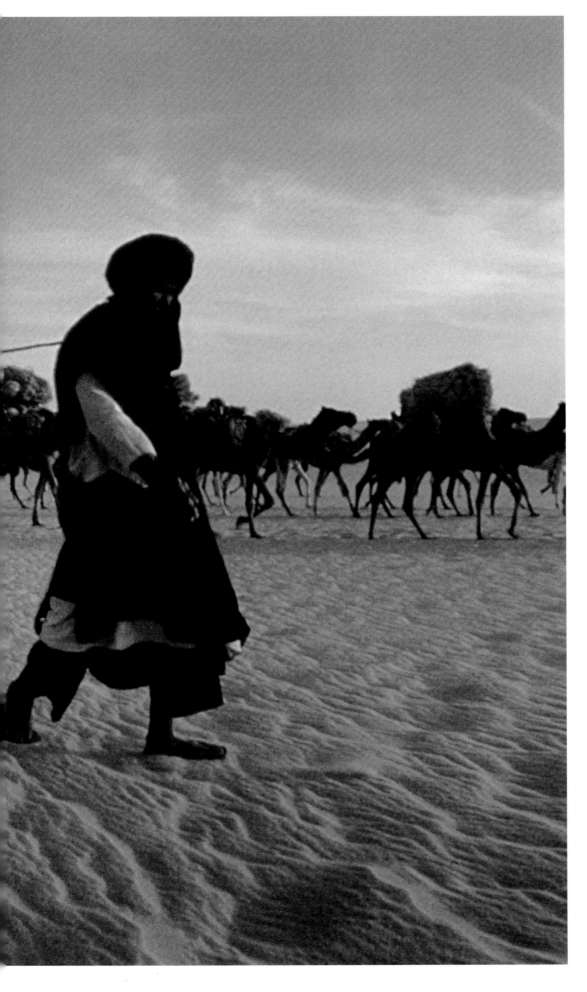

PRINCE OF TRAVELERS

This was my kind of story and I believe it was my best work. I think articles like this are why photographers gravitate to the NATIONAL GEOGRAPHIC and why people read the magazine. Not many of our readers had heard of Ibn Battuta, although he is a household name in the Muslim world. Nearly every child from the age of three or four receives a little comic book about the 14th-century traveler. From Morocco to China, from Russia to India, Ibn Battuta saw the world for 29 years and traveled some 75,000 miles. This was our chance to introduce him to millions, and to illustrate his travels in a very sympathetic, touching manner. Also, it was the first time I worked with Tom Abercrombie. I had followed Tom from the *Milwaukee Journal* to the GEOGRAPHIC, and I had always held him in great esteem. Tom knew the region so well; it was he who said, "We have to go across the Sahara with the Tuaregs." I felt like a child on that camel caravan. It was at that point that I realized I had a great story. There had been some glitches in the coverage up until then; at times I felt I had a little demon on my shoulder saying, "You're not going to succeed on this one, Jimmer." But once we began that journey, everything started to piece together. It just soared, and it was one of the most enjoyable stories I have ever worked on.

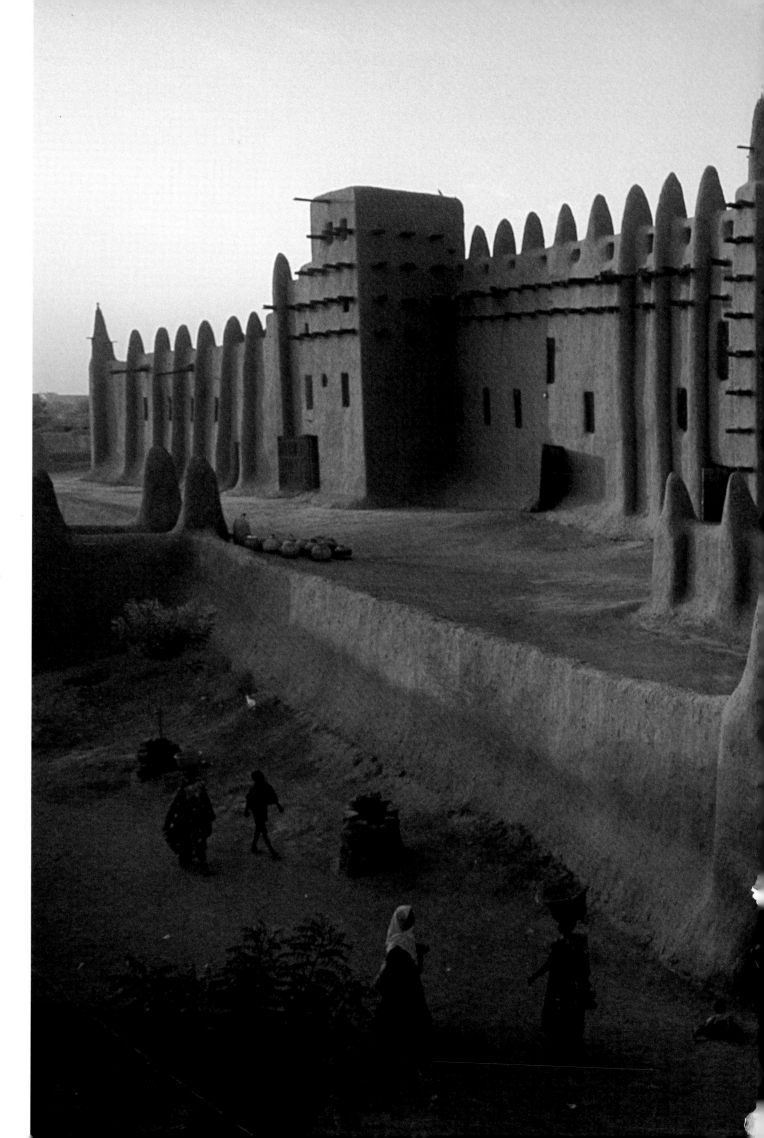

What an incredible sight, this huge mosque built of mud in Djénné, Mali. Ibn Battuta came here on his final journey in 1352. A devoutly religious man himself, he praised the piety of the Muslims in Mali. After the rainy season, the townspeople repair the erosion to the mosque. It is supported inside by many pillars only a few feet apart. At sunset, from the rooftop of a house nearby, I could see the Koranic school being held on the plaza of the mosque, the ladies strolling by. There was no funny person in funny shorts to ruin the mood of the picture.

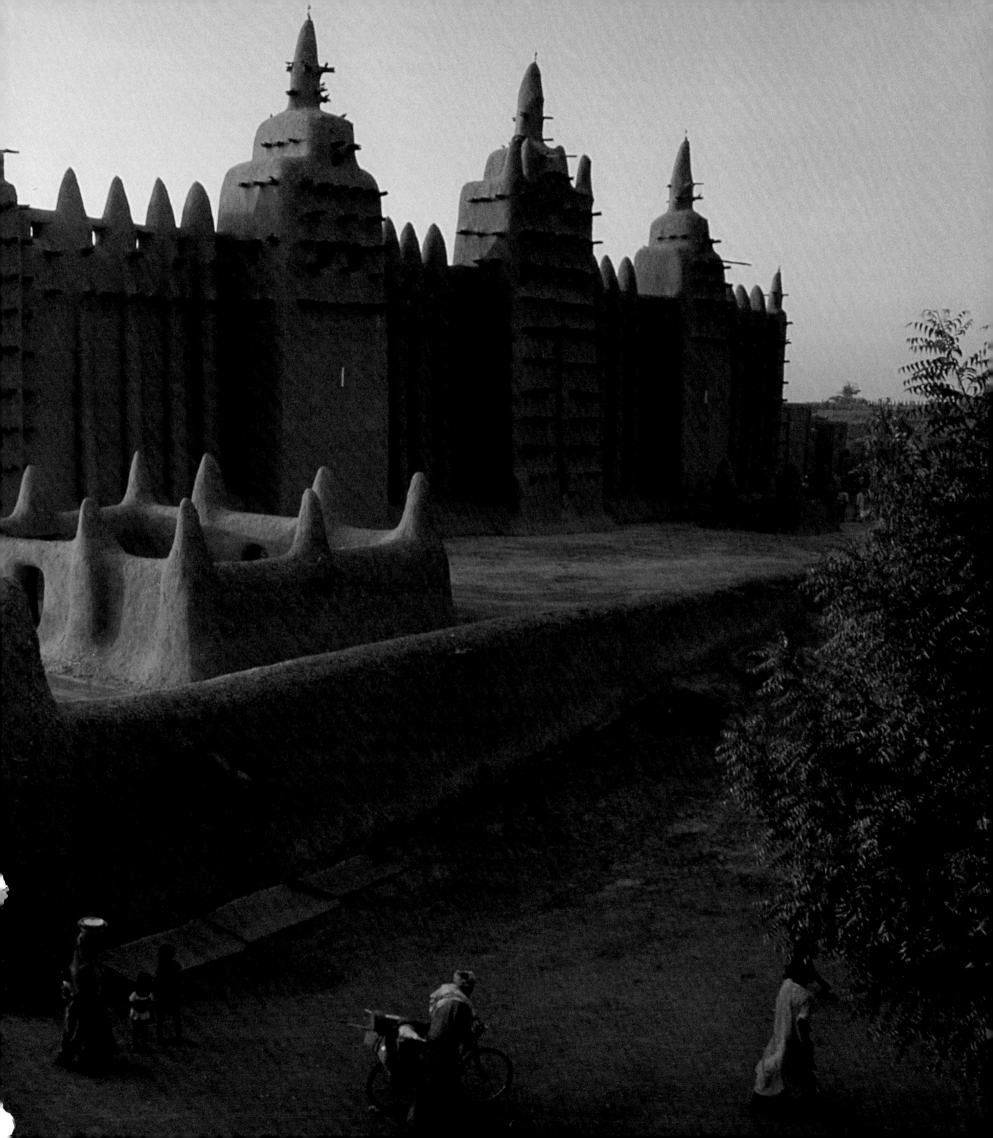

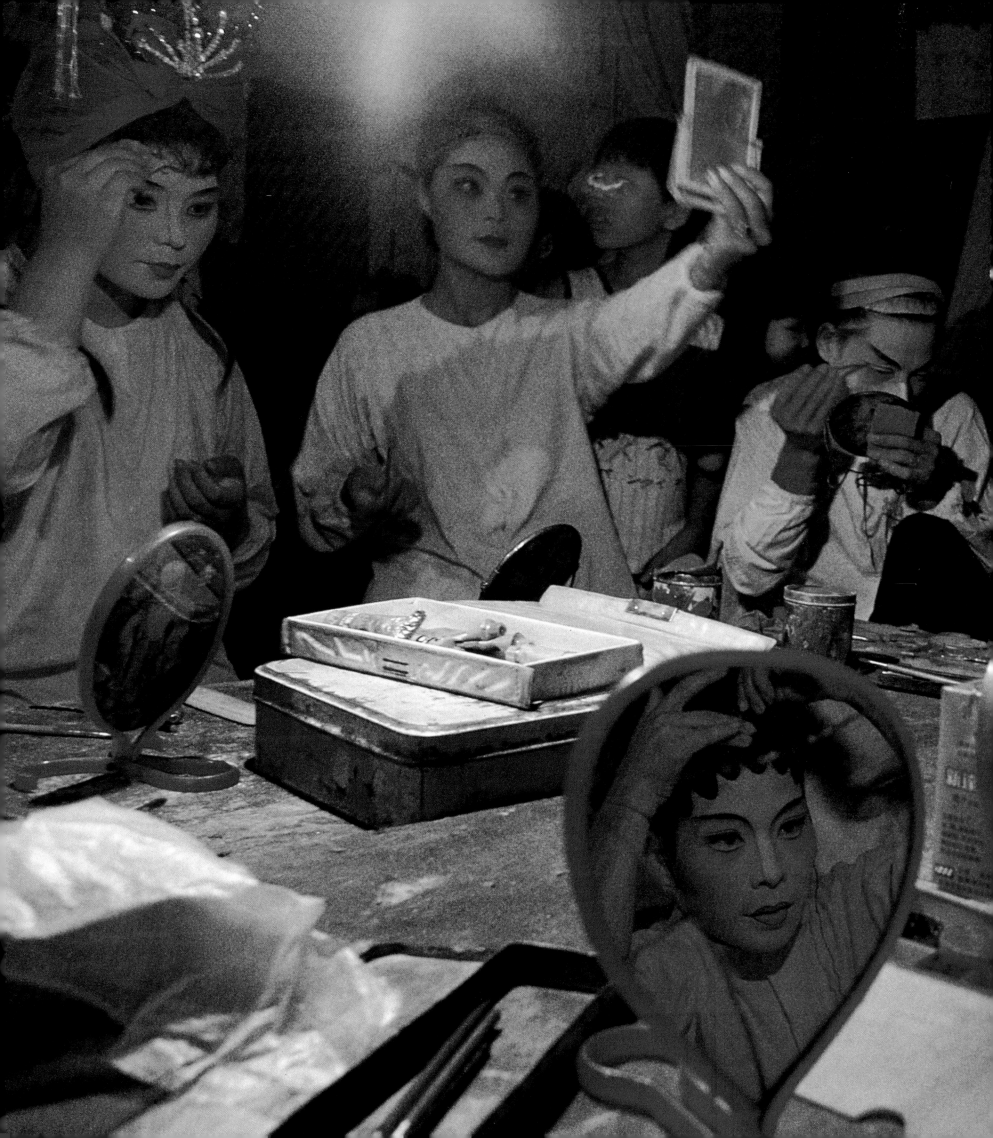

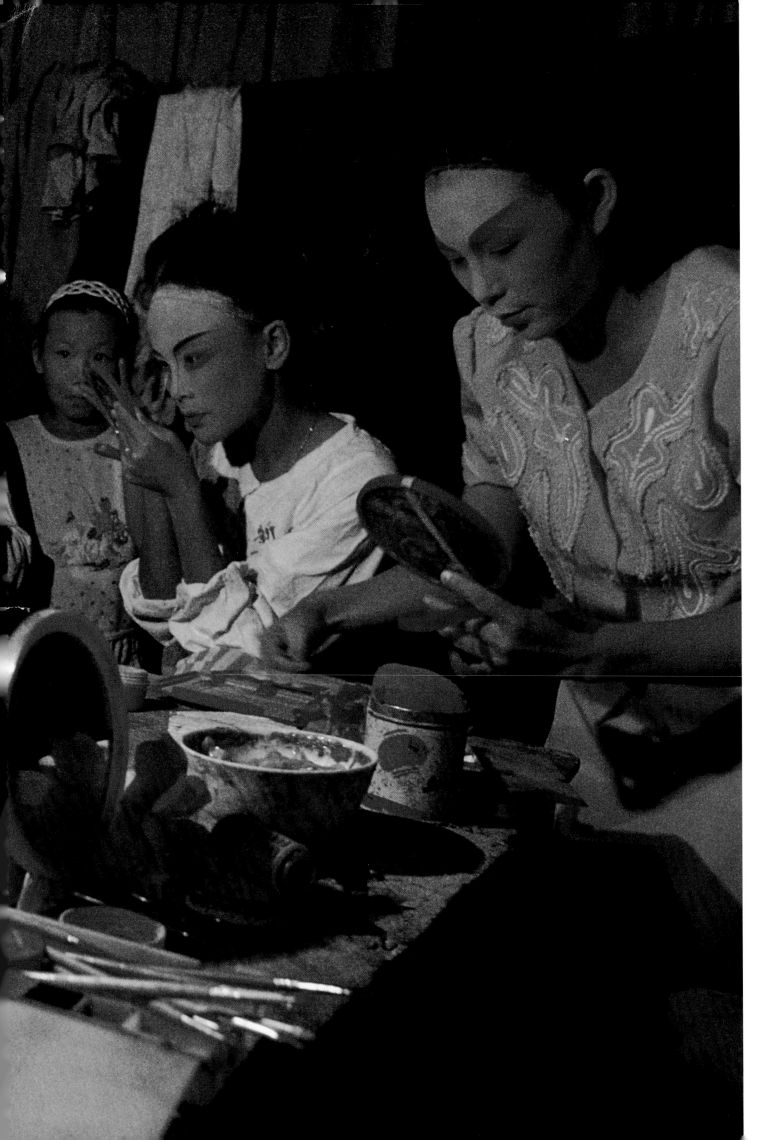

In his journals Ibn Battuta was more apt to talk of religion than the people he met. However, he was infatuated with people who did anything well. The Chinese impressed him, especially their artistic, acrobatic, and dance skills. At an opera near Quanzhou, officials allowed me to go downstairs, under the stage, while the performers were putting on their makeup. They were so used to being photographed they didn't pay me any attention. It was one bare light and Spartan surroundings; but, when they got on stage, their faces, their costumes were flawless.

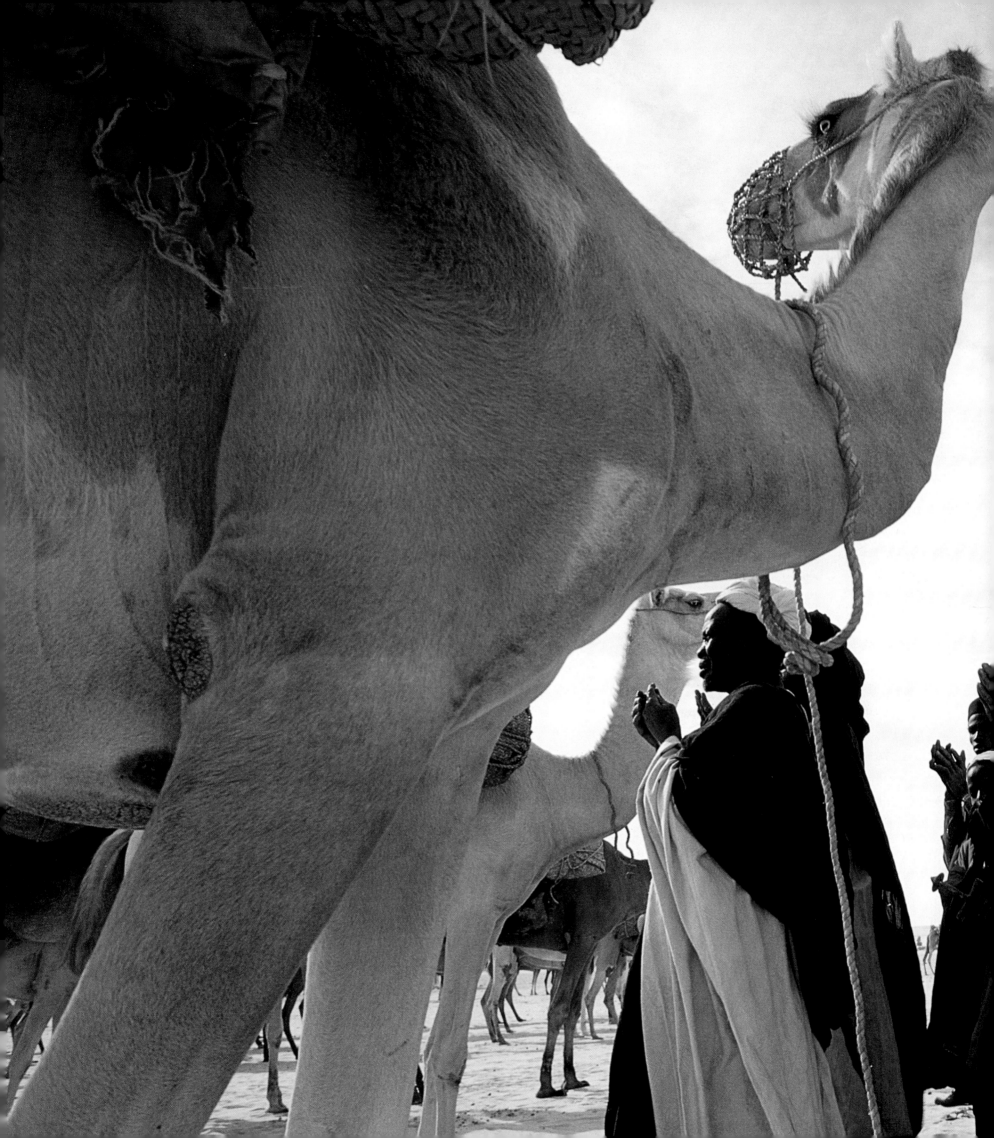